ROBERT MAPPLETHORPE

RICHARD MARSHALL

with essays by
RICHARD HOWARD
INGRID SISCHY

WHITNEY MUSEUM OF AMERICAN ART · NEW YORK

in association with

BULFINCH PRESS · LITTLE, BROWN AND COMPANY

BOSTON · TORONTO · LONDON

First trade paper edition, 1990
WMAA paper edition, 1988
First cloth edition, 1988

Third printing

Library of Congress Cataloging-in-Publication Data

Marshall, Richard,
Robert Mapplethorpe / Richard Marshall ; with essays by
Ingrid Sischy, Richard Howard.
p. cm.
Catalog of an exhibition.
Bibliography : p.
ISBN 0−87427−060−X (WMAA paper)
ISBN 0−8212−1786−0 (trade paper)
ISBN 0−8212−1728−3 (cloth)
1. Photography, Artistic—Exhibitions. 2. Mapplethorpe, Robert
—Exhibitions. I. Sischy, Ingrid. II. Howard, Richard, 1929–
III. Whitney Museum of American Art. IV. Title.
TR647.M365M37 1988 88−17334
779'.092'4—dc19 CIP

Bulfinch Press is an imprint and trademark of Little, Brown and Company (Inc.)
Published simultaneously in Canada by Little, Brown & Company (Canada) Limited

PRINTED IN THE UNITED STATES OF AMERICA

BOMC offers recordings and compact discs, cassettes
and records. For information and catalog write to
BOMR, Camp Hill, PA 17012.

Cover: *Apollo,* 1988 Gelatin silver print, 24 x 20 inches Collection of the artist

CONTENTS

This book was published on the occasion of an exhibition held at the
Whitney Museum of American Art, New York
July 28 through October 23, 1988

The exhibition was sponsored by The Bohen Foundation,
with additional funding from Laura Donnelley, Anne and Joel Ehrenkranz,
and the Sondra and Charles Gilman, Jr. Foundation

FOREWORD

IT IS PERSONALLY very rewarding to be the Director of the Whitney Museum of American Art at the time we present the work of Robert Mapplethorpe, an artist whose photographic work began to receive attention in the late 1970s and who is now internationally acclaimed as one of the most astonishing talents to enliven the art of the past decade.

Although the Whitney Museum of American Art does not actively collect and exhibit photography, the work of certain photographers is so insightful, so allied to the rhythms of our times, that it is essential to incorporate their art into the Museum's programs without regard to medium. Robert Mapplethorpe is one of those artists who has produced images that have become identified with the mores, sexual politics, aesthetics, and personalities of our lives. He has challenged the definition of photography by introducing new techniques and formats into the medium. He has made a recognized contribution to our visual culture and has proposed new solutions to the riddle of understanding ourselves. We celebrate him and are pleased to be the first American museum to present a comprehensive overview of his work.

In the film made during the historic auction of the Scull collection in New York in 1973, there is a scene in which the late Sam Wagstaff introduces Robert Mapplethorpe to Robert Scull and advises the collector that he should know Mapplethorpe's work because it is going to become famous. This was one of many prophetic declarations by Sam Wagstaff, a connoisseur of the avant-garde, who was not fully acknowledged during his life for his extraordinary vision and recognition of young artists. It is a personal sorrow not to be able to share this moment with Sam, as we confirm the confidence he expressed so surely and correctly in Mapplethorpe's art.

The rewards of our efforts as museum professionals are richest when we have the opportunity to work closely with a talented artist. It has been a distinct pleasure to share this endeavor with Robert, who has given himself generously to the project and greatly assisted Richard Marshall, Associate Curator, Exhibitions, to prepare and present his best work. For the catalogue, Richard Howard and Ingrid Sischy have contributed penetrating interpretations of Mapplethorpe's achievement—in aesthetic terms and in the context of our social environment. I am grateful to them and to the lenders, who have generously joined us to distinguish Robert Mapplethorpe through this exhibition and book.

Tom Armstrong
Director

MAPPLETHORPE'S VISION

Richard Marshall

THE DEVELOPMENT of Robert Mapplethorpe's work over the past two decades reveals a strong and consistent vision that strives for perfection and balance in subject and form. Even his earliest works, from 1970 and 1971, display features that would characterize much of his mature art. By 1970, Mapplethorpe had finished art school at Pratt Institute in Brooklyn, where he produced paintings, drawings, and sculpture, and was beginning to experiment in other areas. He was not yet taking his own photographs, but rather was exploring the idea of the found object and questioning traditional notions of authorship and originality by making art with pages torn from books and magazines. His deliberate appropriation of printed material represented a bold acceptance of commercially produced imagery as legitimate media for art and underscored the universality and importance of the photographic image in late twentieth-century culture. These concepts had been promoted earlier by Man Ray and Marcel Duchamp and, more recently, in the work of Andy Warhol (p. 13), whom Mapplethorpe greatly admired. In fact, Mapplethorpe used a published childhood photograph of Warhol for one of his own works (p. 23). This found portrait is composed like a typical Mapplethorpe portrait—frontal, centered, filling the frame. As in all of his magazine pieces, Mapplethorpe masked out certain areas and then spray-painted the remaining surface. In the Warhol picture, a tear bisects the right eye and a layer of spray paint delineates a ghostlike finger shape that seems to point to this torn area, emphasizing the fact that what Mapplethorpe selected, painted, and claimed as his own was a photograph of a damaged photograph. Thus, even at this early stage of his career, he insisted on the recognition of a photograph as an object.

This first portrait of Warhol, although not taken by a camera operated by Mapplethorpe, represents his earliest artist-celebrity portrait. Other works from this same period also include themes and subjects that Mapplethorpe would explore throughout his career. Primary among these are sexuality and eroticism. The untitled kissing boys of 1972 (p. 22), also a painted magazine page, displays overt sexual contact—less frequent in Mapplethorpe's later work, but present nonetheless—and male nudes with visible genitals. The masked and unpainted area over the kissing mouths is that same area usually masked by a black rectangle for censorship purposes. Here it is made more pronounced and noticeable—Mapplethorpe wants to draw attention to the potentially offensive part of the picture. The earlier *Leatherman II* and *Julius of California* (pp. 18, 21) present another aspect of Mapplethorpe's homoeroticism—the fetishized stereotypical man, here as a cowboy and biker. The cowboy has been partially obstructed by layers of spray paint, although the encircled genital area is highlighted; and the leatherman collage shows cropped body parts superimposed over a male torso. Both works speak for Mapplethorpe's early interest in cropping and details. The spray-

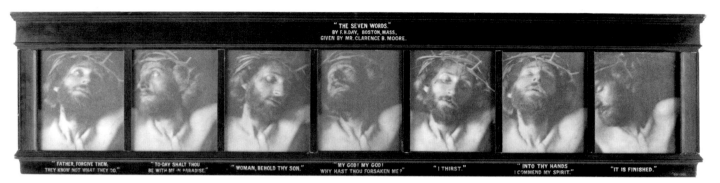

F. Holland Day *The Seven Words*, 1898

painted *Jesus*, 1971 (p. 20), makes reference to Mapplethorpe's Catholic upbringing and foreshadows the religious themes and symbols that recur in his later photography.

These works from the early seventies also reveal Mapplethorpe's desire to manipulate and alter the photographic image in an effort to expand the technical and aesthetic boundaries of traditional photography. In this pursuit, he began to use different printing materials and surfaces, as well as unconventional forms of matting, framing, and glazing. An untitled 1971 collage (p. 19) shows an aggressive ripping of dyed photographs that counters the preciousness usually credited to the photographic print. The slightly later *Model Parade* (p. 25) is another attempt at manipulating the photographic reproduction process. In this work, Mapplethorpe applied a synthetic emulsion to two pages from a male physique magazine in order to lift the image and its color. He then transferred the dried emulsion onto the canvas, adding color and stretching and distorting the image as he arranged it. He would repeat this process—making a painting on canvas from a printed photograph—in his 1987 series of platinum prints on linen.

Mapplethorpe took his first photographs in the early 1970s with a Polaroid camera, which by that time was being mass-marketed, although it was still "new" and representative of advanced technology. It was the perfect device for Mapplethorpe to adapt. He was not a "photographer," did not think of himself as a "photographer," and did not aspire to become a "photographer." He merely wanted to take his own pictures rather than use someone else's from magazines. The Polaroid was popular, casual, inexpensive, and immediate—all features that appealed to him. In addition, it had been embraced by a number of current artists—Andy Warhol, Lucas Samaras, and David Hockney—so that it had a contemporary edge. Mapplethorpe's first Polaroids were of himself. A self-portrait could be done privately without anyone's participation and allowed the freedom of experimentation, trial, and error. A different kind of experimentation—with media other than traditional painting and sculpture—was encouraged by the artistic atmosphere of the early seventies. It was the era of "painting is dead"; it was felt that artistic expression had exhausted itself in Minimalism and Conceptualism. The younger generation, Mapplethorpe included, was left with the task of trying to find alternate subjects and materials to revitalize what they perceived as a stagnant aesthetic mood. The camera, especially the Polaroid camera, was one of many possibilities that Mapplethorpe tried. A 1971 *Self Portrait* (p. 17) consists of three overlapping photographs of an almost full-figure, naked Robert Mapplethorpe. The three prints are not in exact alignment, suggesting a jerky cinematic sequence; and they are unexpectedly encased in a purple paper bag behind an open screen mesh. This unusual presentation again

Man Ray *Rrose Sélavy alias Marcel Duchamp,* 1920–21

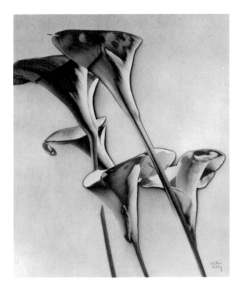

Man Ray *Solarization (Calla Lilies),* 1931

announces Mapplethorpe's ongoing concern with making an "object" rather than a "photograph." In this instance, the paper bag is not just a frame for the pictures, but carries as much visual importance as the Polaroid photographs.

Mapplethorpe continued to develop this idea of making an object that incorporates photographic information in other Polaroid works from 1973, including a multiple portrait of transvestite "superstar" Candy Darling (p. 28) and one of his friend, the poet-singer-artist Patti Smith. This portrait of Smith (p. 27) is the first of many—exceeded in number only by his self-portraits—which continually reveal the close rapport and trust that developed between photographer and subject. These two multiple portraits suggest a cinematic progression, although they are not sequential or narrative, and illustrate the importance of Warhol's paintings and films for Mapplethorpe's work. Again, Mapplethorpe "objectified" the photographic prints, here by framing them in the original plastic cassettes supplied by the Polaroid manufacturer; the plastic mounts for the Candy Darling portrait are painted in sweet pastel colors, and an untitled 1973 composition of six Polaroids (p. 29) includes painted purple mounts. Mapplethorpe's next *Self Portrait* (p. 30) increased the size of the photograph and the prominence of the frame. The photographic print is an enlargement of a Polaroid that depicts the artist wearing a leather vest with a clamp attached to his right nipple. His blurred face displays sensations of pleasure and pain. The heavy frame is covered in black leather, with a strip of red leather across the bottom edge. In texture and material the frame reiterates the subject of the photograph. It is one of Mapplethorpe's earliest direct manifestations of a sadomasochistic theme, one that he would more fully develop later.

Works from 1974 and 1975 are even more ambitious in scale and have a different photographic emphasis. *The Slave* (p. 31) is both a still life and a conceptual self-portrait. It is a photograph of black-and-white photographs in an open book that illustrate two views of Michelangelo's *Dying Slave;* lying across the bottom of the book is a knife and below these is a small plaque with the artist's last name. As a photograph of a photograph of a statue of a male figure, *The Slave* questions levels of reality and notions of reproduction while it emphasizes the physicality of the book and reinforces the idea of photograph as object. It also makes reference to male sexuality and introduces the knife that would appear in Mapplethorpe's subsequent pictures and which suggests the elements of threat, danger, pleasure, and pain that often underlie his imagery.

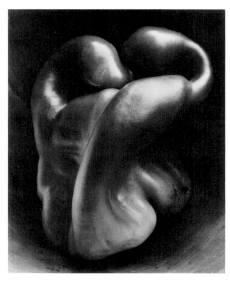

Edward Weston *Pepper No. 30, 1930*

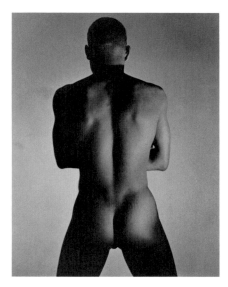

George Platt Lynes *John Leaphart,* 1952

Two related works from 1974 use a photograph in a more detached, conceptual mode. By the late 1960s, such artists as John Baldessari, Joseph Kosuth, Bruce Nauman, and Edward Ruscha had embraced photography as an acceptable means of contemporary expression. Mapplethorpe was not aligning himself with these artists or attempting to emulate their work, but he did employ a similar conceptual approach to open another area of exploration. Both *Wood on Wood* and *Black Shoes* utilize dual pictures and wide frames that outscale the actual prints they surround. In fact, Mapplethorpe designed and constructed the wood-grain frame before he determined what it would contain—a process that again reveals his continued interest in making beautifully designed and crafted objects regardless of their function or contents. *Wood on Wood* (p. 32) is all about the frame and not about the photographs. Mapplethorpe thought the wood back of the frame was so beautiful that he photographed two areas of it and set these two black-and-white photographs into the frame, thus allowing the front and back of the frame to be seen simultaneously. The work is art about itself—about the formal concerns of its own making and presentation. *Black Shoes* (p. 33), two black-and-white photographs of two pairs of black shoes seen from above (possibly symbolic portraits of Mapplethorpe and Patti Smith), is similarly arranged and framed. *Self Portrait* (p. 35), also of 1974, shows Mapplethorpe more involved with shaped and painted framing. This stark, moody work is an enlargement of a Polaroid photograph, which accounts for its somewhat grainy resolution. The eccentric shape of the green frame is actually patterned after that of a Polaroid print as it is pulled out of the camera, with angled edges on one end and a tab on the other. This *Self Portrait* is another example of Mapplethorpe's attention to formal concerns, to aspects of the work that make reference to and are dictated by the materials and medium.

Francois, 1974–75 (p. 36), is one of Mapplethorpe's most severe and formalistic works to date. It consists of the cropped face of a male repeated four times, each face presented in a trapezoid frame with one angled side echoing the line of the subject's neck. The photographs are printed in the primaries red, yellow, and blue, and the frames are constructed in black or white. The four pieces are arranged horizontally and at equal intervals, with one flopped and reversed image and frame facing the other three. This work is very sculptural and recalls not only Warhol's repeated images but, more directly, the repetition and modular construction of Donald Judd's minimal objects and Brice Marden's multipanel paintings (pp. 12, 14). Like other artists of his generation, Mapplethorpe was seeking ways to reconcile two sometimes contradictory aesthetic impulses —the figurative-emotional-intuitive with the abstract-geometric-logical. This search shows Mapplethorpe to have been in sympathy with current ideas in New York painting and sculpture and aware of the concerns

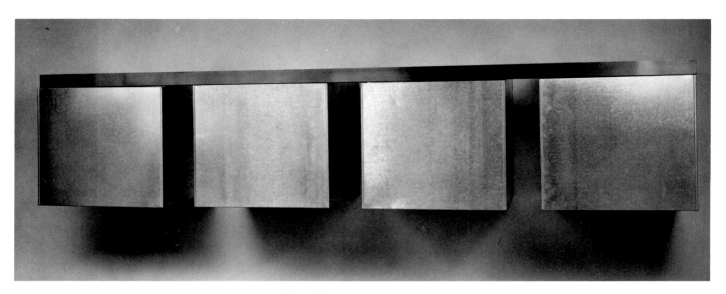

Donald Judd *To Susan Buckwalter*, 1964

of contemporary photography. His attempt to combine the formal with the subjective is not unlike that of other artists at this same moment—Jennifer Bartlett's introduction of recognizable and rudimentary imagery into a strict, gridded format of metal plates; or Susan Rothenberg's use of a horse profile superimposed onto a structured and delineated rectangular paint surface; or Gilbert and George's personal photographic narratives in multipaneled geometric arrangements.

Through the mid-seventies, Mapplethorpe's development was gradual and private—his work had only limited and sporadic public exposure. The invitation to have two simultaneous exhibitions in 1977 prompted him to energetically produce a specific body of work that focused on new types of process, presentation, and themes. He had recently acquired a large-format press camera that produced 4-by-5-inch negatives and next a Hasselblad camera, which he felt confident and comfortable with. His early experiments with the new cameras were, of course, with himself and Patti Smith as subjects. They then progressed to an ever-widening circle of friends and acquaintances that included artists, composers, architects, socialites, pornographic film stars, and members of the homosexual underground. By this stage, the camera had become Mapplethorpe's sole means of expression. He did not feel a strong ideological commitment to photography; rather it simply became the medium that could best convey his statement. But he realized that photography had a history, and he set out to educate himself about it. He developed an appreciation for Nadar's portraits and Julia Margaret Cameron's photographs. F. Holland Day's subject matter, homoerotic themes, and framing especially intrigued him. Day's self-portraits as the crucified Christ (p. 9) appealed to Mapplethorpe's awareness of his own Catholicism and his use of the self as subject. In addition, Day's strict insistence on designing the frame and controlling the presentation of his photographs was an important precedent for Mapplethorpe's efforts to make the photograph a unique object. Edward Weston's dedication to nudes, portraits, and still lifes (p. 11) also paralleled Mapplethorpe's specific interests, and George Platt Lynes' seductive depictions of the male form (p. 11) set another precedent.

Along with this keener awareness of styles, subjects, and techniques in the history of photography, Mapplethorpe also came to respect the work of Marcel Duchamp, David Hockney, Man Ray, Edward Ruscha, and Andy Warhol—all of whom produced photographs, paintings, drawings, prints, sometimes sculpture and films, with equal conviction. In addition, like Mapplethorpe, all enjoyed a type of celebrity status, a popularity and renown which, although connected to their art, went beyond the borders of the art world to a

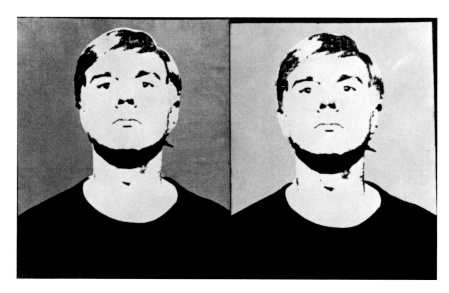

Andy Warhol *Self Portrait, 1964*

larger audience. Although similarities between their art and Mapplethorpe's are numerous, a few specific examples illustrate shared concerns. Duchamp's alter ego in drag, Rrose Sélavy (p. 10), introduces the concept of self as art that extends beyond self-portraiture. Mapplethorpe's self-portrait in women's make-up or clothes is an obvious comparison, but in the 1978 *Self Portrait* with a whip inserted in his ass (p. 75), or the 1982 *Self Portrait (with Gun and Star)* (p. 109), Mapplethorpe uses his body as an artwork or to represent another persona; the photograph serves to acknowledge the idea or to document the event. Man Ray's solarized photographs of calla lilies (p. 10) not only parallel Mapplethorpe's own interest in floral still lifes, but in experimenting with photographic techniques and procedures as well. Warhol's importance to Mapplethorpe goes beyond formal concerns of repetition and a distanced, nonmoralizing posture toward subject; the two artists also favored similar subjects—shoes, self-portraits, celebrities, genitalia, transvestites, and flowers. And Edward Ruscha's conceptual approach to photography, his appreciation of graphic design, and his use of moiré fabrics (p. 15) are similar to Mapplethorpe's own interests.

During the late 1970s, Mapplethorpe produced a number of multiple-panel photographic objects. These often involved double or triple views of the same person, with slight cinematic variations in posture, or shifts in foreground and background, or a progressively closer focus on the subject. The most pronounced feature of these pieces is the careful attention given to the presentation. Mapplethorpe chose fabrics in rich colors to surround and mat the photographs. This matting integrates a strict, formal geometry with the softness of the human or floral form. The mats often bleed off one edge—top or bottom—or form three equal squares—which may not, however, be centered in the frame. The size and composition of the matting and framing are determined by the photographic print itself. The geometry and proportions are dictated by the standard square format of a photographic image situated on a rectangular piece of photographic paper. In his usual manner, Mapplethorpe is acknowledging the given characteristics of a photograph and its objectness and allowing those factors to determine the arrangement of multiple images. Similar formal considerations are at work in his design of the wood frames and internal divisions. He often employs a double frame in woods of different sizes and grains in order to further reinforce the physicality of the work.

In addition to what is seen, Mapplethorpe is also concerned with how it is seen—or how the eye looks at a surface. The triptych portrait of Brice Marden (p. 43), for instance, includes one empty section that contains only glass, which reveals the wall behind. This concept not only makes a reference to the monochromatic panels

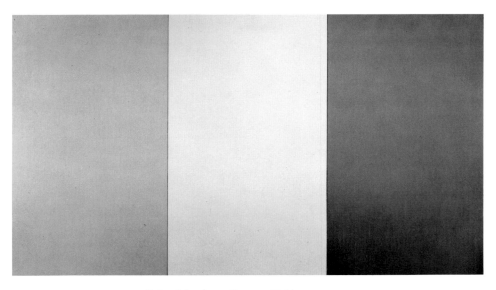

Brice Marden *Summer Table*, 1972–73

of Marden's own paintings, but startles the eye by forcing it to read depth—to look through the picture. In a similar way, Mapplethorpe engages the viewer by including a mirror as one panel of a piece. The viewer, reflected in the mirror, is brought directly into the picture. This can be especially startling when one sees oneself flanked by two erect penises, as in *Bill, New York*, 1976–77 (p. 66), or surrounded by flowers as in *Easter Lilies with Mirror*, 1979 (p. 67). Mapplethorpe wants to make viewing both participatory and confrontational, particularly with shocking or sexually charged images. His choice of subject matter, combined with the manner of its presentation, reveals a number of consistent attitudes. He maintains a desire to make beautiful objects with printed photographic images. He attempts to reconcile the formal concerns of color, texture, form, and balance with the subjective and emotive associations of the photographic image. He wants to allow the photograph to be experienced in a different way, to be accepted on the same aesthetic and critical grounds as painting and sculpture.

Concurrent with Mapplethorpe's assimilation and evaluation of prevalent aesthetic issues of the 1970s was his awareness of the dominant social and sexual issues of the decade. The so-called sexual revolution promoted sexual freedom, liberation, and the acceptability of what had previously been considered aberrant behavior. Within the homosexual population, various substrata flourished, and with them an increase in bars, baths, and clubs that supplied a setting for these different interests. The group identified as sadomasochistic represented both a type of sexual behavior and an adopted style or attitude—often associated with leather and bondage. Mapplethorpe was a sympathetic participant in this group. He felt it was worthy, legitimate, previously unexplored, and an almost obligatory subject for him to treat. He approached it not as a voyeur but as an advocate, wanting to instill through his photographs dignity and beauty to a subject that was outside the accepted norms of behavior. The body of work that Mapplethorpe completed on this subject from 1976 to 1979 brought him a great deal of acclaim and criticism and confirmed his position as an artist of strength, confidence, and talent.

Mapplethorpe's photographs of the early 1980s show a shift away from multiple-panel presentation and away from actively sexual imagery to a phase of refinement of subject and composition that emphasizes a classical, quiet, and formalized sense of beauty. He began a more concentrated approach to the subject of the nude, both male and female, and also continued to do flower still lifes as well as formal portraits of a widen-

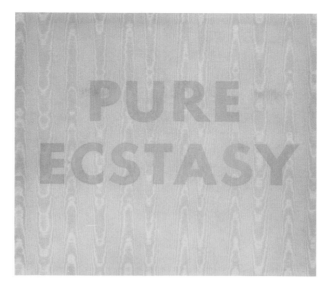

Edward Ruscha *Pure Ecstasy*, 1974

ing celebrity pool that included not just artists, but movie, fashion, and corporate personalities. He also started to dramatically enlarge his favorite images and have them framed to his specifications. This process was yet another way to make a photograph a one-of-a-kind object. At the same time, these larger pieces could better compete with the size of paintings and have greater visual impact in an exhibition setting. Mapplethorpe continued to explore and extend the boundaries of photographic works by using a variety of printing techniques: color Polaroid, photogravure (both color and black and white), platinum prints on paper, platinum prints on linen, Cibachrome color prints, and dye transfer color prints. In each case, his subjects remained consistent with those in his black-and-white gelatin silver prints, but the visual impression, size, edition, and color quality would vary—all part of his ongoing quest to see things differently. At one point, he attempted to deal only with the formal, geometric design issues inherent in his work and exclude the photographic image completely. This series of objects is composed of traditional classic forms—cross, star, x, triangle—and allowed Mapplethorpe to explore issues of shape, surface, materials, reflection—that is, purely abstract and reductive issues. Although he had eliminated the subjective content of the photograph, these shapes are strongly associative and carry their own symbolic references. These works, such as *White X with Silver Cross* (p. 124) and *Star with Frosted Glass* (p. 125), both of 1983, are in some ways elaborately constructed shaped frames without a picture. They remind us that in the late 1960s Mapplethorpe had made sculpture. They also recall the shaped frames he made during the 1970s and foretell the complex and symbolic framing devices used in 1987 in such works as *Andy Warhol* and *Chest* (pp. 173, 175).

The platinum print on linen works of 1987 are especially important because they synthesize a number of Mapplethorpe's concerns. By having a technique devised for printing a photograph on linen, he was able to fuse characteristics of photography and painting. The color, texture, and geometric composition that had always appealed to him are incorporated here as individual panels of stretched fabric which bracket the photographically printed panel. This type of serial arrangement had been present in Mapplethorpe's compositions since the earliest Polaroid groupings, but now it is more fully and successfully realized. Conceptually and visually, he has achieved a beautiful photographic object. His continuing interest in proportion, color, texture, and scale are magnified in these multipanel fabric and platinum on linen works. As in all his art, Mapplethorpe combines abstract, formal considerations with his personal and refined vision of idealized beauty in a photographic image to achieve a powerful and memorable statement.

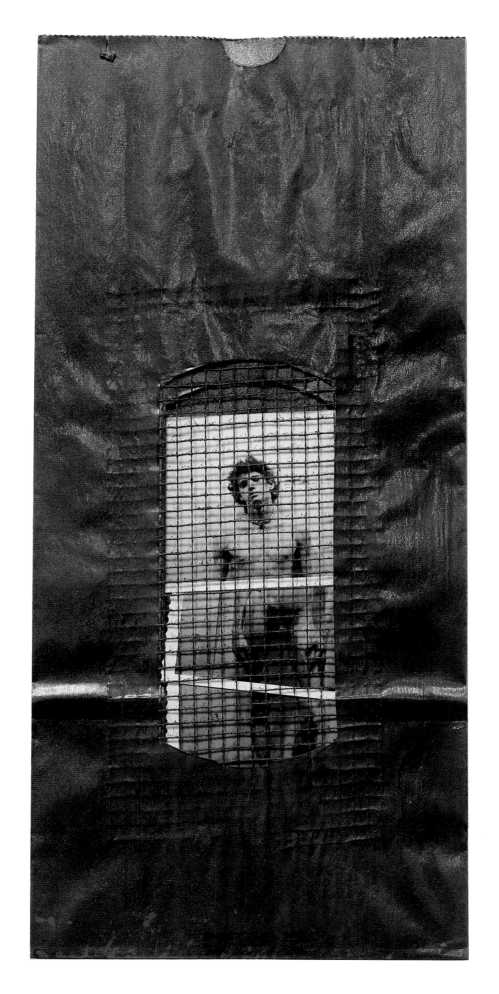

SELF PORTRAIT 1971

17

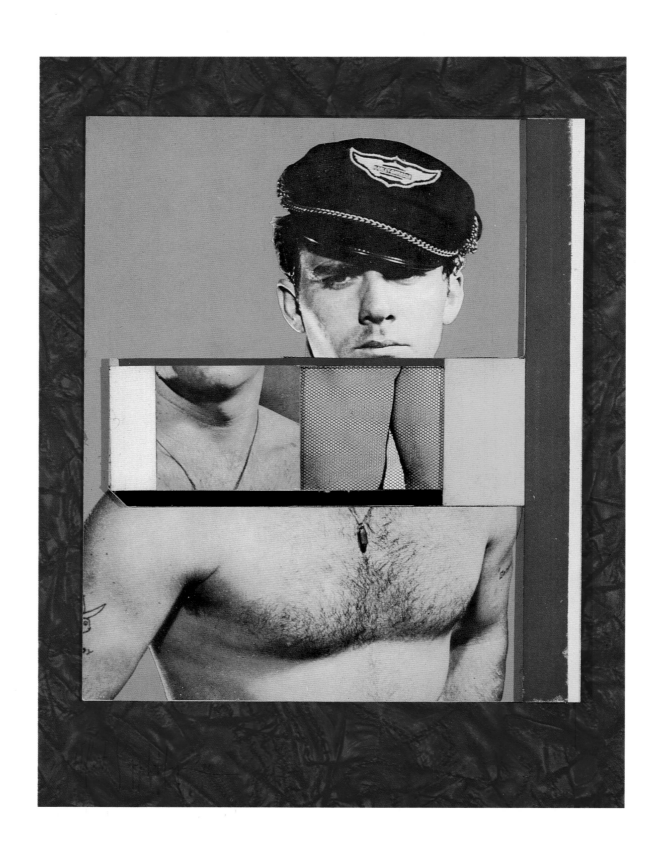

LEATHERMAN II 1970

18

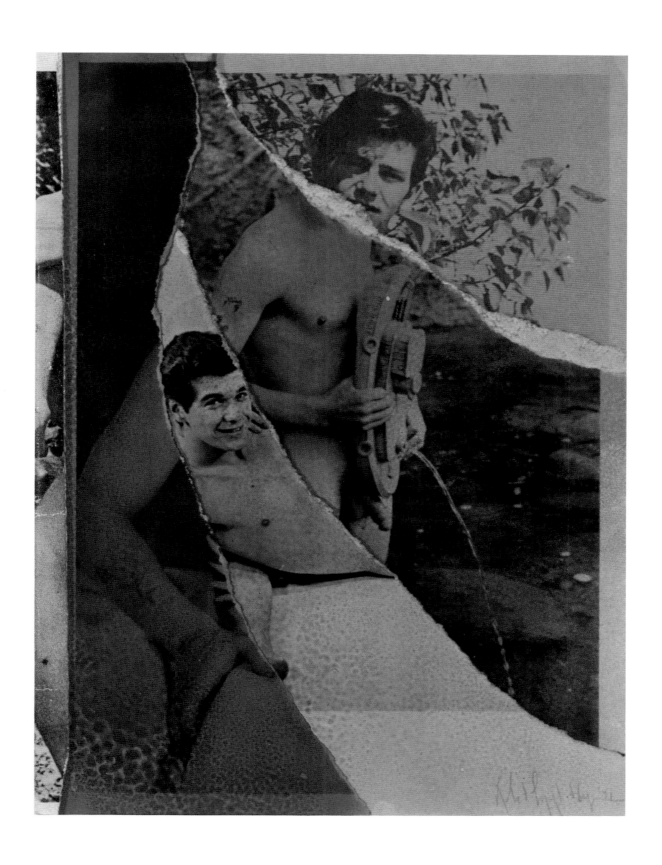

UNTITLED 1971

19

JESUS 1971

JULIUS OF CALIFORNIA 1971

21

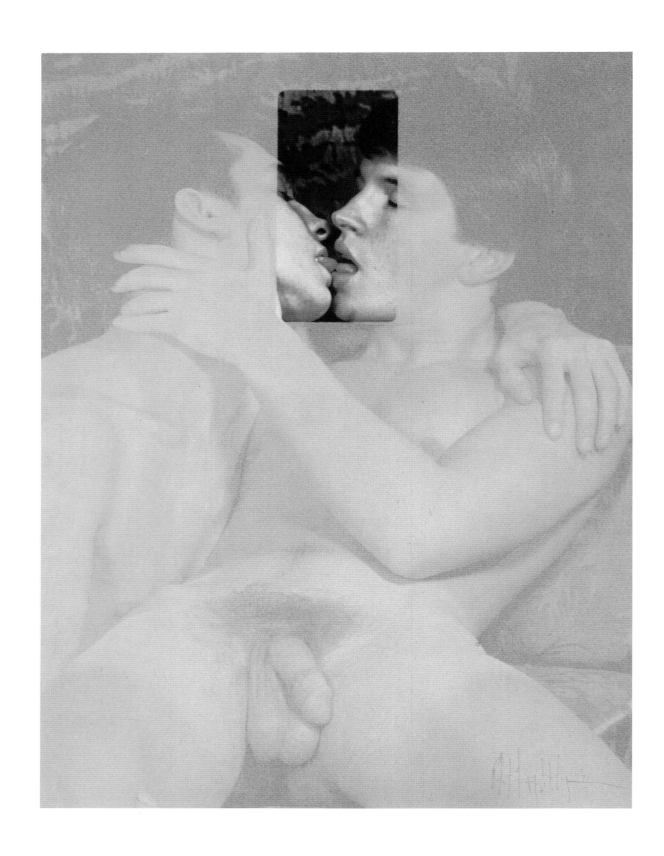

UNTITLED 1972

22

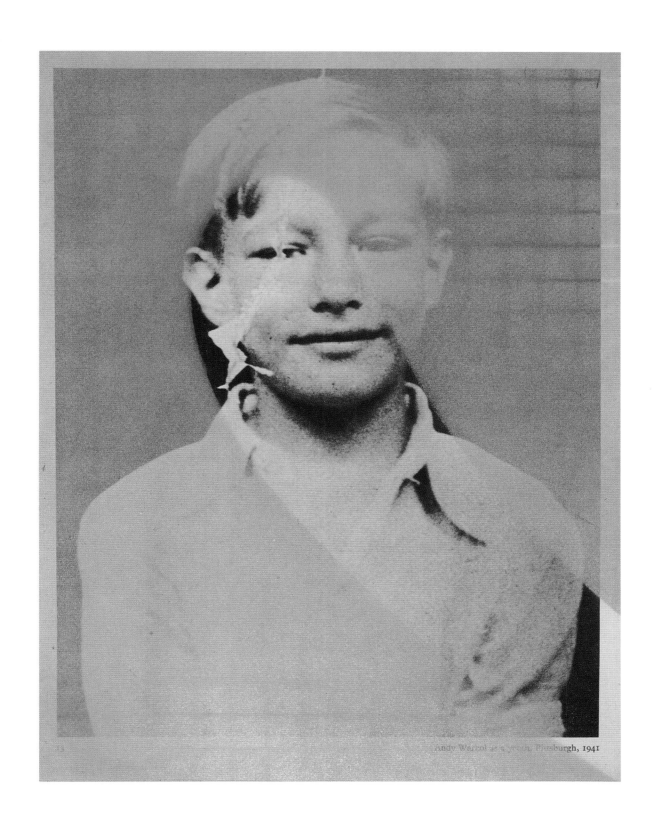

Andy Warhol as a youth, Pittsburgh, 1941

ANDY WARHOL 1971

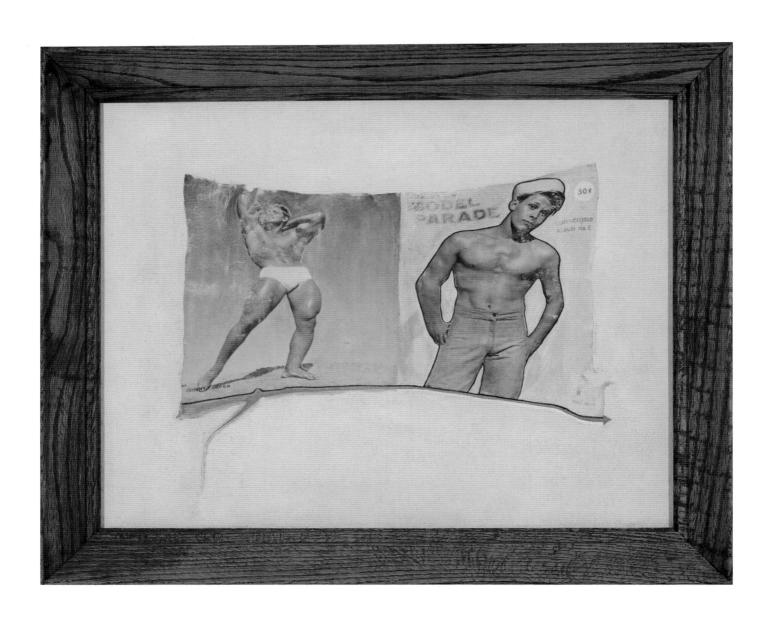

MODEL PARADE 1972

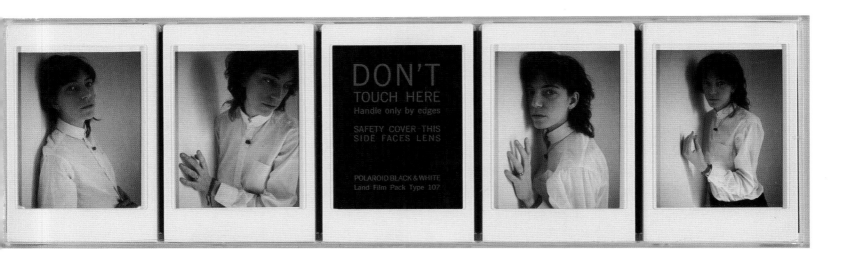

PATTI SMITH (DON'T TOUCH HERE) 1973

27

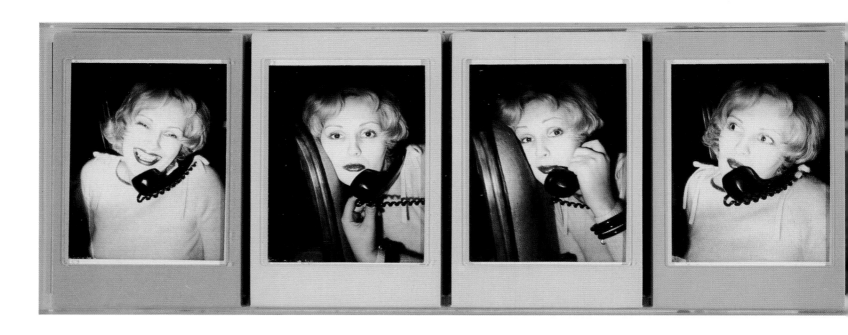

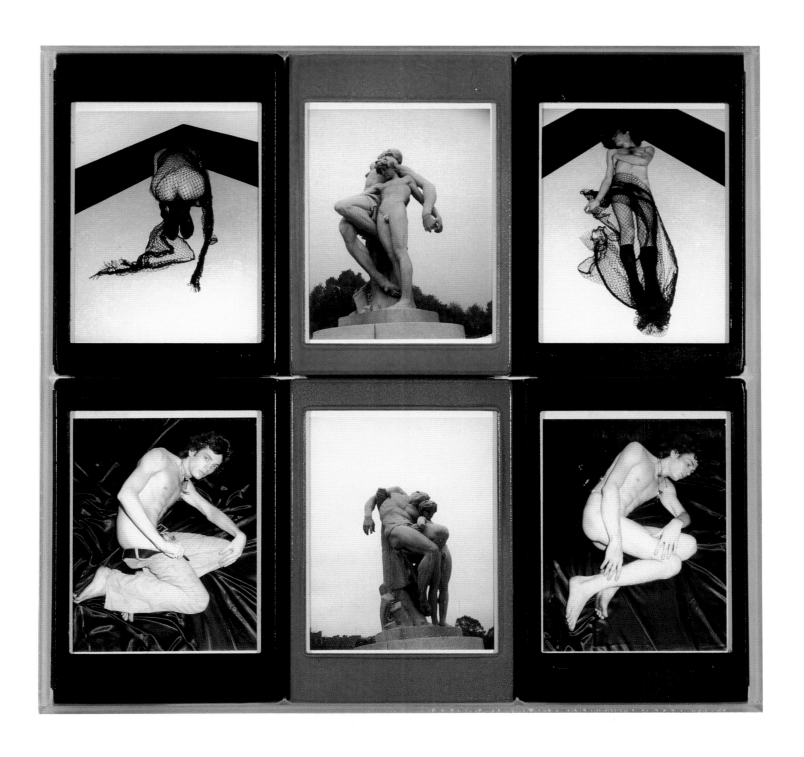

UNTITLED 1973

29

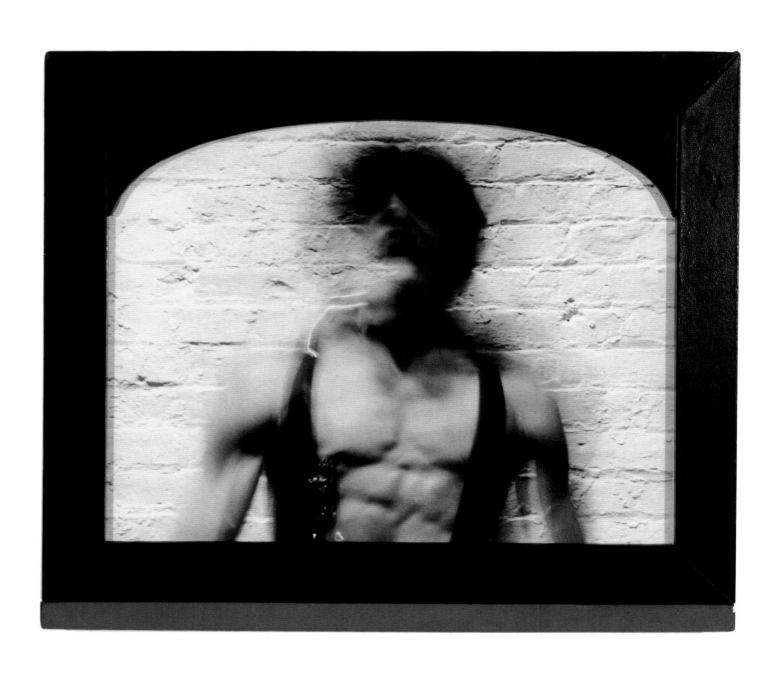

SELF PORTRAIT 1973

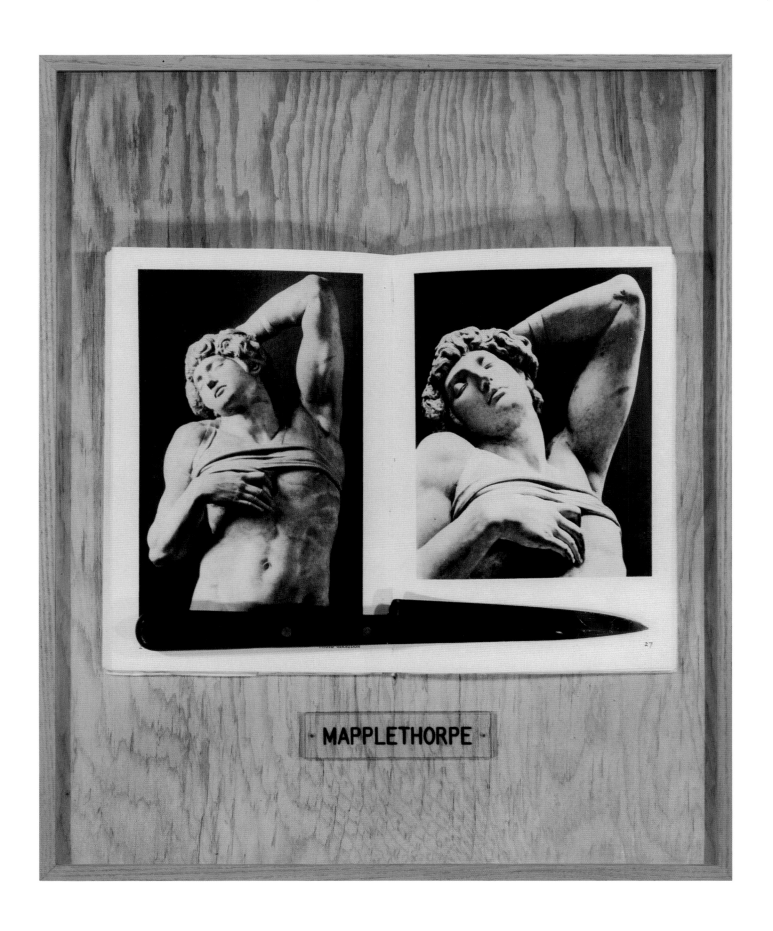

THE SLAVE 1974

31

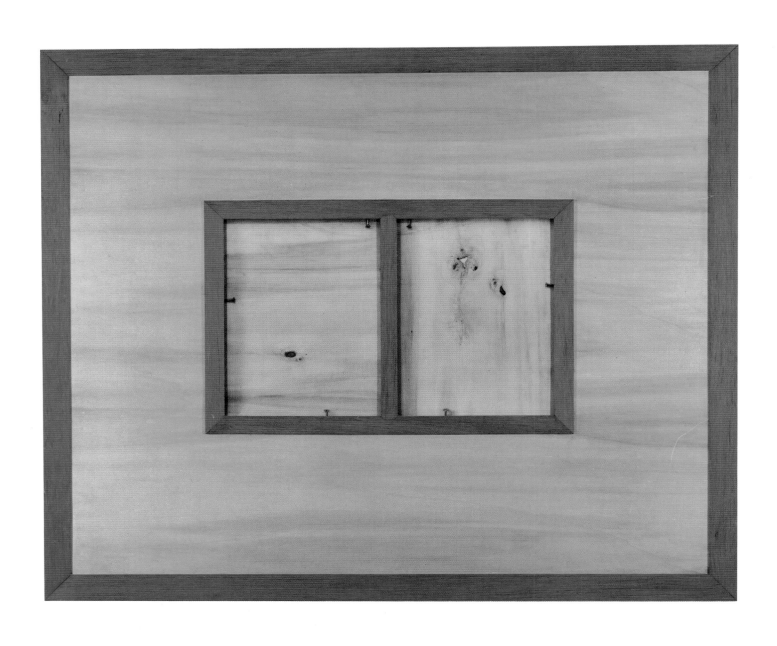

WOOD ON WOOD 1974

32

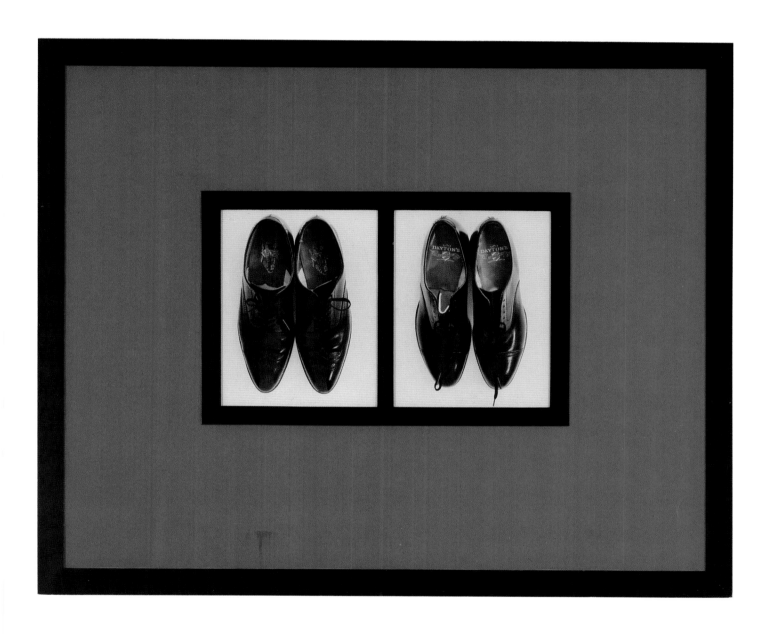

BLACK SHOES 1974

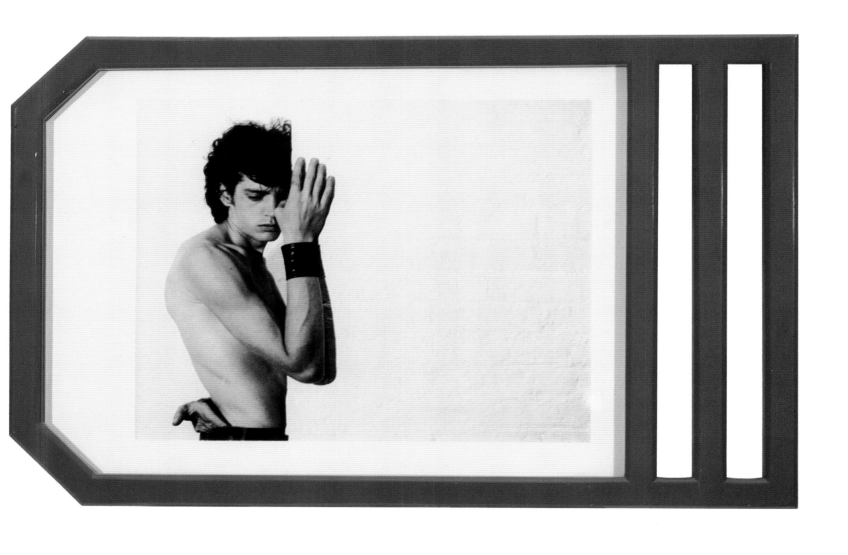

SELF PORTRAIT 1974

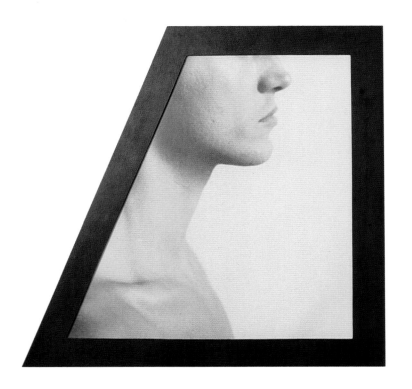

FRANÇOIS 1974–75

36

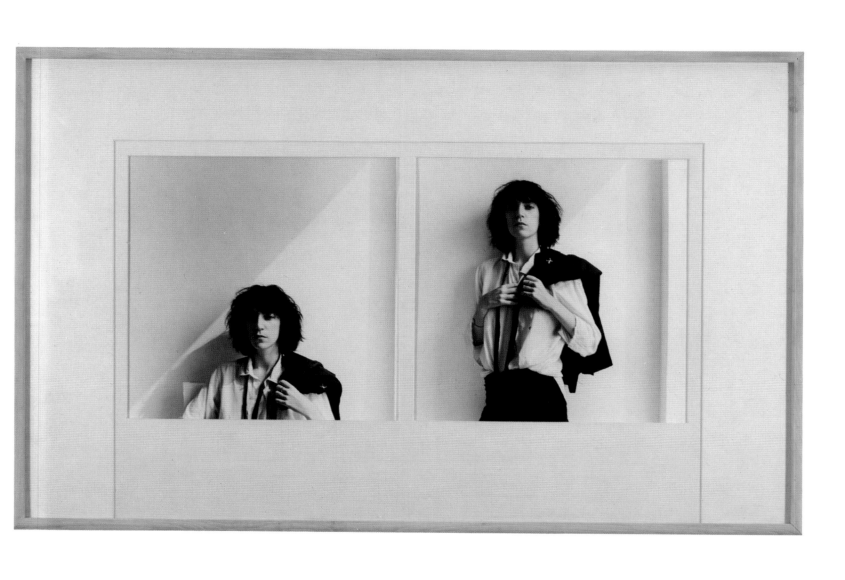

PATTI SMITH (HORSES), 1975

39

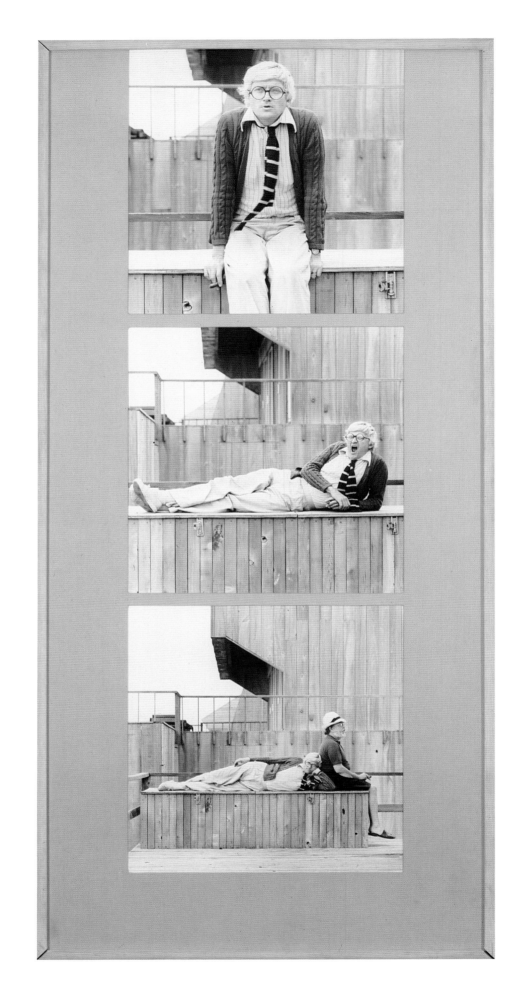

DAVID HOCKNEY AND HENRY GELDZAHLER 1976

40

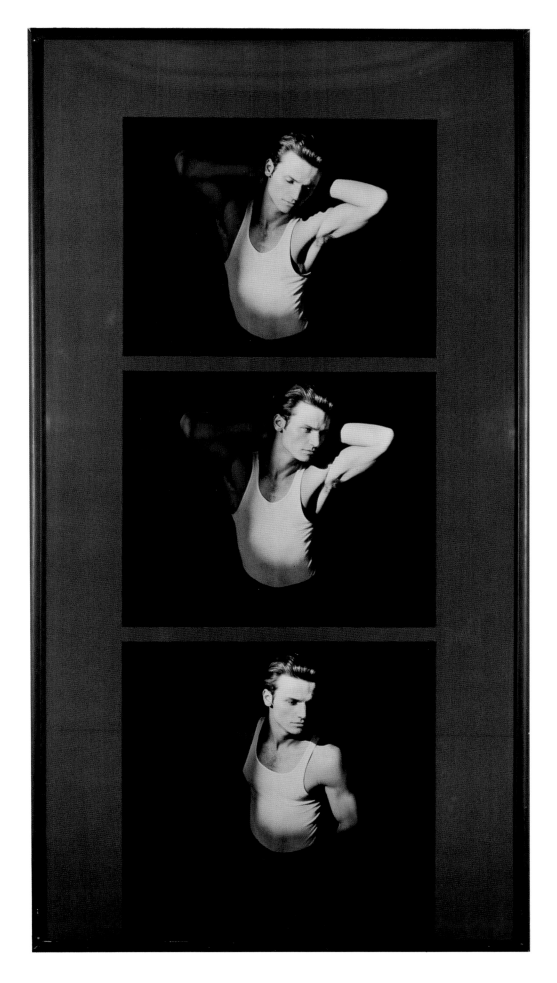

DENNIS 1976

41

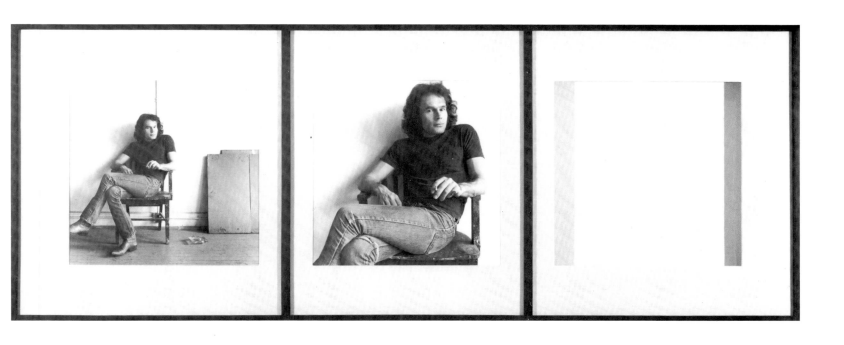

BRICE MARDEN, NEW YORK 1976

43

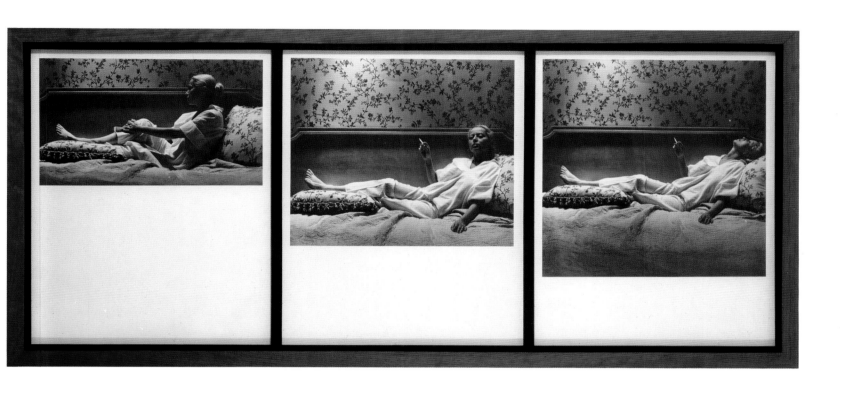

PAN HEAD AND FLOWER 1976

46

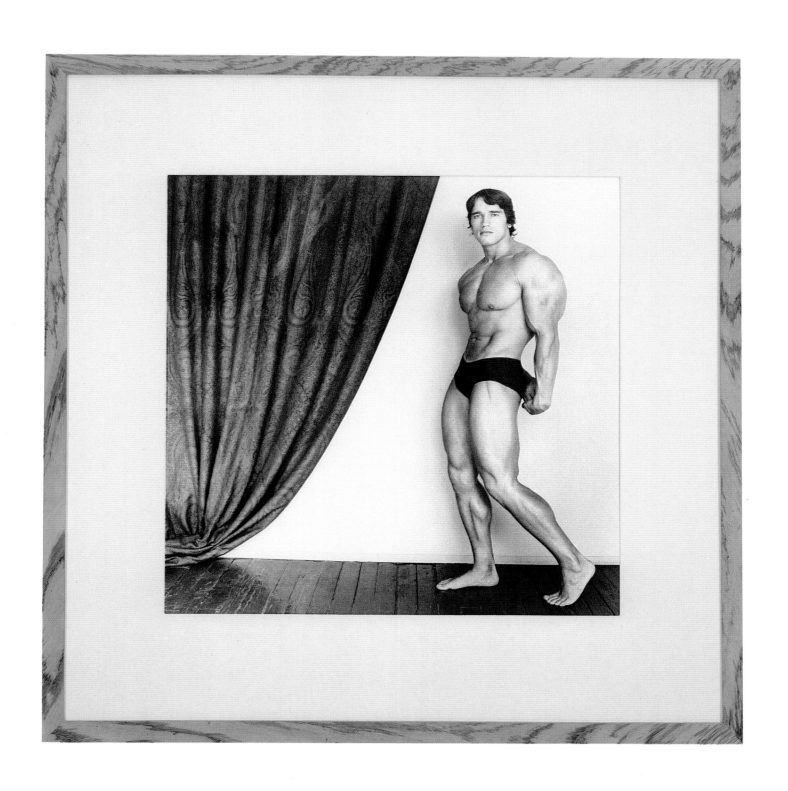

ARNOLD SCHWARZENEGGER 1976

47

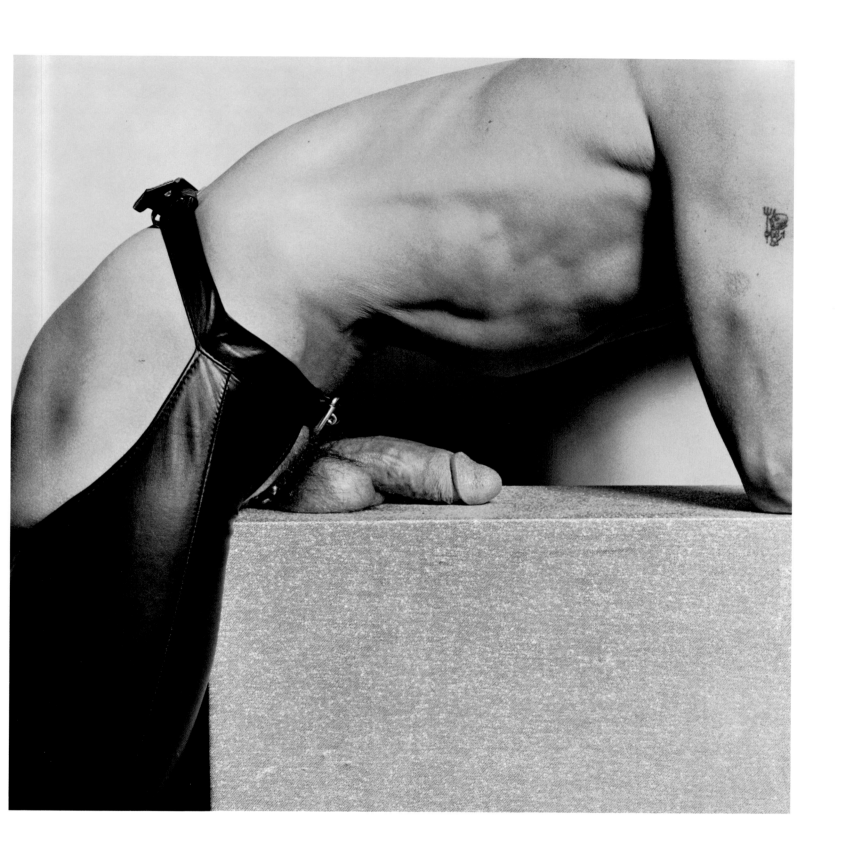

MARK STEVENS (MR. 10½), 1976

49

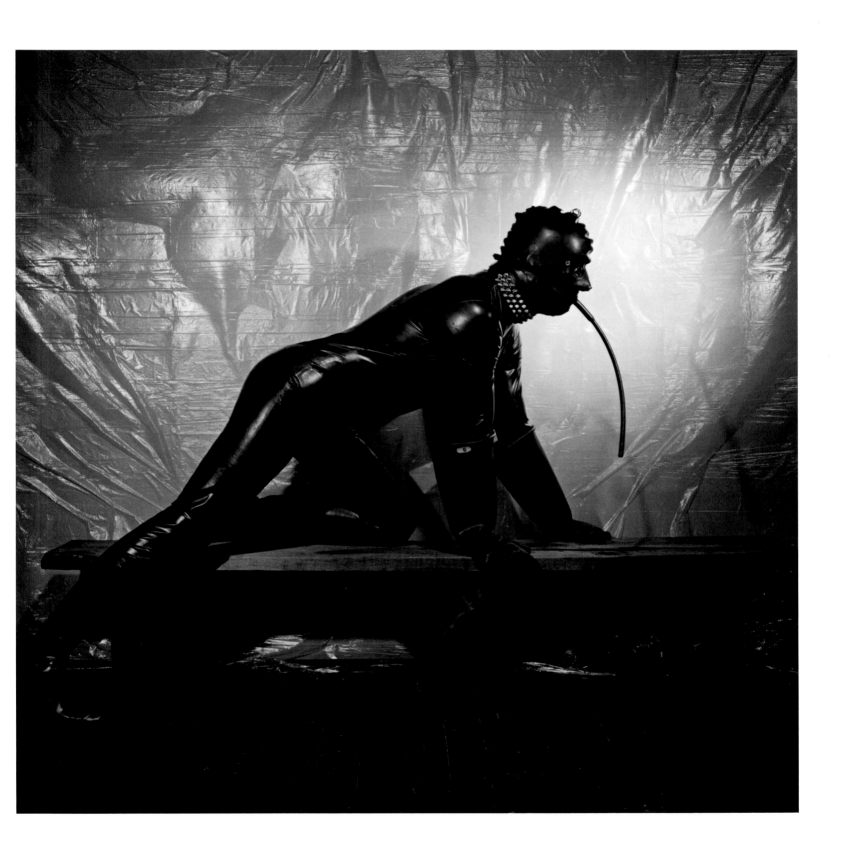

JOE 1978

PHILIP GLASS AND ROBERT WILSON 1976

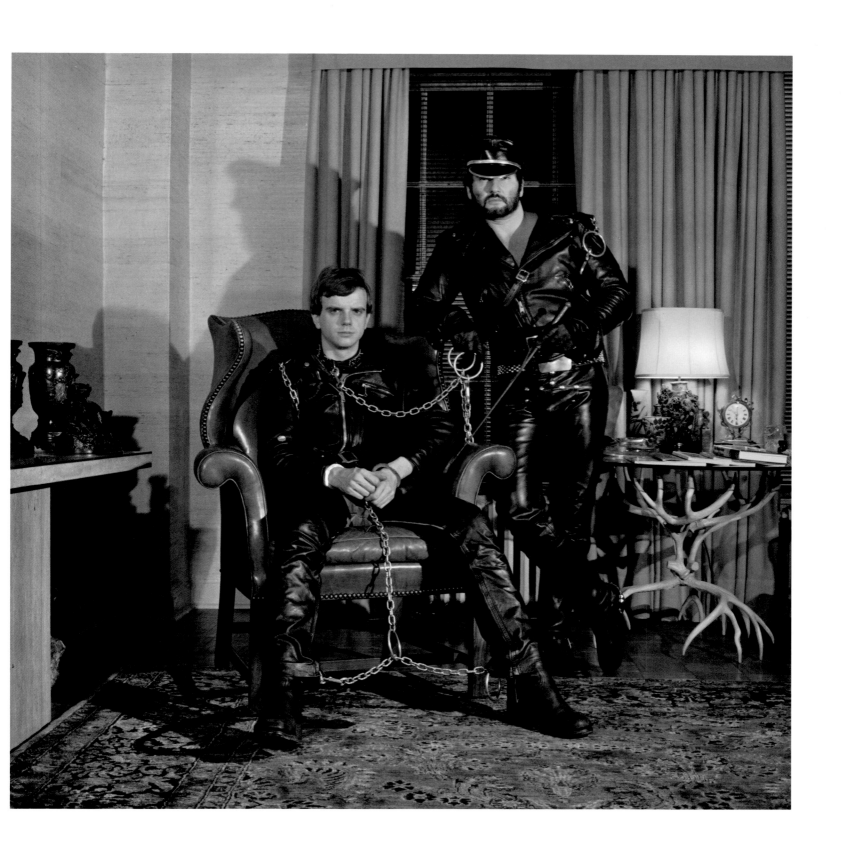

BRIAN RIDLEY AND LYLE HEETER 1979

55

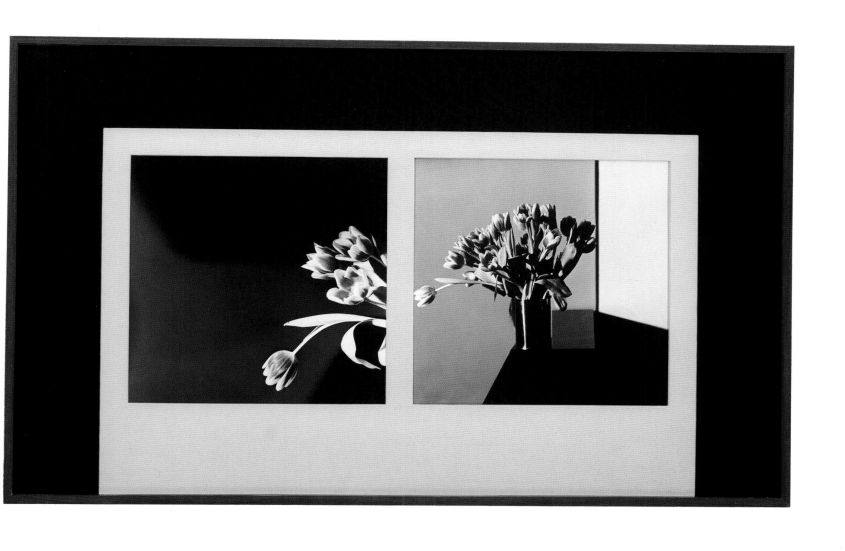

TULIPS 1977

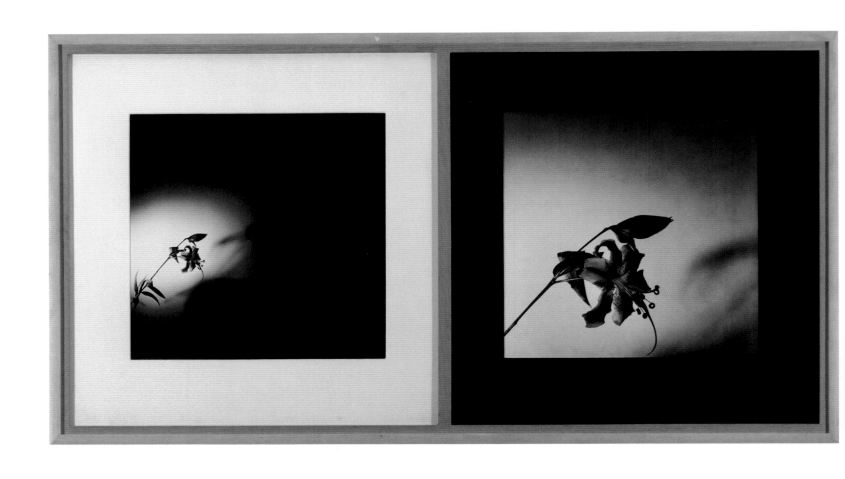

TIGER LILY 1977

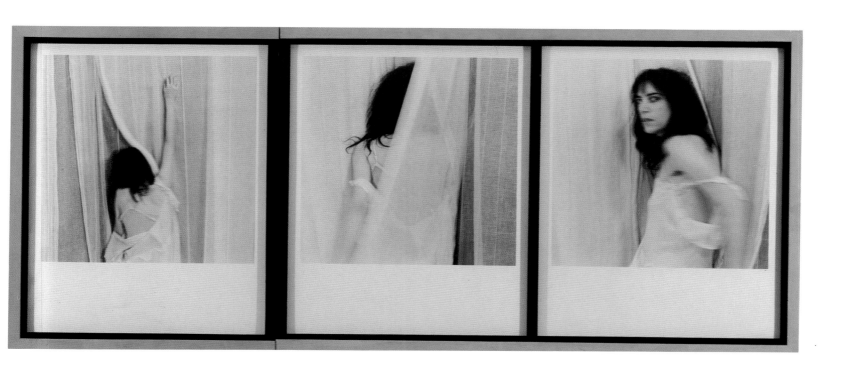

PATTI SMITH (STILL MOVING) 1978

PHILIP JOHNSON 1978

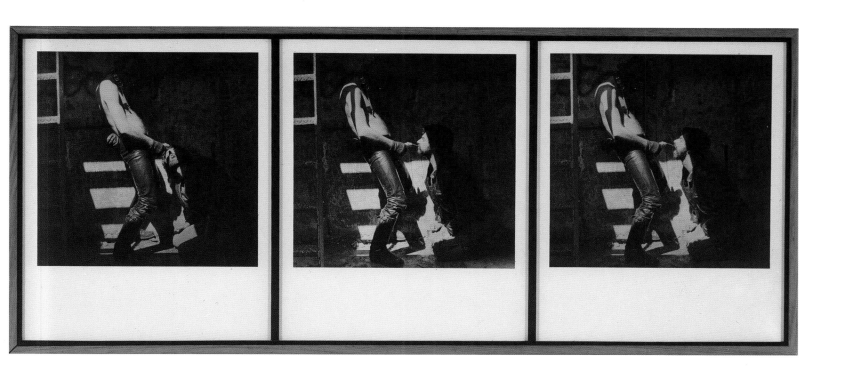

JIM AND TOM, SAUSALITO 1977–78

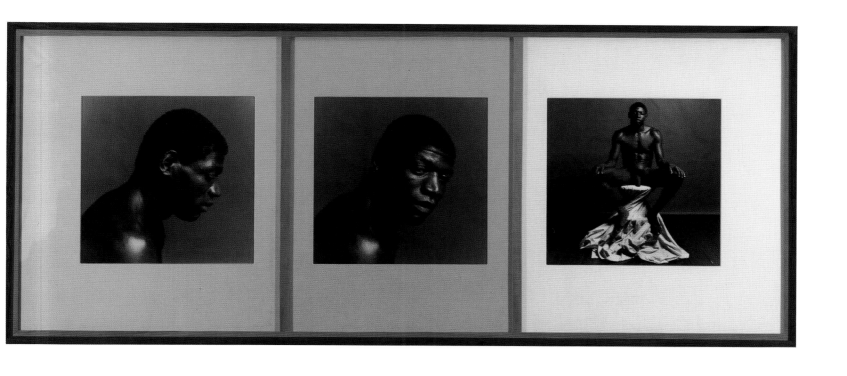

BOB LOVE 1979

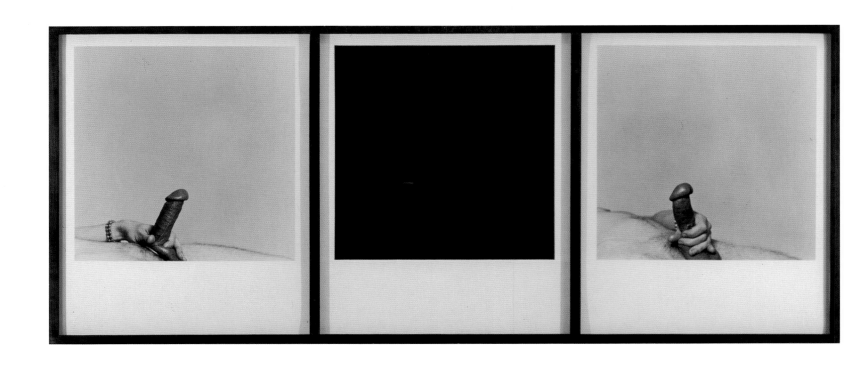

BILL, NEW YORK 1976–77

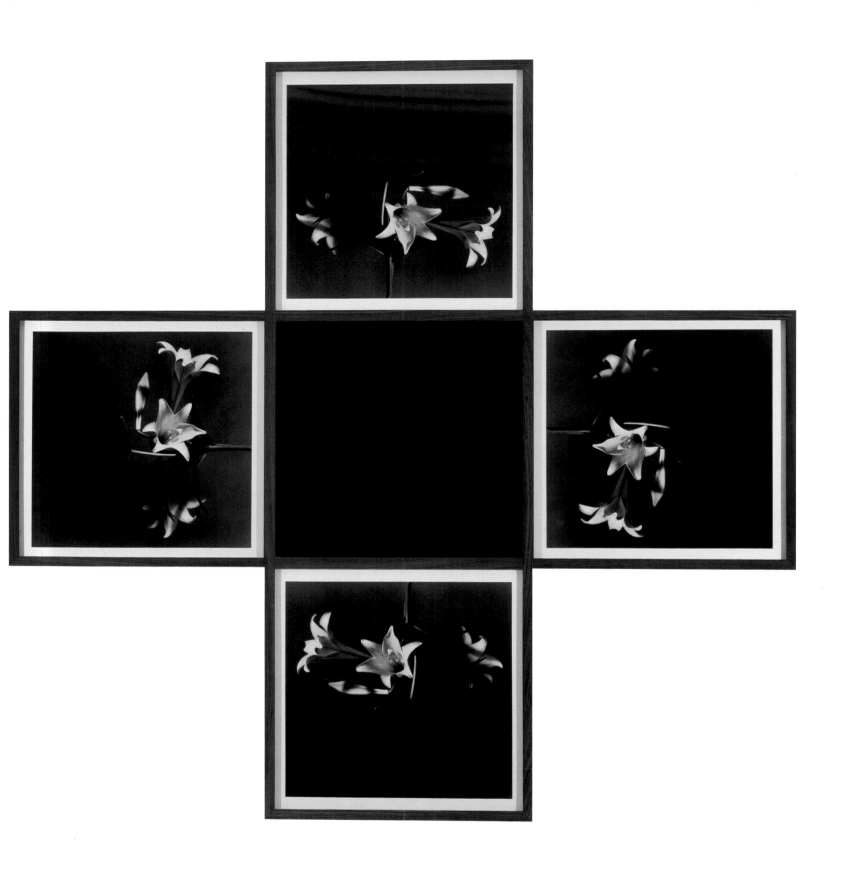

EASTER LILIES WITH MIRROR 1979

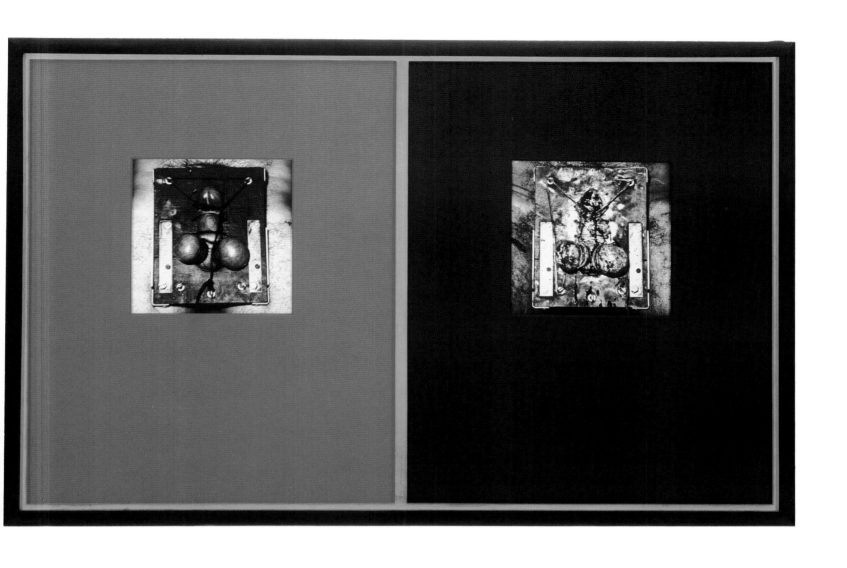

RICHARD 1978

69

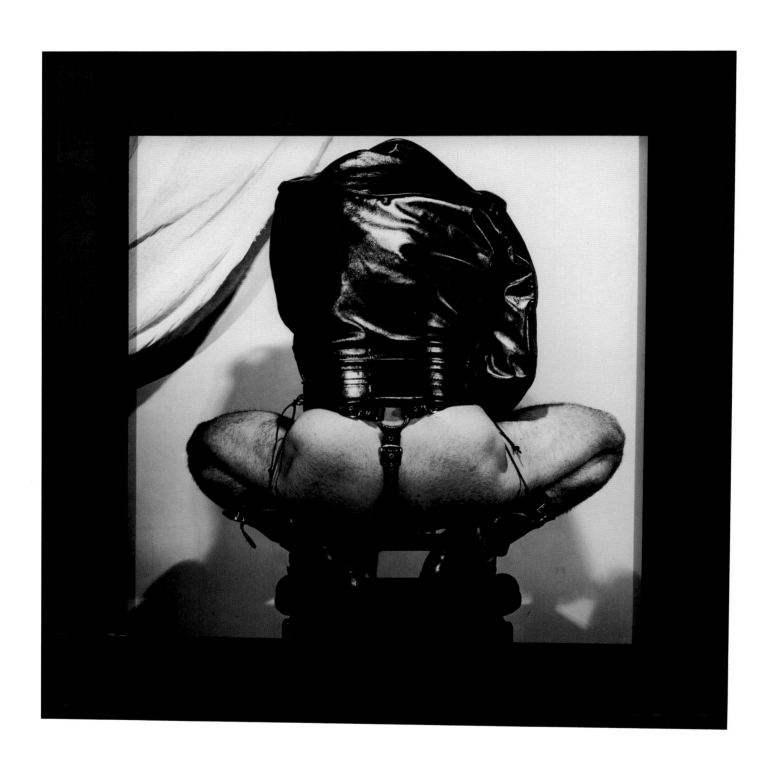

HELMUT 1978–79

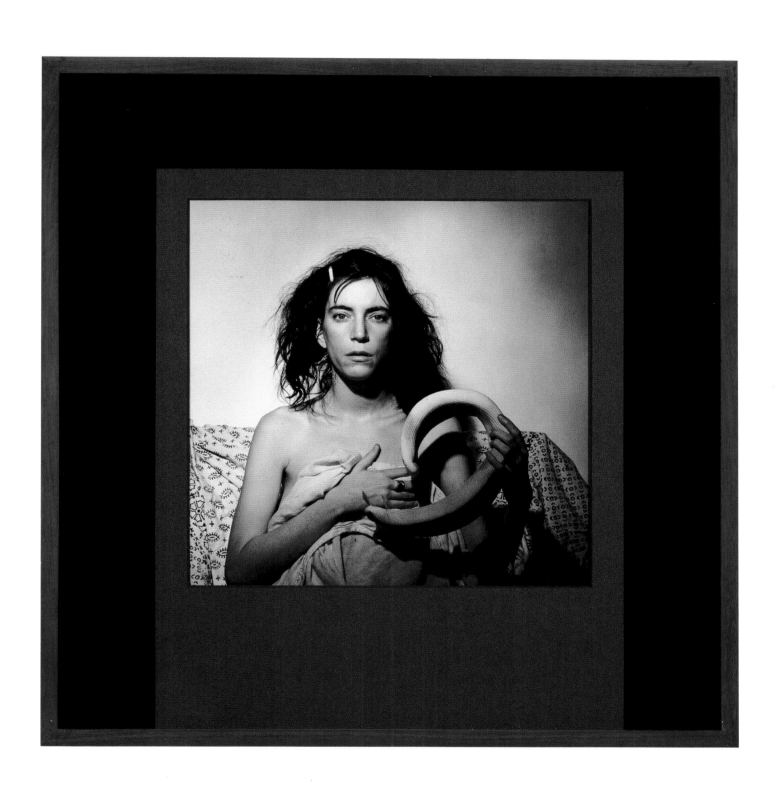

PATTI SMITH (WITH NECK BRACE) 1977

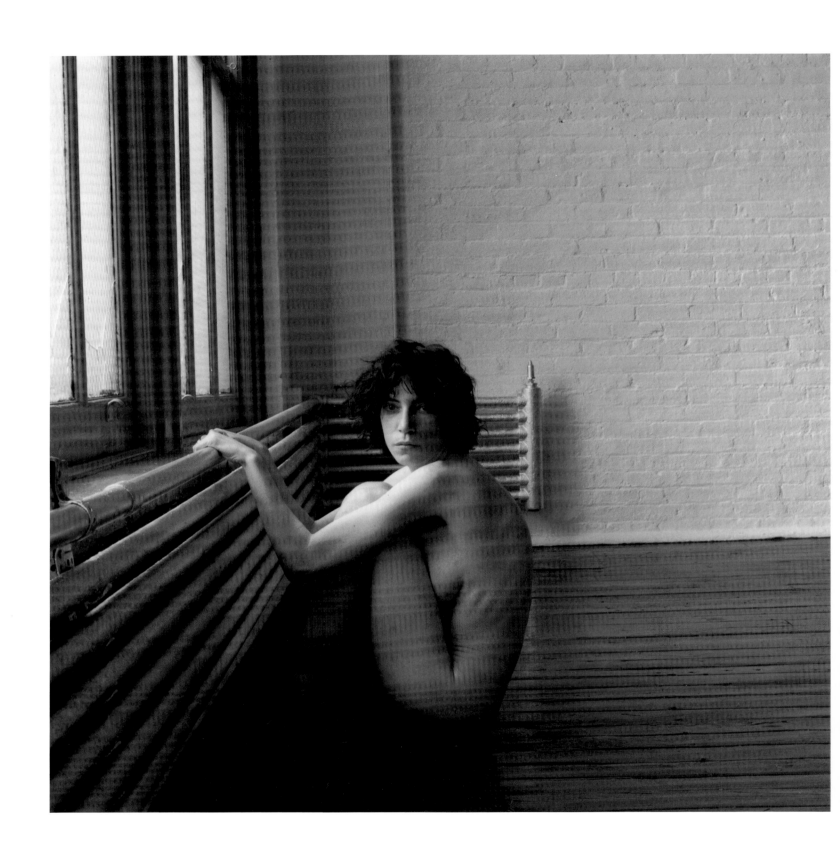

PATTI SMITH 1976

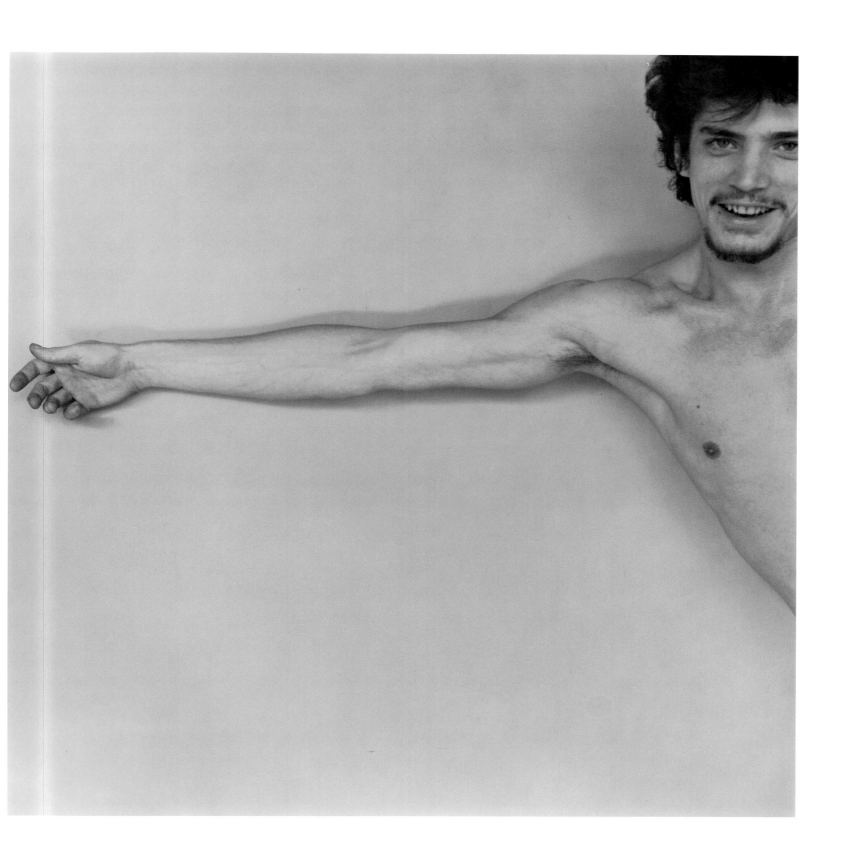

SELF PORTRAIT 1975

73

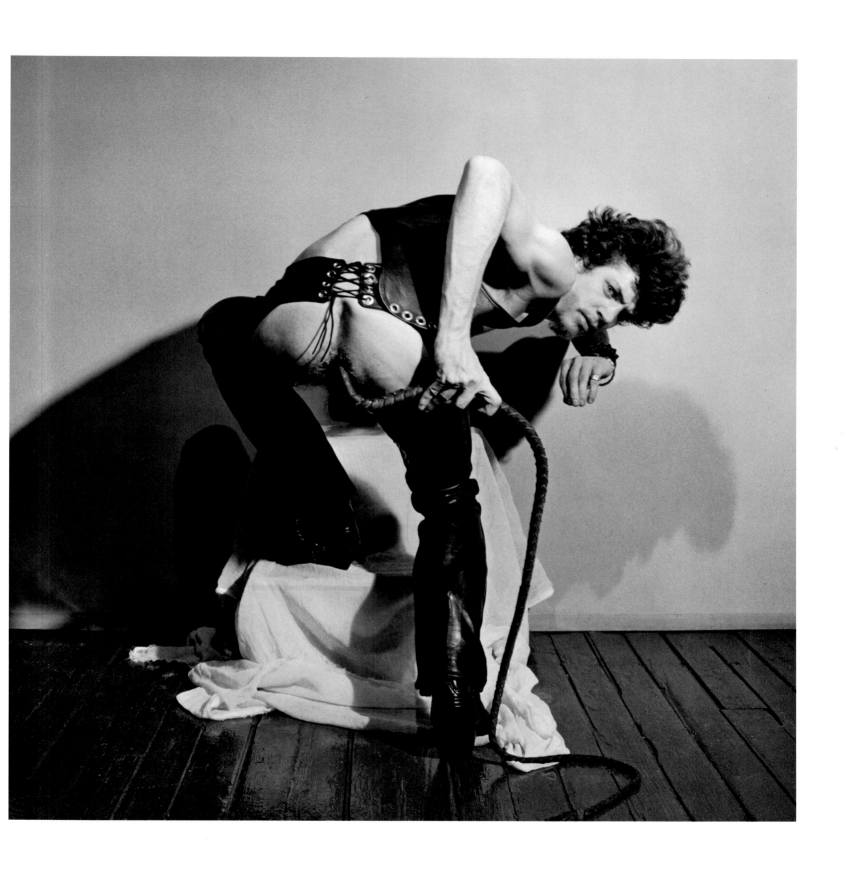

SELF PORTRAIT 1978

A
SOCIETY
ARTIST

Ingrid Sischy

I am a paralyzed veteran of Vietnam. I wrote to you months ago explaining that you are my favorite photog. I asked you to send me some original signed works of yours. My nurse was going to display them on a wall near my bed so I can enjoy them. . . . I am crippled and fought for America. I am poor destined to spend my life in bed. . . . Ansel Adams the best photog. we ever had with his bad legs and pain was my pen pal and he sent me several original signed works which are still on my wall. I would never sell them. What can I do with money, go out and dance? You and he are still my favor-ites. I was an army combat photographer when I got my ass all blown up. . . . May God still bless you and keep you and yours healthy. My best, [his name]. (From a letter to Robert Mapplethorpe)

EVERY PERSONAL LETTER written is to bridge a gap—of distance, of silence, of feelings—and each one is at the same time an object which represents that gap. From the tone of most teenage fan mail, for example, it's obvious that these letters are often deeply intimate vehicles for the expression of a voice that no one around it seems to be hearing. In adult life, people who are imprisoned—who are incarcerated behind bars, who are bedridden, or who have the feeling of being trapped by their situation or condition—make up a large pro-portion of those who raise up their voices to try to reach across the gulf of their invisibility and powerlessness by communicating with someone they see as having power or visibility. A letter written under these circum-stances often represents more than a gap; it can show a world where every place one turns there is an abyss, what an English astronomer once called "the awful abyss which separates us from the stars." The choice of who is written to, of who the writer feels will have empathy, is usually made because of a strong sense of connection to that person or to what he or she has come to symbolize.

Such as the above letter sent to Robert Mapplethorpe. Sentence after sentence of this correspondence opens an abyss: between those who went to war and those who didn't; between those who can move and those who can't; between the independent and the dependent; between a world where money counts and one where not even money can help; between Ansel Adams' heroic American West and America during and after Vietnam—Robert Mapplethorpe's America. The man lying in bed wants to see both on his wall; between them and within them are the splits in his country and his life.

Adams worked outside, in the West, returning over and over to certain spots or types of view like a police-man on a multiple-crimes case. A preservationist who wanted to capture the drama of industrial life's assaults against nature and thereby lobby for controls on it, Adams used mountains, waterfalls, trees, and rocks like heroes under some terrible threat to their being. Surrounding the frame of each image is the noise

of modern living, which Adams composed as an atmosphere, a looming tension, by keeping it out of the picture, knowing it is in the viewer's consciousness. But so is another split—the fact that a machine, the camera, took these pictures, and that for this to occur a person had to be there, had to be standing in a landscape whose very romance is that it seems to be the last place left unchopped, unploughed, unlittered, untouched by human hands. Each picture contains inherent splits between what was, what is, and what could happen next, and the pull at your sentiment, the beat of your heart goes over the top when you come across names like Old Faithful Geyser and Rainbow Falls.

Mapplethorpe looks like Adams' opposite. Working in a studio, in a city where the words "build and produce" seem to hover over the skyline twenty-four hours a day, he also returns over and over to certain spots or types of view. Yet if Adams' role was to be a guardian, pushing for the protection of nature from culture, Mapplethorpe appears the reverse because his vision straddles those territories as though they were one. And part of his terrain is not on American soil, but on the last places on the body that are permitted to be shown, let alone to be seen being touched. At times breaking the codes that are imposed on this area of nature in the name of preservation, he seems more like an outlaw, robbing his pictures' surveyors of the comfort of going along with the rules of what belongs where.

Sometimes Mapplethorpe's booty is not so threatening, as in pictures of flowers so symbolically pure or, at the other end of the scale, so visually lavish that their scent attracts and carries the viewer into what feels like the prettiest of natural worlds. A second look shows nature not so kind, not so natural, and not so youthful. Some of the flowers prickle—roses have thorns—and many could only be the result of hothouse cultivation and hybridization. Even when they aren't virtually created by human science, all of them betray the touch of human hands: they have been cut, arranged, and now are held by a camera. These frozen bouquets are so exquisite that they might almost have us forget the fact that hours or days after they have posed here they will end up on the street waiting for the garbage trucks, were it not for Mapplethorpe's light, shadow, and emphasis on falling angles as well as the highest pitch in toning or coloring—all details that intensify the flowers' evanescence.

Sometimes Mapplethorpe's lens crosses a more guarded border and then unwraps images almost guaranteed to unnerve if not offend the categories or rules that come along in all of our lives and have kept the seen and the unseen, the genders and the races, in their respective places on one or the other side of a division so strong it might as well be a fence. There are groups of pictures which make people on both sides of the fence feel as if they've been robbed. Chauvinists can take his photographs of Arnold Schwarzenegger, but they are uncomfortable to see their notions of women as the weaker sex violated, mocked in the images that depict the naked bodies of women with both a classical beauty of form and so much strength that they could out-Atlas anyone. Yet these same images have received criticism from others; for example, they leave some feminists feeling burned, shouting Fire—yet another woman's body that can be viewed as a male's object of desire. And Mapplethorpe's photographs of naked black men, in studied poses, more than once on his studio pedestal, stir up an even more historically loaded broth, an even thicker steep of bias and bondage. Like the pictures of women bodybuilders from a number of perspectives, they have been judged troublesome because they gut clichés, transgress borders, have an undeniable chic, and show a casting system in which it seems there's only room for the superbody. True—but these elements belong to the how and why of what

Mapplethorpe is holding up for us to see; and these are the ingredients of his alchemy. This is part of the shock of the image—its "magic," as he would say. Almost instantly we are looking at another universe. There it is in the blink of an eye, lit to perfection, and the result is that all the symbols and forms of difference —difference from our expectations and our usual experience with the categories that come to mind—seem translucent, as though illuminated by a new moon, the photographer's eye. The impact is very real—this is photography, these figures already existed, he didn't make them up; sometimes they reinvented themselves, and he saw them, stopped them so that they could stop us in our tracks. Mapplethorpe finds figures— or, often, they find him—whose physical work on their own bodies asserts the break with the traditional views that have made their bodies the property of others, and who contribute to that break by letting Mapplethorpe illuminate it through his depiction of details or qualities elsewhere deemphasized, excluded altogether, or made shameful: with the women bodybuilders the cultivation of strength and control is completely integrated into an image of beauty and grace; this is also the case with his images of naked black men, many of which include a frontal view so that the visible penis adds to their statement of self-possession with a clear indication of having nothing to hide.

Despite objections to these male and female nudes, they have been the focus of a great deal of pleasure on the part of many of those who the image police would expect to file complaints. The pictures have in fact redistributed assets such as strength and pride in the banks of mass-media and art-historical imagery, which have always shortchanged the accounts of women and people of color, always mediated them, whether consciously or not. In addition to these, another of Mapplethorpe's themes—homosexuality—has in part been responsible for a redirection of aesthetic attention to this topic, which has also been in a visual ghetto. The official institutions of fine art, of art history, and in particular of photographic history, for example, have always lightened the work of artists like Baron von Gloeden, have always categorized them as less "important," less "serious," more "fluffy" than the big guys; yet these photographers' contributions to the art of the nude would surely have been stitched in with the studies of Thomas Eakins and Eadweard Muybridge but for the lack of covertness of their homoeroticism, which seems to prejudice the eyes of some viewers against them. In this context, it's worth noting that Mapplethorpe's own homosexuality, in his personal life and sometimes, no less openly, as a subject of his work, has often resulted in a kind of soft-pedaled editing of his photographs in their appearances on the museum circuit. (This has been more the case in America than in Europe.) In general, he has been one of those artists whose work is kept in high-profile circulation because of its loyal and sizable audience (and, because of its dealers, and writers both for and against).

However renegade some of Mapplethorpe's subjects have been, the fact is that he has accumulated a broad and deep sense of visual history, of the images and objects that are both "in" and "out" of the temples of taste. This knowledge is evident in the contents of his photography collection, most of which was sold in 1982; in his collection of glass vessels, sentiently lined up like the tackle and lures in his fishing box; and, most available to the viewer, in the art that he makes. This art is a complex complex of machine and hand, of eye and memory, of invention and found images and materials, of design and spontaneity, and, perhaps most formally, of the premodern, the modern, and whatever it is we're having now. These multileveled elements can be found throughout his work, even in those same nudes, which may look simple, and their beauty is that they can be; but they are more. Herein lies another of Mapplethorpe's holdup actions, his "lifts." Again take those nudes, again in the context of photographic history as he does, sometimes undoing it, sometimes flipping it over, sometimes playing with it, sometimes reminding with it, sometimes transforming with it. The

"lift" in some of these pictures seems to happen so quickly, or rather so organically, that it's hard to separate cause and effect, difficult to know whether the past images that echo out of the photographs were stimuli for his pictures or whether the new ones almost unnervingly release our own memories of photographs both specific and generic, provoking them to pop up and show through from behind the new imagery. There is no one answer. The results, however, are myriad. Partial views of bent-over nudes may bring to mind Edward Weston's still lifes of single peppers. Weston explored the vegetable's shape and form as a content that added to the period's investigation of abstraction. Yet his pictures retain a strong realism and a punch because they never lose their grip on the concreteness of their subject. Mapplethorpe's equally careful attention to the tension between his abstracted bodies and the realism of their flesh puts the pepper back into photography's use of abstraction, which too often has been reduced to arty surfaces. In one photograph a black nude wears a pointed hood that suggests a Ku Klux Klan cloak with its motive of concealment as well as its by-product, the release of hate so bloodthirsty that for the prey, too, facelessness becomes a defense: if you can't be found you can't be bloodsport. The hood in Mapplethorpe's photograph is an object which represents this world of the witchhunt, but the man is not hiding. The contrast between his covered head and his naked body, which plainly exhibits a lack of shame, is the twist throwing the shame elsewhere—back to the hiding Klan.

The nudes also turn the tables on the work of those artists who have sought to travel outside the image world of the West by portraying what they see as "the primitive." This tradition has a different look from the obvious splits and insults of, say, black and white segregated bathrooms, and often it even claims to be complimentary. But this exotic route has often been merely a circular one, the culture returning to itself, reflexively feeding on the idea of a white nature and a non-white nature and an abyss between, with the white thought of as civilization and the other as its opposite. Such white noise can be subliminal, the more so the more smooth and perfected its machinery becomes. Nowhere has this vicious cycle been more glamorously kept in circulation than in fashion and in advertising—and in art that uses their mechanisms—and at no time does it have more panache than when it's compassed by those who understand the polish and glamour that have to go into a war in order to get people into its spirit. Hitler's moviemaker Leni Riefenstahl had that glamour well under her belt, along with a specialized version of these abysmal theories of civilization and nature, by the time she ran away on her exotic forays to Africa to photograph the people of the Sudan and of East Africa. Piling gilt upon guilt, she brought back her naked-warrior images, thinking—and she was not alone—that they shone with the truth of her subjects' nobility. Instead, her theatrics, her kitschy choices and angles betrayed the fact that she saw these people through those Aryan glasses that seem to have only one end in sight—the creation of an *Übermensch*. This idea of supermen may arrive in the notion of an army of sophisticated, disciplined blonds purified of "darkness," or it may be packaged in a negative of that theme, a vision of darkness as "pure" nature; or as we see on television and in the movies, it can be some sci-fi construction of unfathomable bionic stuff. However it comes, not far away is the stink of its sickness, of its binary categories of weak and strong, of pure and dirty.

Mapplethorpe has always offended these categories—for example, in those images that represent "the weaker sex" as very strong, or in photographs that portray sex acts and sexual arousal, often zooming in on the penis, subjects which have long been banished as dirty, as not belonging to the higher, purer realm designated for art. Mapplethorpe's rejection of such a system is expressed all the more effectively because he also works with the wheel of glamour, turning it to his vantage—a view as far away from Riefenstahl's trips with those tribes as could be. This is very evident in his black nudes. Instead of her "jungle-ism," her reductions of,

say, the Nuba people or the Masai, to picturesque members of an animal kingdom—there for the snapping of the paparazzi who want them in their "natural habitat"—Mapplethorpe's relationship to his subjects is all about consent and belongs to the studio tradition of the artist and model. His work has the unmistakable urbanism that one always feels from the artificial lights and clean backdrops set up for the studio shot. There is a picture of a naked man posing at the wheel of a printing press, or there are images in which a model stands in a large ring, a studio prop, often seeming to be struggling to push it around, as if it were almost immovable. Although these photographs position the subject in the role of physical laborer, they are arch and give the images the edge or irony present in anything that looks so posed. There is a sense of balletics, of models in position, ready for the portrait that will then make them individuals, recognizable when they're out in the world. There are also reversals of the categorizing devices through which society splits and fragments us, pictures with which Mapplethorpe can localize and extract the change in feeling he wants his art to generate, as in the deeply moving shots of black and white men together, especially one of two men embracing.

Mapplethorpe's series of shots of Lisa Lyon, who took the title at the *First Women's Body-Building Championship*, Los Angeles, focuses on a ready-made reversal of the superman image. As represented in the book *Lady, Lisa Lyon* (1983), it is a multifaceted portrait including well over 100 details, individual images that map out and play on the restrictive history of consigned female identities—the bride, the vamp, the butch, the high-fashion model, and other types, mostly from the European tradition but with a touch of the Orient. Together these photographs, the nudes most of all, use the body Lyon has brought into existence to articulate contradiction, and to cut through society's assumptions of gender and nature. In 1983, the English daily *The Sun* got the point, in a way, and expressed it in the headline it ran with two of the photographs: " . . . a startling new shape . . . Miss Muscles!" Lyon's own words are more pertinent: "If one looked at a tiger running across a veld, one would never say, 'That musculature is so masculine.' It's not separated as being male or female." Somehow, in the hands of other photographers, Lyon seems flattened out, even cheapened, like that genre of pinup they used to call the "art photograph." Mapplethorpe's portrait of Lyon is alive because her sculptural approach to her body directly connected to and could be expressed by the sculptural life in his work, and by the work of his life: the exhibition of whatever the elements are that make a picture a physical event.

Physical sensations and reactions are usually generalized and distanced when it comes to art; Mapplethorpe's achievement is that he pins them, personalizes them, activates them. His double portrait of Ken Moody and Robert Sherman is almost an outline of how he does this. Again, Mapplethorpe is drawn to the racial splits that divide our culture; and the ingredient of split is here made blatant by the image's exaggeration of the relative difference in skin pigmentation to which one is accustomed in a black and white photograph of a black and a white person. Mapplethorpe's lighting and toning make this contrast the first subject of the photograph. Highlighting the hue black and the hue white, how blank white can sometimes look when it's flush against black, how black and white together can virtually create the light of a picture, the photographer animates the subject of color. The issue of color is never a latent subject, never avoided. In Mapplethorpe's work with color film, you can witness the emergence of every last drop of color right up to the surface, where it vibrates as though it could lift right off the picture. In the black and white portrait of Ken Moody and Robert Sherman, the color difference pops up, and then the same light that revealed it reveals patterns of sameness—made stronger since both men are bald as a result of alopecia—until it feels as if the overlapping profiles could collapse into one, yet still retain their individual outlines.

Most art calls primarily on what we have learned to recognize, or on how our lives have trained us to put something together or take it apart. Mapplethorpe's work does this too, but it really revolves around something opposite—around those people the culture is reluctant to recognize, does not want brought to the surface; around those images it does not want shown or taken apart, in fact around the whole training of "do nots" and "are nots." This has been such a source of energy in Mapplethorpe's work that its impact touches all of his photographs. It gives even the less controversial works—the many portraits of luminaries as well as those privately commissioned, for example—an added dimension of excitement. It is a version of guilt by association, the forbidden by association, and he knows how to needle it in everywhere. It's part of the fabric that draws some to the work and pushes others away. And it's what makes his art so perfect for its time.

Every period has many images and objects that are said to capture the moment's essence. Most of them fade with the years, but in a few cases, the hookup between imagery and time can be so dynamic and so acute that the work comes to essentialize the period. This is when art enters and carves what George Kubler would call "the shape of time." It happened, for example, with the Cubists at the beginning of this century—you can see and feel in their dissolution of perspective the breaking apart of old views. Mapplethorpe is one of those artists whose work will define the past two decades, which have had a similar dynamic of change. But right now, at the end of our century, it seems as if many of the pieces we need to puzzle out our future have the most difficult and intractable shapes. And it often feels as if our anxiety—for example, our current fear of sex —encourages the return to archaic views. When Mapplethorpe is asked about the work that people have found to be the most difficult—his sexual pictures—which were in fact the images that created his entry into "the shape of time," he always answers with the same phrase and the same story. The phrase is "that feeling in my stomach." The story goes:

I would see a young kid walking down 42nd Street and then go into a magazine storefront, which were places I didn't know anything about. I became obsessed with going into them and seeing what was inside these magazines. They were all sealed, which made them even sexier somehow, because you couldn't get at them. A kid gets a certain kind of reaction, which of course once you've been exposed to everything you don't get. I got that feeling in my stomach, it's not a directly sexual one, it's something more potent than that. I thought if I could somehow bring that element into art, if I could somehow retain that feeling, I would be doing something that was uniquely my own.

What Mapplethorpe calls the feeling in the stomach is the internal, physical signal that a change in one's self-awareness is taking place, brought on by intensified or intensifying sensations, emotions, and perceptions. The stomach is a very hard place to reach in art. It is the inward seat of many of our feelings, the place where our secrets lodge when the mind can't afford to recognize or contain them. To get to it, art has to travel through and beyond the usual visual elements that might reach the heart, the brain, or the spirit, beyond the look and feel of a work. It has to be in some way meat and potatoes, has to activate or break through senses not always considered (although always lurking) in art: hunger and taste.

Mapplethorpe's meat and potatoes come from the subjects that have been forced by our culture to be hidden like secrets. He realized their force in the late 1960s while walking in the stomach of New York City, Times Square, a place a tour guide might call our island's badlands of the body. But Mapplethorpe was not passing through, he was landing. He had been hovering over this territory with the fetishistic jewelry he was making and the found pornographic images whose surfaces he was reworking. Somewhere in all of this, and heightened by his reaction to those sealed (and, inside the seal, unedited) pictures in the magazine stores, lay the

bridge between what he was intuiting in his work and feeling in himself, and what he could do in art. But first there is another bridge to be crossed between Times Square, where the altars and signs are dedicated to forgetting everything but the pleasures of the present, and a few signs and altars of Mapplethorpe's past.

Joan and Harry Mapplethorpe had six children: four boys, two girls. Robert was the third born. In his environment, there were objects and imagery based on the cross before he started to cross all those lines, and there was an atmosphere that made a strong impression, one with effects and affects that go deep: "I was a Catholic boy, I went to church every Sunday. A church has a certain magic and mystery for a child. It still shows in how I arrange things. It's always little altars. It's always been this way—whenever I'd put something together I'd notice it was symmetrical." This autobiographical information gives a certain feel to Mapplethorpe's background as well as to his artistic style. It also contains an obvious analogy to the way he described the visual and psychological power of those 42nd Street storefronts. Those words illustrate the magnetic force which draws in people who have a hunger to see what our Judeo-Christian teaching insists be kept out of sight, a scripture with proscriptions that help keep those booths in business as places of guilty excitement.

Mapplethorpe remembers a secure childhood in Floral Park, Queens, and then sums up these years with a characteristically terse but canny understanding: "I come from suburban America. It was a very safe environment. And it was a good place to come from in that it was a good place to leave." Mapplethorpe didn't go far when he left home, in 1963—not to Paris, or any other of those European cities with cafés that Americans used to be pictured smoking and drinking in when they went off to become, or to be with, writers and artists. This was the 1960s, and Mapplethorpe was to go to Pratt Institute in Brooklyn, where he got an unsentimental art education.

An anecdote from Mapplethorpe's Pratt days about his first encounter with the poet and musician Patti Smith is resonant. It has a magical beginning most fitting for what turned out to be a magical bond, a relationship that is the stuff of dreams, myth, and history. Like most such stuff the story of how it all began had its practical details. Mapplethorpe described it to me this way: "I had a basement apartment. She wandered in off the street into my house. Actually I was asleep and I opened my eyes and there was somebody I had never seen before. She was looking for someone else and came into my place because the door was open. Remember it was the '60s, hippies, nobody locked their door."

By now the connection between Mapplethorpe and Smith is well known, almost overknown, overshadowing what meant so much; the mechanisms of fame always seem to need to suck just one image out of the fuller picture. The image we have been left with is more one of early punk than of the exploratory culture that preceded it and which is truer to the spirit of their respective developments. But the sleeping-beauty first moments of friendship between these two people is quoted here not just for the sixties mise-en-scène it sets up. Mapplethorpe's memory of opening his eyes and seeing Smith evokes the atmosphere and feeling of awakening, reminding us of the importance of what the two of them had together. They woke up each other's dreams, spurred each other on, each taking the role of ideal viewer and listener for the other at a crucial time—the beginning of their beginnings as artists. Recently, when Mapplethorpe and I were talking about how someone who matters in your life can help you believe in yourself, he said of Smith: "We used to stay up all night and she would do her thing and I would do my thing and then we'd take a break and smoke a cigarette and look at each other's work. It was great. She was one person who respected what I did. The

school that I was in wasn't very behind what I was doing [and so] to have one person who you think is intelligent and who you're doing it with, who I was doing it for, sometimes [is what you need]."

"Doing their thing" in these years for them meant drawings, scribbles, jewelry, collages of found images and objects, and for Smith, poetry too, and generally the generation of ideas, the finding as well as the creation of the crumbs marking the paths that each of them would clear and traverse; it was the kind of searching around you do when you're trying to locate a special space for your expression as an artist. Smith and Mapplethorpe were fellow spirits, fellow outlaws. Later they were fellow new kids in town, and as they became insiders, while maintaining their identities as outsiders, together they made acquaintances with people such as John McKendry and Sam Wagstaff, who each played important parts in their lives. And along with all of this discovery came the seventies version of a star-crossed lovers plot. But even after sexual preference eventually led them to choose different roofs and different routes, they continued to be each other's knock-on-wood at critical moments in their lives.

Although not that numerous, Mapplethorpe's portraits of Smith can be seen as an informal lifelong project begun when he took his first Polaroids. Despite huge intervals along the way, his portraits of her stretch right into the present with his 1988 picture for the cover of her newest record. Because these photographs capture different periods in her life they come to stand for time, intensely so, as do all his images. They work photography's time-travel effect to its full capacity. Each one is taken from a perspective that is inside the time it will forever describe, that is "with it," not outside it like a voyeur. Whether with or without telltale props, every Mapplethorpe photograph is a madeleine of sorts, capable of transporting the viewer back with it into its world. If the world in the picture is unfamiliar, the viewer may have farther to travel; it may be to a world that at some other time had to protect itself in secrecy, or the journey may be to a place the viewer doesn't wish to go. But Mapplethorpe's camera and his subjects seem to have the same relationship that light has to flowers—it makes the petals open. You see this clearly in his pictures of Smith: the process seems almost palpable, his images of her shyness giving view of what lies deep inside, which explains why these pictures have meant so much to her followers from the second his Polaroid camera snapped her ragged edges.

A camera has a quiet sound, but a lot of noise has surrounded Mapplethorpe's pictures after they were made, particularly those that go beyond what's considered representable, go so far that they're viewed as reprehensible, better off as dirty secrets. This is because they have to do with sex. The topic of sex has been so censored and made to seem so dirty that it also habitually stays out of any discussion of personal relations except for the most intimate exchanges, in which one feels safe enough to share a secret. What follows is such an instance, although intended for the ears of the world and as much about disliking secrets as telling them. Patti Smith can be overheard confiding to a friend in Sandy Daley's 1970 film featuring Mapplethorpe and titled *Robert Having His Nipple Pierced*: " . . . like it was my boyfriend or nothin'. I guess the thing I don't like is that they got secrets." As Smith's language often does, these words, so casually remarked, move like an arrow through the flesh of the times in which they were spoken and land right in the heart of today. They are about both personal and public relations and they take this essay into the subject of secrets as well as the secret of Mapplethorpe's work. Secrecy is an old tale when it comes to the subject of sex, and his pictures explode it. They have enormous consequences for the deepest split in our collective opinion about sex: should it stay in the dark or be brought into the light?

Here is a story of the dark. It is about sex and the medium of light, photography. I heard it from the photographer G. Botsford, who heard it from his friend, who heard it from the horse's mouth, her mother. It was graduation day, 1910, for the girls' school that the mother had attended, and there was no way that her friends, family, or teachers could persuade her to join the group that was sitting for the senior-class photograph. So the picture is without her, an absence that she explained to her daughter as follows: the night before, at the class dance, a fellow had taken her hand, placing his around her wrist and giving it a squeeze of affection that literally terrified her. She was convinced that he had made her pregnant and was too scared to tell anyone about it, but knew that if she sat for that photograph her shame would show through the print, and everyone who looked at it, her school, her friends, her family, her whole world, would be able to tell. This is the terror that occurs when the zipper is pulled up to conceal what we need to know, tyrannizing us into fear of consequences that have nothing to do with the plumbing of the body.

The mother who absented herself from the picture passes on an anecdote that seems very relevant to Mapplethorpe's work and to today. It has multiple plots—historical, biological, psychological, art historical. These have echoes that vibrate in our moment because of how they strike similar chords. There's the period —Victorian-Edwardian; there are the facts of life—never has anyone gotten pregnant from the squeeze of a wrist (a blush, yes; a baby, no); there's the fear and the resulting irrational correlations that come when we are in the dark about a subject which either seems to—or in fact does—threaten the order or well-being of our immediate world; there's our old tradition of X-ing out images, and there are the various voodoo powers we give them.

Mapplethorpe's most fearful-looking pictures are those with a sadomasochistic sexual plot. They were made in the mid- to late 1970s. One variety is of men in leather or another constricting material: some alone, some in twos, some in groups; some partially naked, some rigged up head to toe; some chained, some terribly disturbing and intricately frightening; some sitting as ceremoniously as an aristocrat posing for a society portrait; some hanging. Part of the upset and brilliance of these pictures is their matter-of-factness, their forensic quality, creating the kind of sharply focused ground for belief that only the least sentimental evidence can offer. When these pictures first appeared there were shivers and most often people turned away, myself included. Eventually they became the portion of his work which stayed in the drawers, only appearing on the rarest of occasions and many of them never again seen. But no one who knew about them forgot these scenes, even if the knowledge was only by rumor. They stayed in the back of the mind, tugging a little every time another Mapplethorpe work went by. I have wanted to look at them a lot lately. They are still tough to see but they are masterpieces and they really matter. Their revolt against the idea of the sexual secret is epic. And from the point of view of today, what also matters is how they tap and provoke that old tyrannical nonsense of a punitive system ruled by the gods—with supposed consequences which are said to be brought on when you decide for yourself what is right and wrong to do with your own body. They give us an opportunity to untangle such myth.

I write this because in the present these images are vulnerable to being used as a different type of evidence, as pictures that can offer proof of a false logic. Today, any image of sex, especially of male homosexual sex, filters into the culture through the screen of death that has been placed in front of the subject because of AIDS. The risk with these criminal-looking pictures is that some viewers—upon seeing this private world which enacted the plot of crime and punishment—would jump into the new scenario of injustice that is playing

throughout our world, which confuses sex as the originating agent rather than one of a variety of conduits for what is currently a virological mystery with an unknown etiology. To look at these pictures and feel superior is to be a juror arriving at the wrong conclusion because the evidence seemed so persuasive. To misunderstand a physical disease as well as the society and the events which these images describe would be a real crime, a bit of madness we cannot afford. We now have a world in which even children know that a hand on a wrist is not a penis in a vagina. We see that it was a symptom of the girl's ignorance and terror to think in this way and to imagine the photograph as proof of her faulty equation. But in our present situation it is also a symptom of terror and ignorance to make similar associations. The faster we reject any faulty equations—such as between homosexuality and disease as its inevitable consequence—the better. This tendency toward crosswire thinking arises because sex has been so cloaked in mystery, secrecy, and shame, so used and abused by houses of worship—and their extensions, houses of guilt—that when it is brought into the light it's hard to have clarity. First you have to drive yourself through the fog which I suspect surrounds each of us because we all live in this world. We have all felt the terror of one phantom court or another. And the gavel always threatens to come down again when this misty screen has been made denser by an extra film of blindness caused by fear. This is the moment when it's critical for the witnesses to appear.

Mapplethorpe's frightening pictures bear urgent witness. Sadomasochistic scenes such as the ones he brought into public view are not exclusive to any single subculture. And they remind me of Voltaire's *Candide*, which attacks the Leibniz "school" that promoted indifference to suffering, because all is for the best in this, the "best of all possible worlds." Voltaire took the reader through various plots that show a different world, one that is far from the best for some.

The twenty soldiers who guarded us had sworn never to surrender; but the extremes of hunger to which they were reduced forced them to eat our two eunuchs for fear of breaking their oath. A few days later they decided to eat the women.
We had a Mohammedan priest in our fortress, a most pious and compassionate man. He preached a beautiful sermon to the soldiers persuading them not to kill us outright. "Cut just one buttock off each of these ladies," he said, "and that will provide you with a delicious meal; if you find you need more, you can have as much again in a few days' time. Allah will be pleased at such a charitable action, and the siege will be relieved."

To look at Mapplethorpe's pictures that appear so felonious is to be conscious that a world in which a sexual life has to remain secret is also far from the best of all possible worlds and has to affect in some way the sense of self of those who feel so unprotected that they have to hide. It is to be conscious of the terrible loss you feel when you don't experience safety, when this leads you to furtiveness, and to the association of your desire with illicitness. It is to be conscious that this theater of criminalism was staged in the context of a culture that forced the homosexual world into secrecy to avoid punishment, forced it to create one place at least where it could control power and powerlessness. It is to be conscious of what all this does to your sense of the possibility of intimacy—it hurts it. It is to be conscious of how much it meant to human dignity to say, as we did in the gay liberation movement that had already begun—no more dirty secrets, no more hiding.

Mapplethorpe couldn't have recorded the abyss between self and world that these pictures reflect unless the individuals had wanted to exhibit themselves through his camera. These men were not studio models for hire, reaping the profits of the viewing audience's boredom, and the images have none of the emptiness of,

say, Helmut Newton's peek-a-boo, this-is-what-the-rich-do, pseudo-Victorian ticklers, where models hang around, figuratively and literally, and you imagine them complaining to their agents about having to wear all that leather under the hot lights. Neither do Mapplethorpe's pictures distance themselves from their subjects through a point of view that somehow insinuates that the photographer is plunging down into this other world of freaks and monsters. That sense of descent oozes out of the work of Diane Arbus, and although it makes her subjects no less memorable, it alters the found quality that is essential to the power of her images. If we let ourselves ask, we end up wondering whether she's taking these people down with her. We always hear about Arbus' capacity for identification, but one suspects that her discomfort with it was the source of her tragic life—that she simply couldn't get over the fact that she so clearly shared something with her outcast subjects. Mapplethorpe doesn't look down on his subjects and he doesn't look up. He looks at. Perhaps it is easiest to see just how directly he does this in his portraits, which of all his pictures are the least likely to distract the viewer with other issues.

After the S&M scenes Mapplethorpe made his transition from the rough conjoining of bodies to anatomical classicism, which shows an intimacy with the body we rarely experience in art. Intimacy is the core of his work, what runs through it like a hidden zipper. Pull it down and you'll find a picture like this: a tightly cropped image in profile starts with a man's mid-stomach and ends about a foot down his thighs; his right arm is stretching down and the hand is splayed open so that the flexing of each finger echoes as well as reinforces the presence of the penis; the thumb is curling up as if it were moving into erection. The details in this picture make it so intimate, and so specific, that they attract the viewer's careful attention. Consequently they can unearth buried feelings as well as locate—or still—responses that are usually too ingrained to perceive.

Since the day they were made, Mapplethorpe's photographs about sex have received a mixed welcome. Not everyone wants to look—and some critics have said the pictures are disgusting. I decided to show them to a purveyor of what I thought was meant by "disgusting," a man who publishes pornography, and he in turn said, "I don't even want to look." Then he continued: "I know those pictures, I've never liked them. They're so personal." In its typical formula, pornography invokes distancing mechanisms that invite one to feel one's control over the image, to feel that what one is looking at is not a person but an empty vessel for one's ego. These mechanisms are not at work in a Mapplethorpe. Other critics have complained that his pictures of sex are too "fashionable"—too polished, too aestheticized—but fashionability has been one of his biggest crossover instruments and is among his sharpest devices. By making his subjects so fashionable, he makes knowledge of them fashionable instead of something dirty.

There is a line of Susan Sontag's about Mapplethorpe: "(However wide his subject matter, he could never become a war photographer or a photographer of accidents in the street)." As I was reading through the literature on Mapplethorpe in preparation for this essay, Sontag's parenthesized perception that he could not become a war photographer especially surprised me, which in turn started me thinking about why his work has always meant so much to me. Something had always made me pause when I came to pages in books, or spots on the walls of art shows, with Mapplethorpe pictures featuring military dress or militarist connotations. There are quite a few—for example, one of a frayed American flag. Another photograph is almost empty but for a battleship, way down at the bottom of the horizon line. There are several photographs of his friend Jack Walls in army uniform; there's one of Milton Moore, in a sailor suit, saluting. These

are among the few contemporary militarist images I know of that are without the spectacle of violence; yet they are as keyed into the national mood as Rambo. They are respectful pictures; the emptiness of their flat gray backgrounds switches their meaning, so that they show not action but men ready for action. There's another such photograph—a silhouetted bust of a man saluting, hand to head. He appears to be naked except for his cap. Behind the shadow that fills in and outlines his form are two large white vertical spaces that look like empty pages in an opened book, or like plaques on a wall for recording names. It is the most solitary of all of Mapplethorpe's photographs, rendering the other side of the emblems and polish that are used to inspire belief in the grandness of fights and wars—the shadow side, loneliness and loss. I look at this picture and the empty vertical spaces seem to fill up with names, particularly two communities of names, those who died in Vietnam and those who have died of AIDS. The shadow evokes history and, with it, remembering or forgetting—ideas present in other Mapplethorpe works which emphasize fragments, such as the polished-looking classical torsos and busts that he has recently begun collecting and photographing, or, another of the objects he has occasionally featured over the past two decades, the skull.

When Mapplethorpe is asked about the body of work that he has created, he says, "I wasn't setting out to make a statement, that isn't the way I work. The statement grows out of what I do." There are many statements to be gathered from his art but they are all connected by the polished surface that emblematizes his work, the looking-glass layer, on occasion made literal through the presence of mirrors, reflective materials, and in works within which you can see the same image exactly repeated or slightly varied. There is always the mirroring back and forth between world and studio world, between the content of the work and the viewer's experience, and between the photographer and his various subjects, a link made most directly in his self-portraits. The mirroring and the polish work together, as though the one caught what was going on—by reflecting it—the other by freezing, finishing, and perfecting it. Here lies yet another of Mapplethorpe's crossings—the polished military look with the polished cultured look. And here we have the genius—and the fortune—of what he has given us. By holding up images which not only show the splits in our culture but also some which create reversals and transformations of those splits, he gives us a vision of wholeness. This is his secret service. He is not really an outlaw; he is a preservationist. The only thing he is robbing us of is ignorance. And whether the wholeness projected by his art is envisioned in images of women bodybuilders, of black and white men together, of portraits that are the record both of recognized figures and those usually passed by, or in pictures that include what has always been behind a fig leaf, it almost always entails the highlighting of those very details that symbolize our history of splits—many of which owe their ability to keep things split to the fact that they are usually not confronted. Often they seem too controversial to bring into the light and so they stay unexamined, and it is from underneath the surface that they exert and perpetuate their divisive controls. Mapplethorpe never leaves them there, always bringing them out for view, all polished up for inspection.

This is an artist who has made a deep incision into our culture, here going into the no-nos placed upon the flesh, there making brilliant portraits that connect familiar and unfamiliar faces via the look of polish that they all receive. In between there is the scent of flowers—the photographer's spice of things we think of as nice—and many other still lifes as well as the occasional miscellaneous subject. And all along there is the trace of the man who made this work, his self-portraits. Marking the path he takes everywhere, these photographs by and of Mapplethorpe give a many-sided view. The picture keeps changing—now he's very elegant in black tie, now an outlaw in a hip jacket and holding a gun, now winking, now in drag. In one picture of

him bare-chested and with horns, he outsmarts a reading of the image as evil by quickly slipping it into humor; but another self-portrait is truly unsettling, with a whip shown going up his ass. Then there's a glorious young self-portrait in which you can only see the lunge of his head and one extended arm into the picture frame, like a funny grand entrance. There are none of him in fatigues. And he hasn't gone to war. But it seems to me he has also, in fact, been a version of the kind of photographer that to Sontag he could never be. What he has recorded and the style with which each image or object has been made ready for presentation calls up that ready-made image of war—the battle. It is literally there in his work in the battleship, and in the pictures of men in military dress. Atmospherically it's always there because of the general look of spit and polish. But Mapplethorpe transforms militarism the same way as he does other found imagery. Most notions or images of war end up perpetuating the idea of the wipe out—either of a people or a threat. Mapplethorpe's work has been about not wiping things out.

Robert Mapplethorpe has been a society photographer in the largest sense. There are many communities within the collective, just as there are many selves within an individual. So choices always have to be made. In Mapplethorpe's instance the choices he went with are the subjects which drew him, and this in turn drew the picture we have of Mapplethorpe as an artist and as a man. Like all pictures, it offers many possible interpretations. In 1988 something seems very urgent to me. It has to do with memory, and with freedom. So I chose to emphasize in this essay that part of his work which is a record of our civil battles, and an expression of our civil rights. This is work that is ultimately about no coverup, no censorship, no shameful secrets, no burial of what should be seen and what must be remembered. One picture by Mapplethorpe, *Thomas and Dovana*, epitomizes this. It is of a couple dancing. The man is black; he is naked. The woman is white, she wears a white evening dress, white gloves. She is arched in a melodramatic pose, and he supports her. The picture is a twist, a tie of images that summon *Gone with the Wind*, *Mandingo*, and fashion all in one, and the knot that holds it together is very different from anything we might expect. It is the opposite of the tradition of burying; it is part of the tradition of showing, and thereby of knowing. In "John Brown's Body," the poem about America and the Civil War, Stephen Vincent Benét writes "Bury the whip, bury the branding bars, / . . . Bury the fiddle-music and the dance, / . . . And with these things, bury the purple dream / Of the America we have not been. . . . "

Mapplethorpe's picture of *Thomas and Dovana*, as well as much of his other work, might as well be a *do not* placed in front of each of Benét's "bury's," as if to say, do not forget what we have been. How can we, as long as Mapplethorpe's art is around.

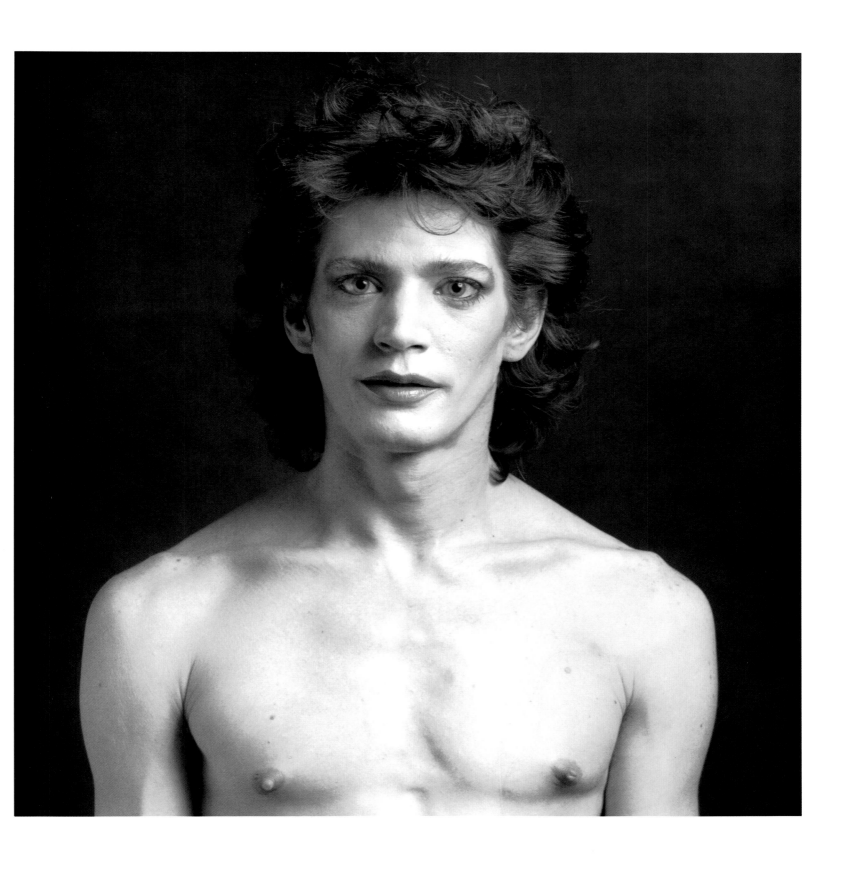

SELF PORTRAIT 1980

89

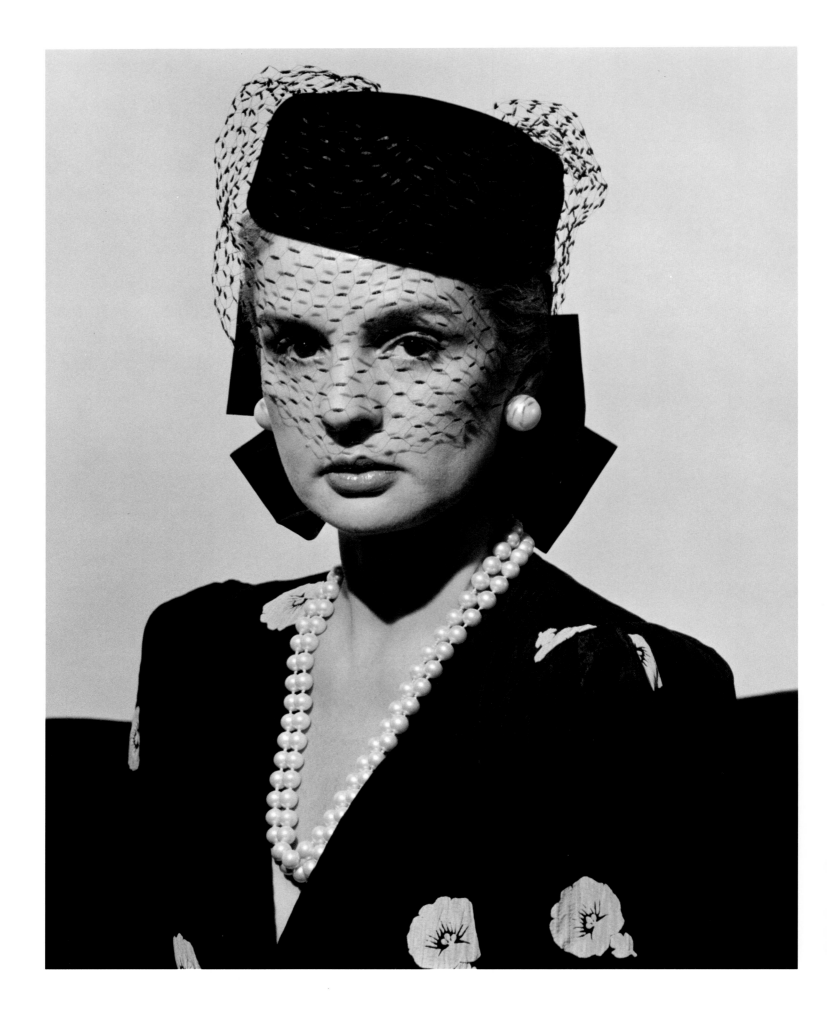

CAROLINA HERRERA 1979

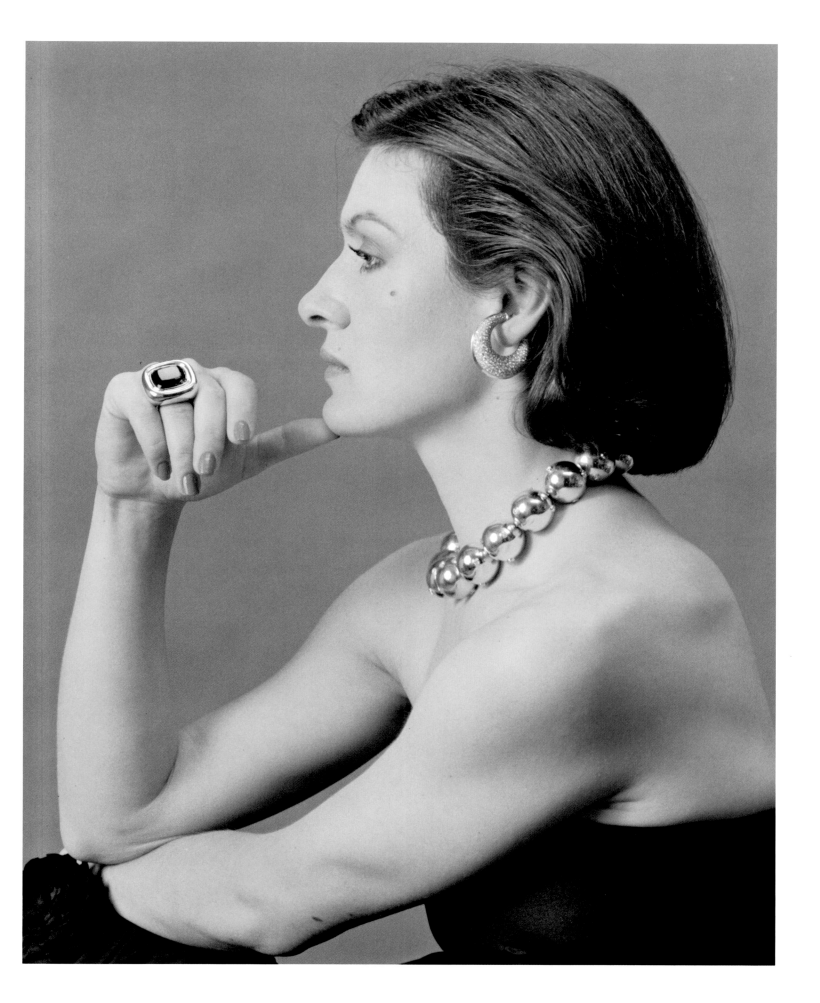

PALOMA PICASSO 1980

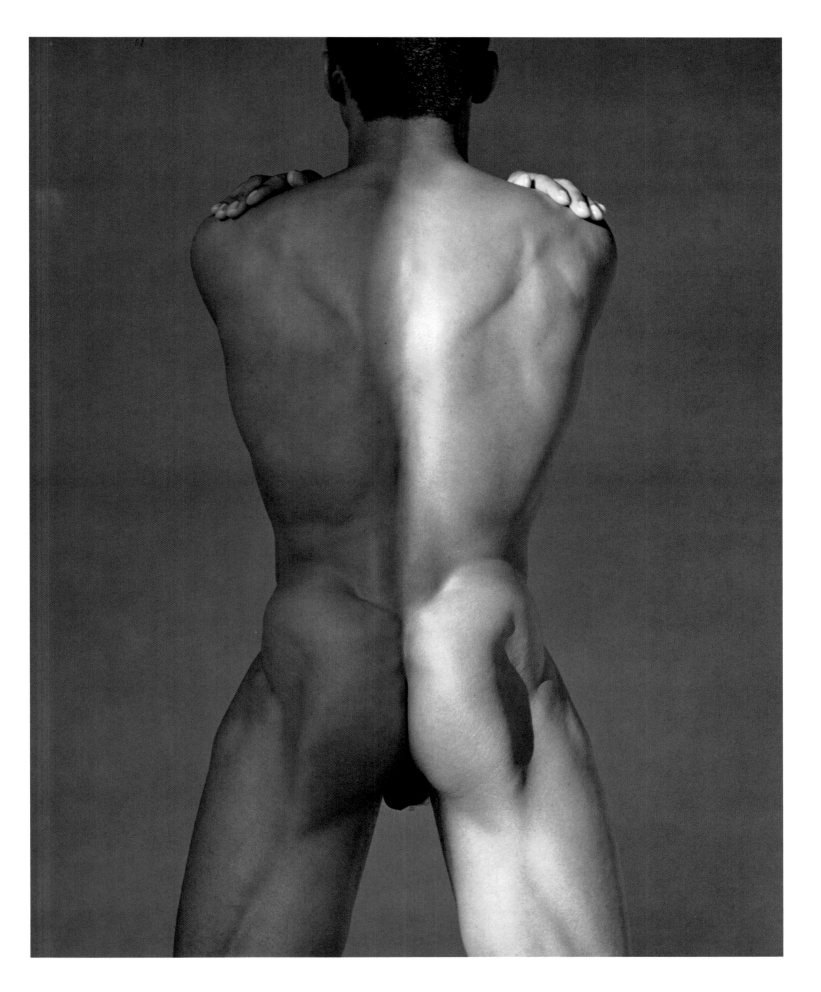

DAN 1980

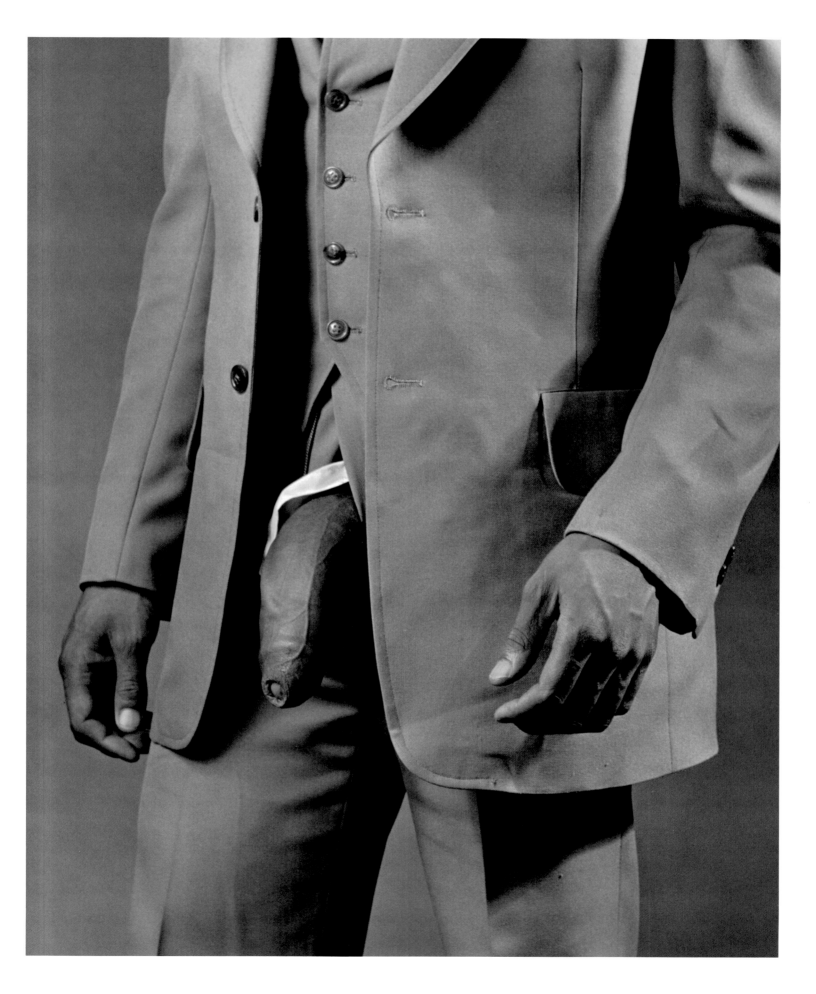

MAN IN POLYESTER SUIT 1980

95

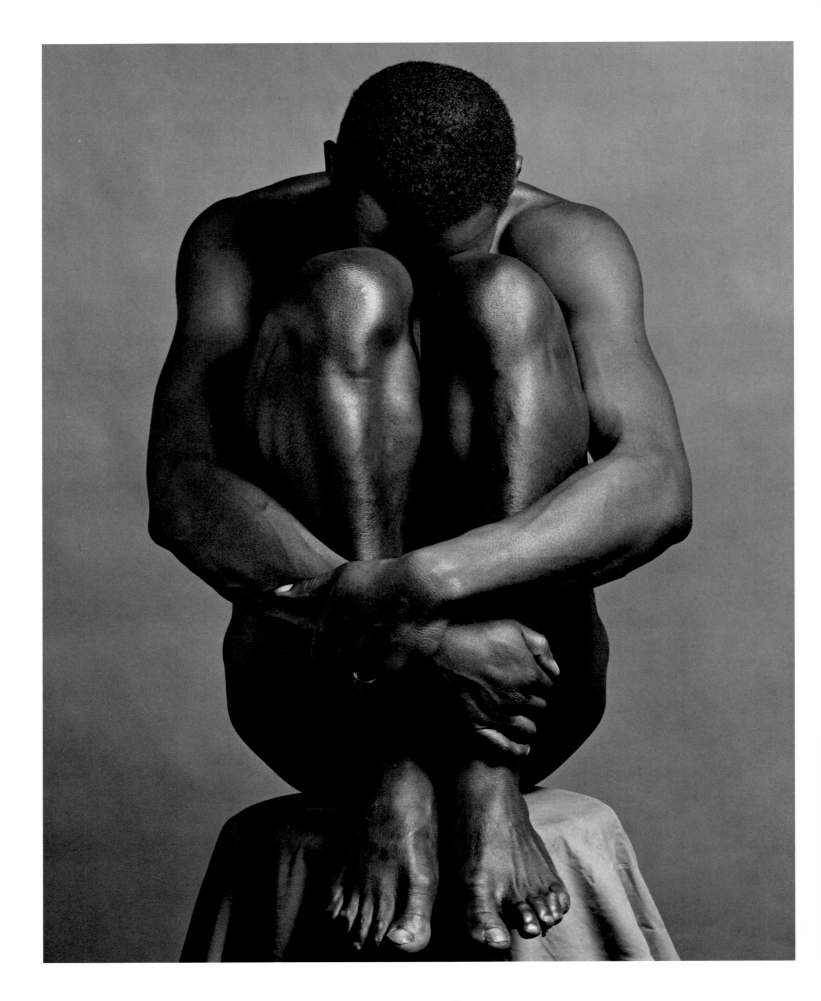

AJITTO 1981

96

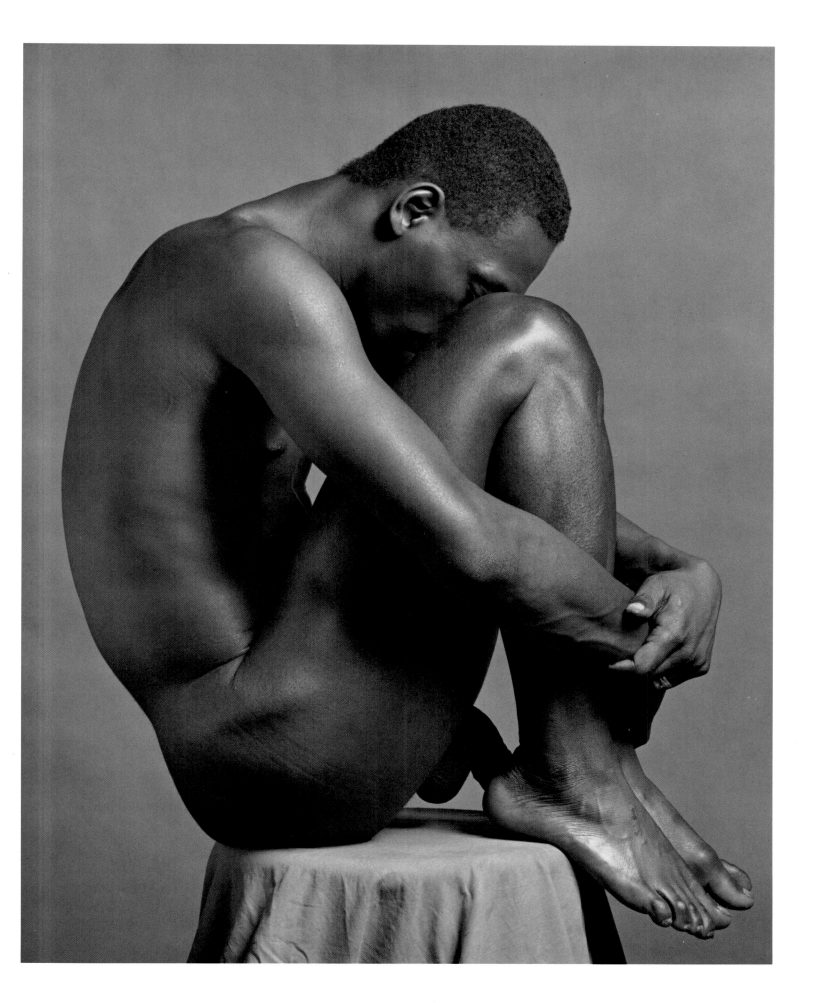

AJITTO 1981

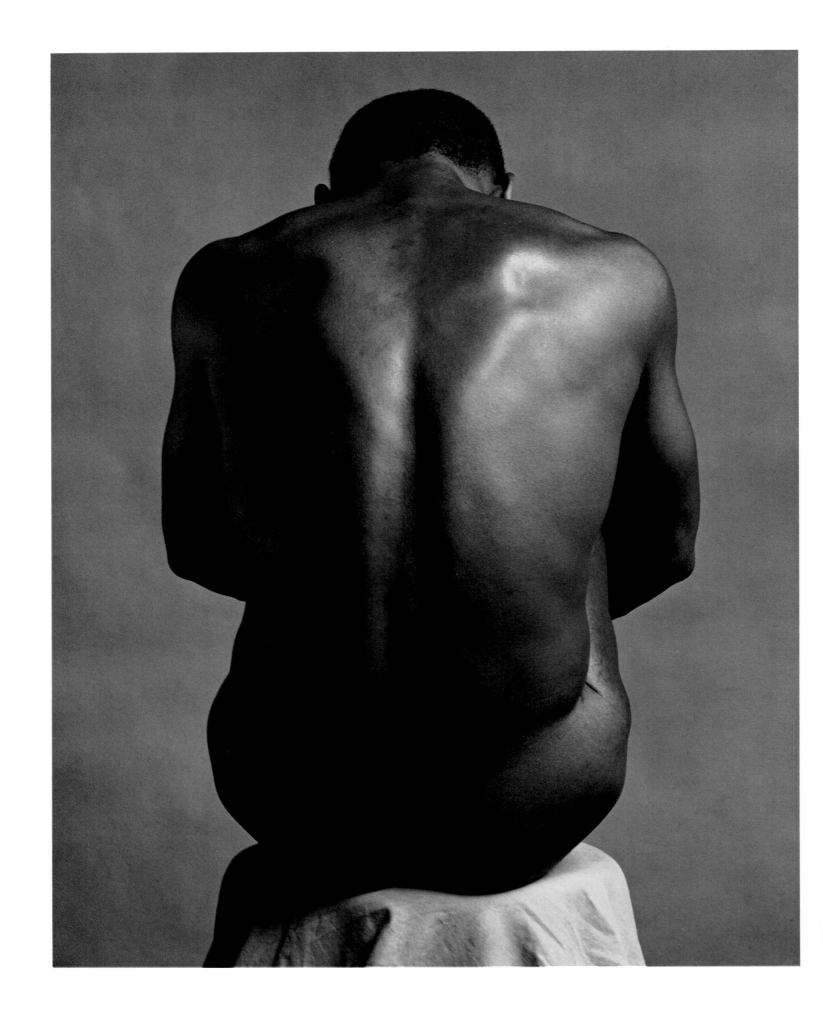

AJITTO 1981

98

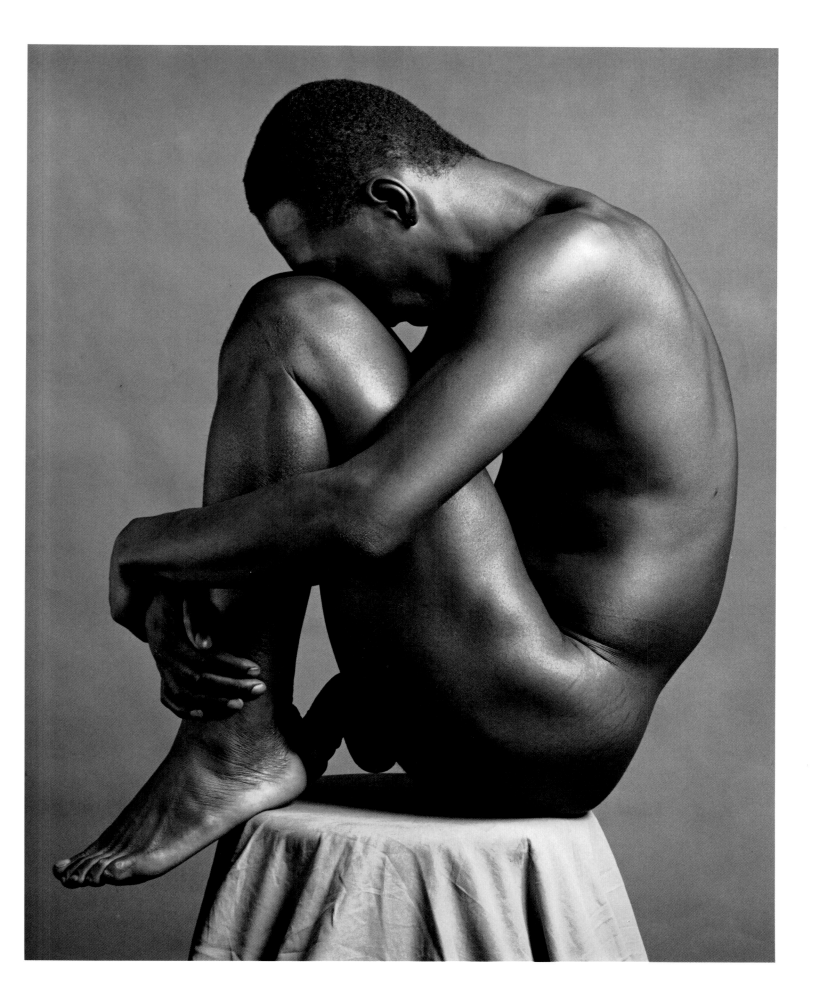

AJITTO 1981

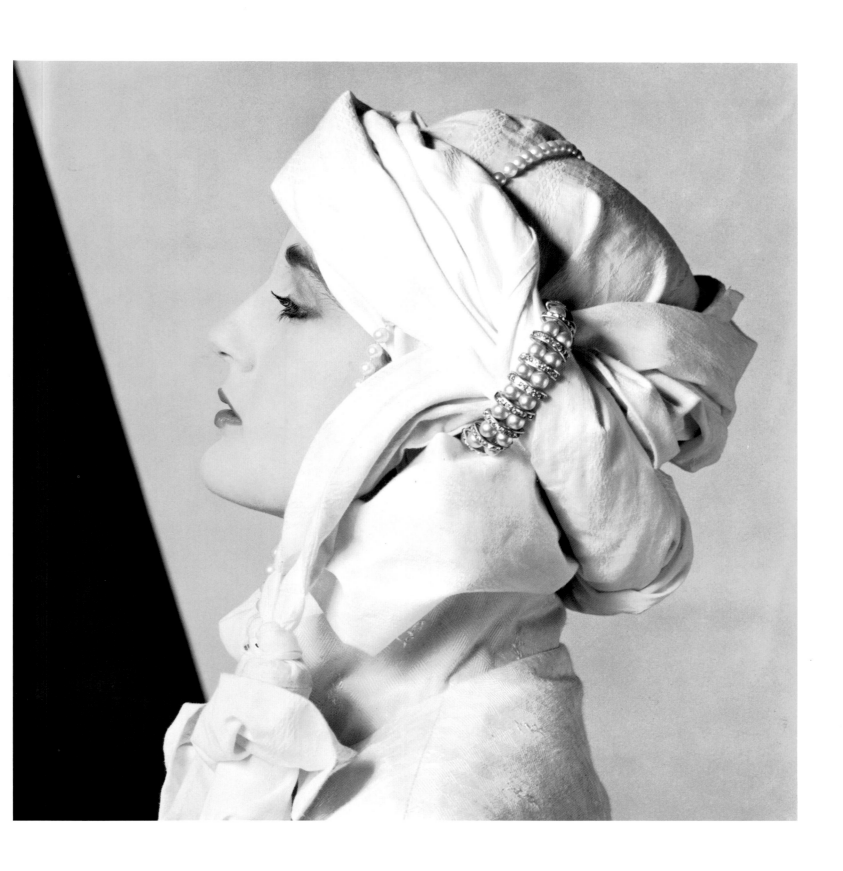

FRANCESCA THYSSEN 1981

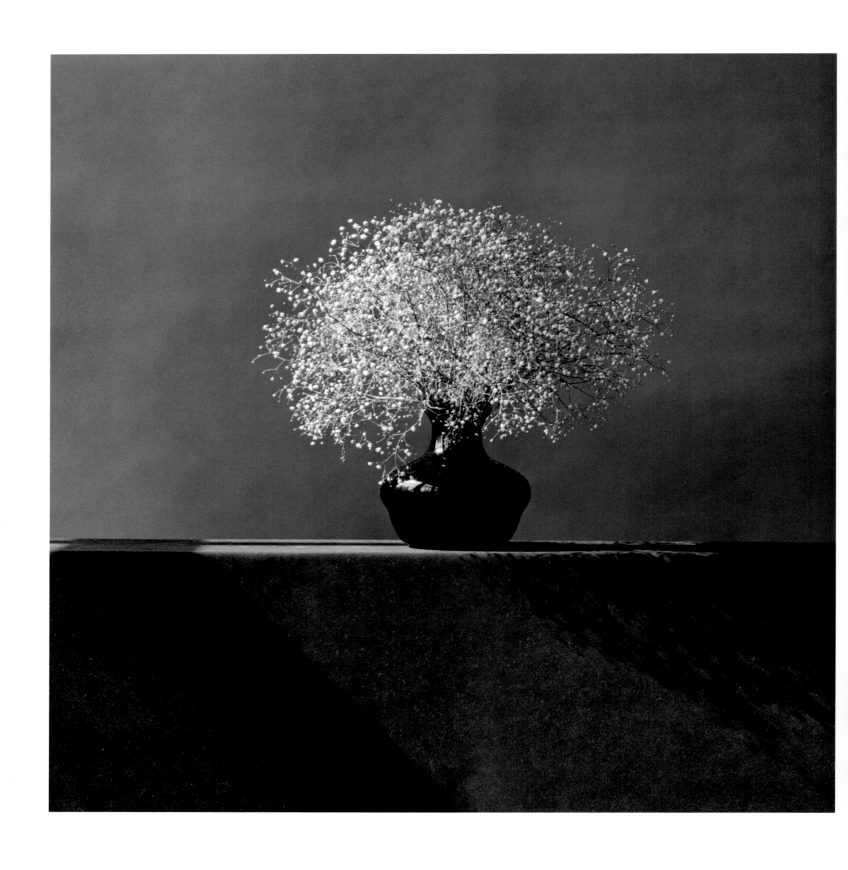

BABY'S BREATH 1982

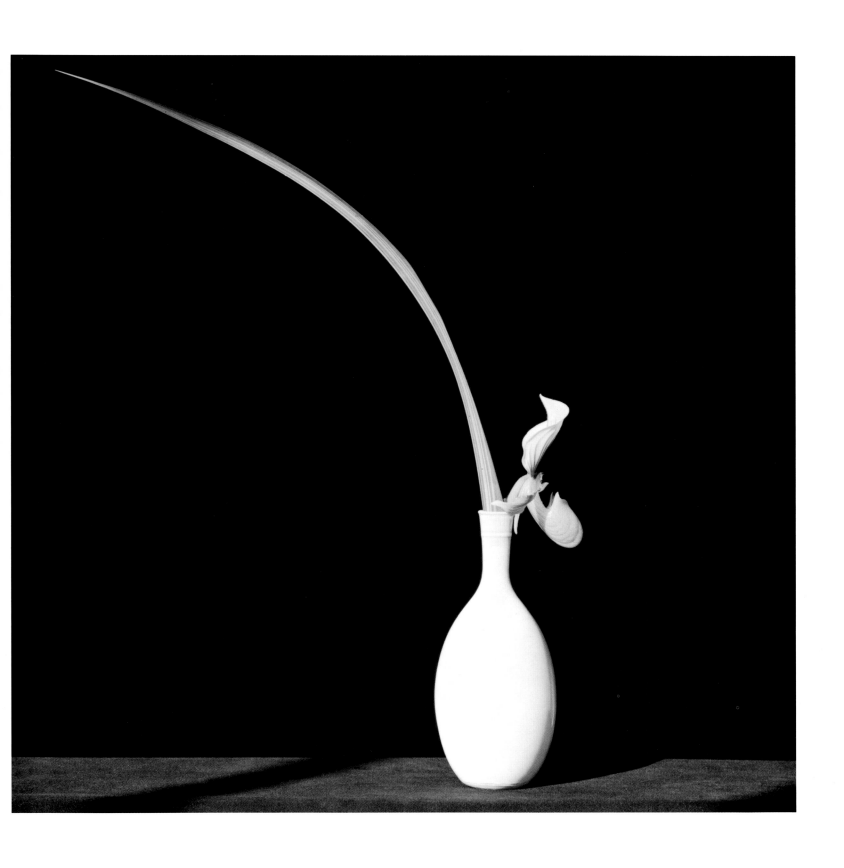

ORCHID AND LEAF IN WHITE VASE 1982

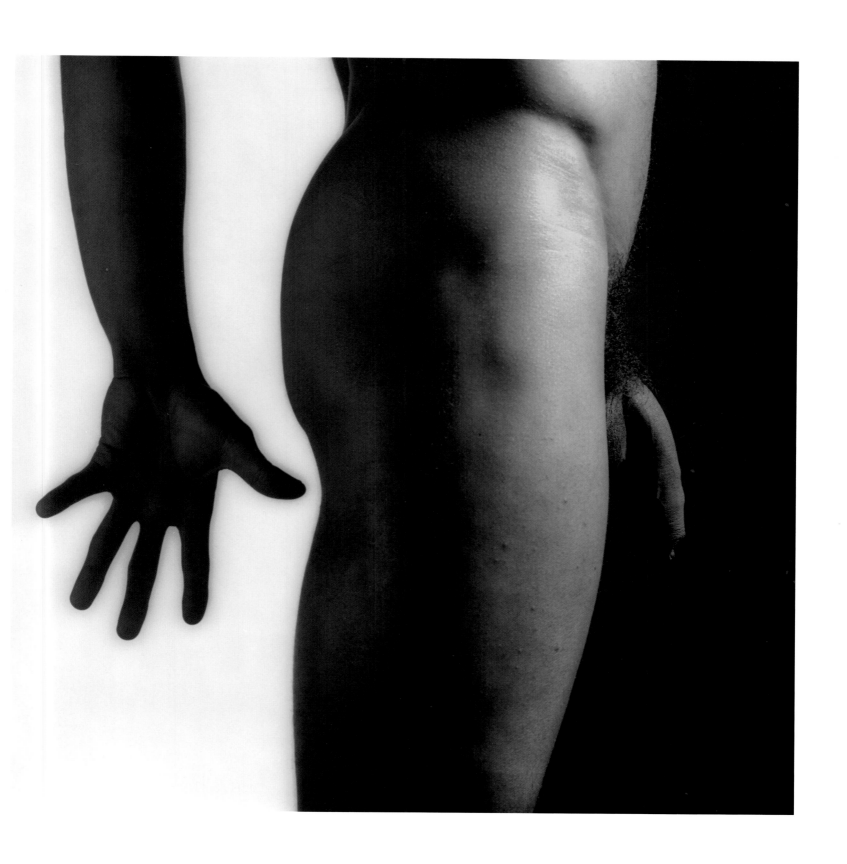

UNTITLED 1981

105

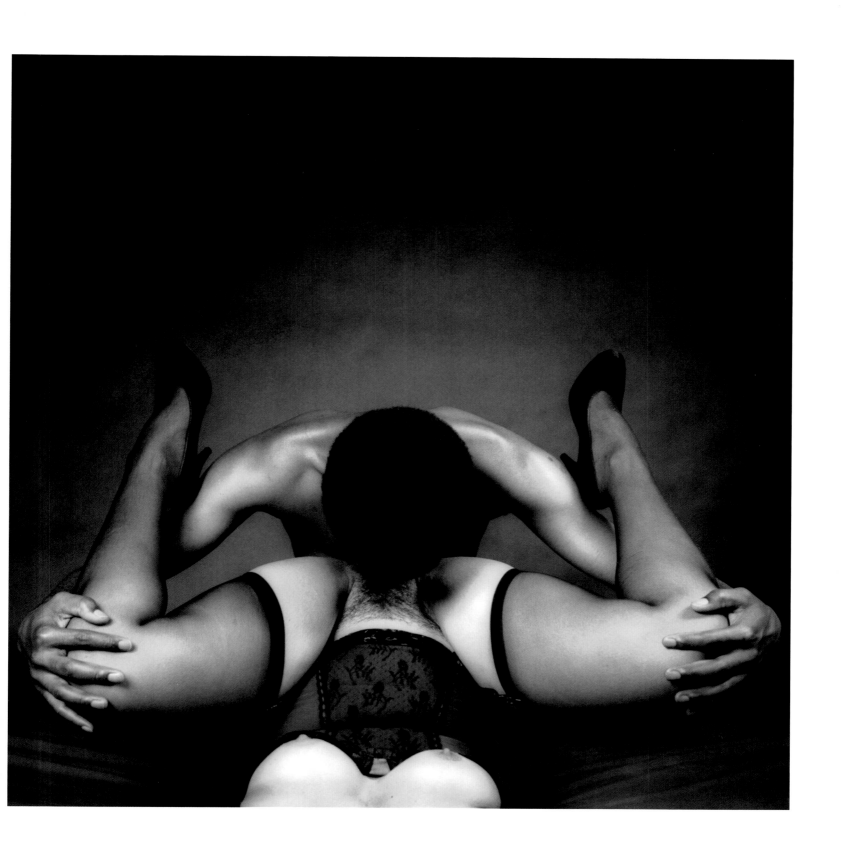

MARTY AND VERONICA 1982

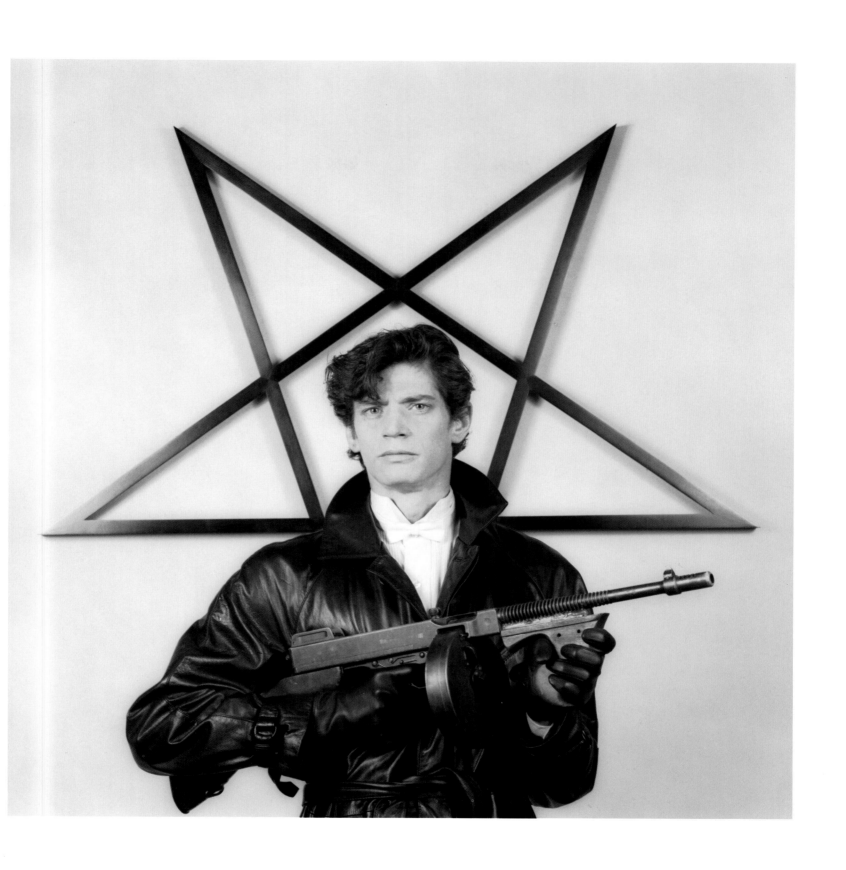

SELF PORTRAIT (WITH GUN AND STAR) 1982

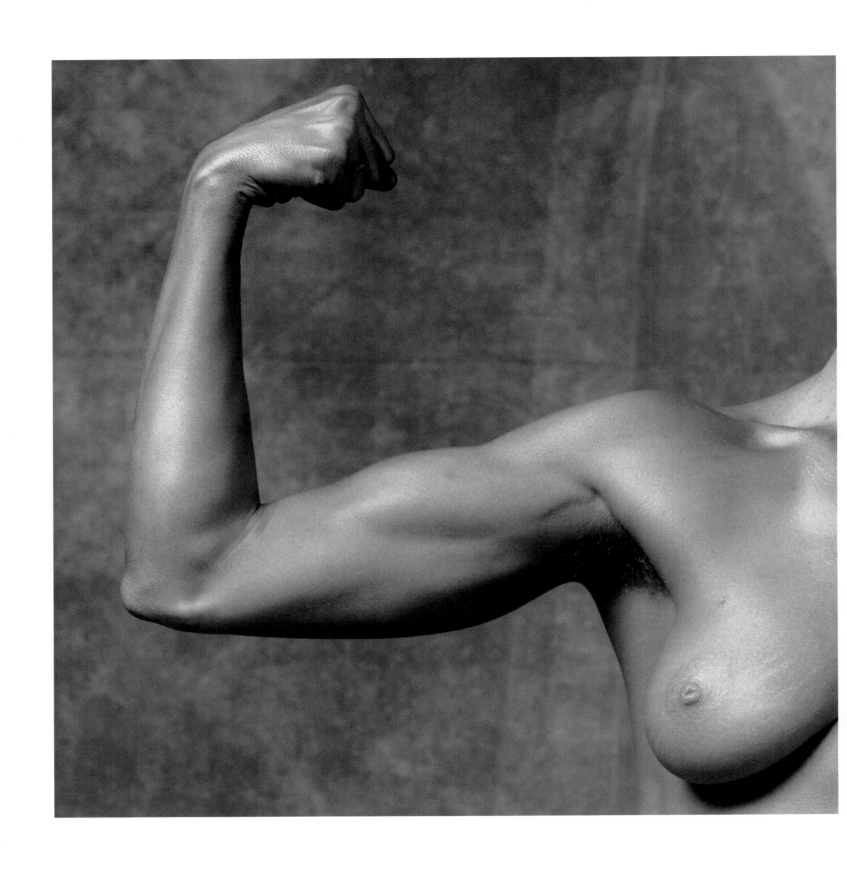

LISA LYON 1982

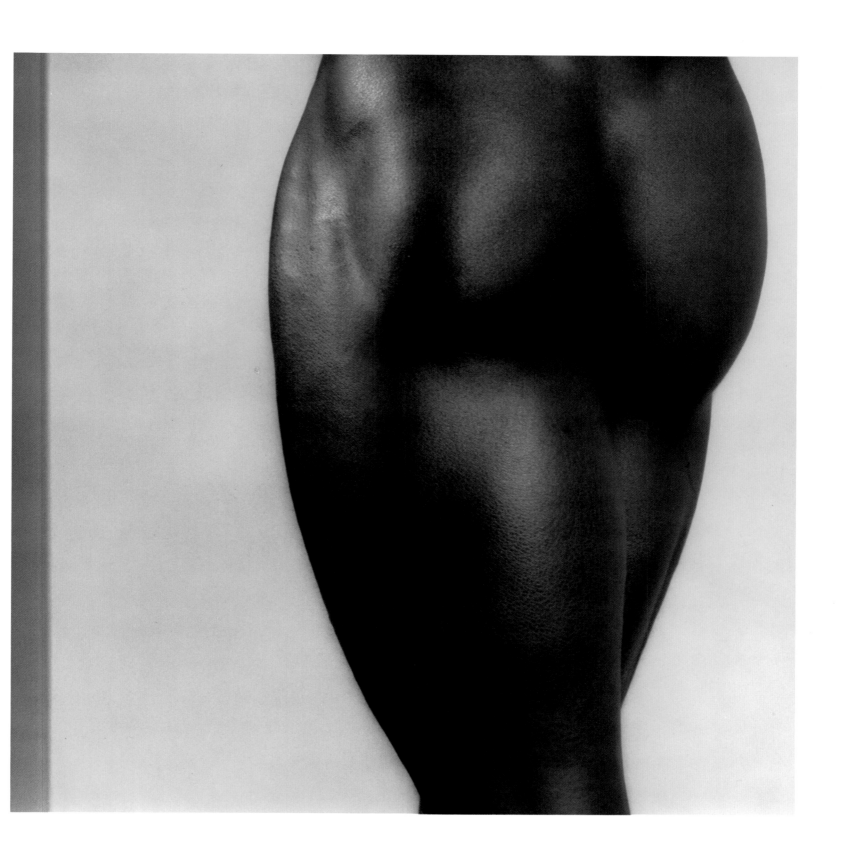

DERRICK CROSS 1982

III

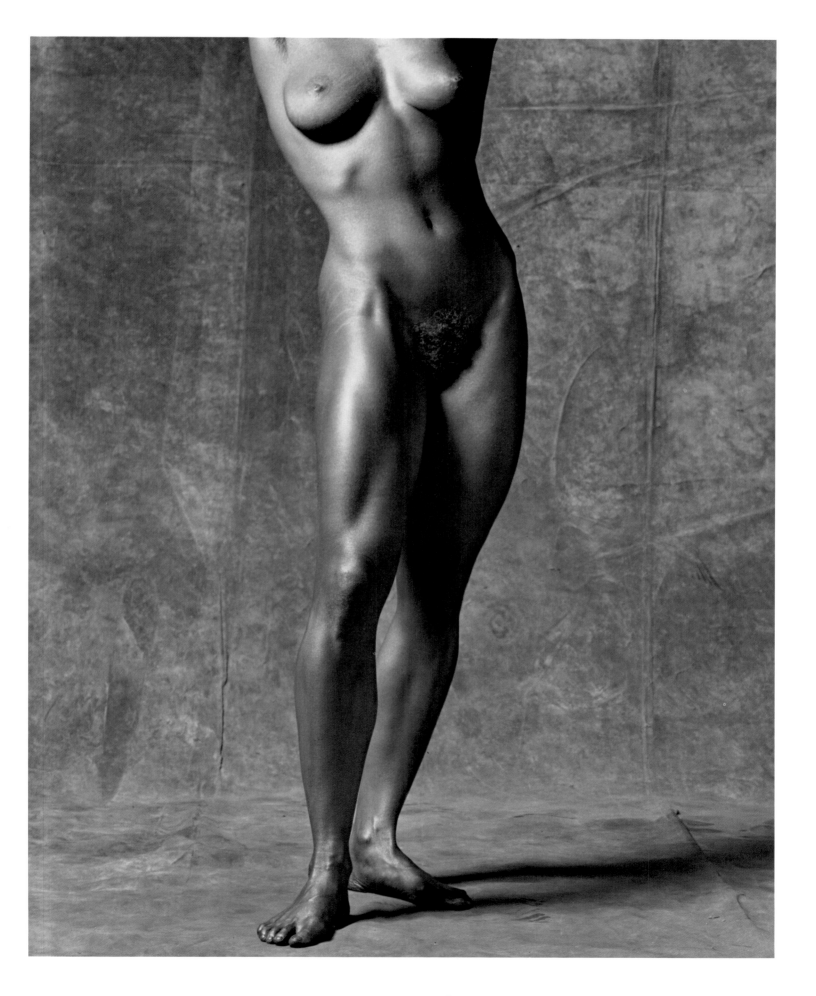

LISA LYON 1981

113

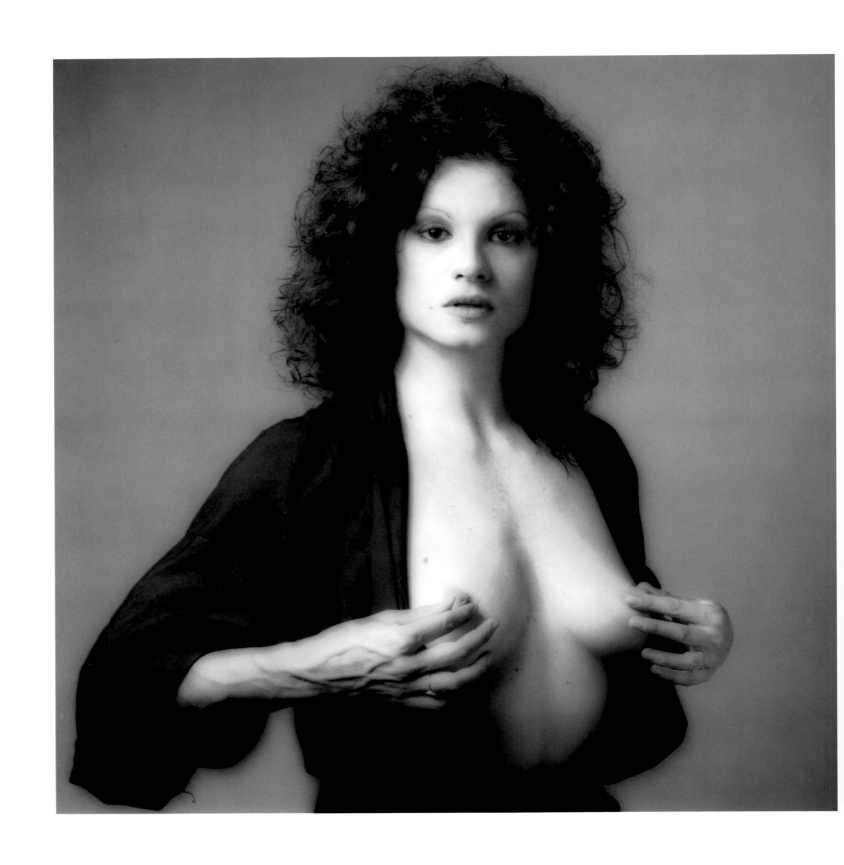

LISA LYON 1982

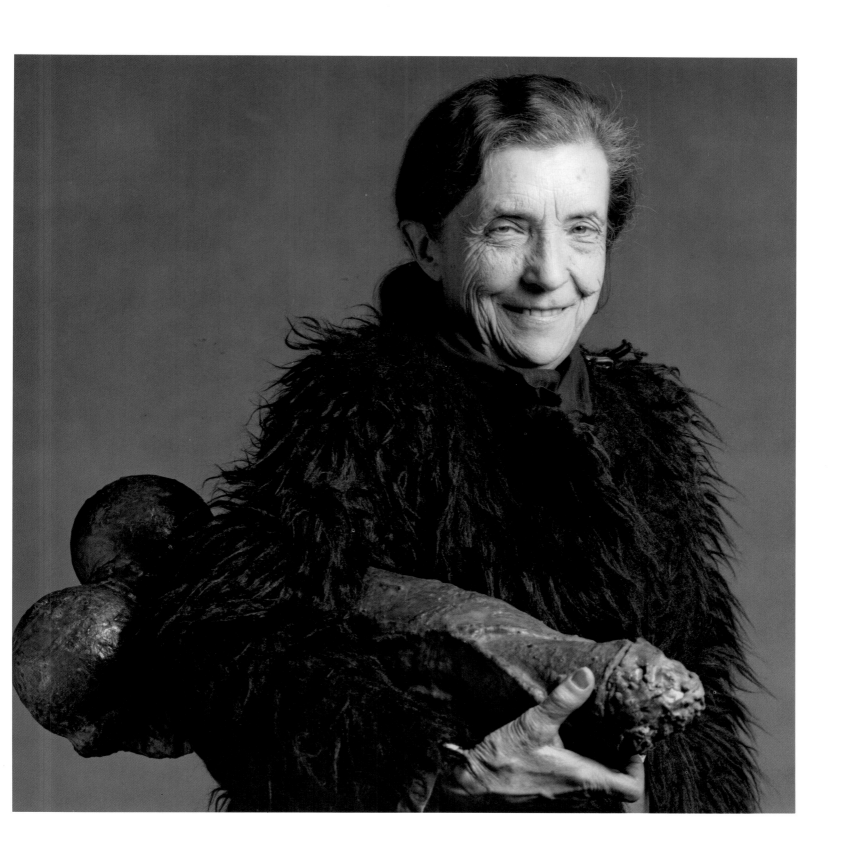

LOUISE BOURGEOIS 1982

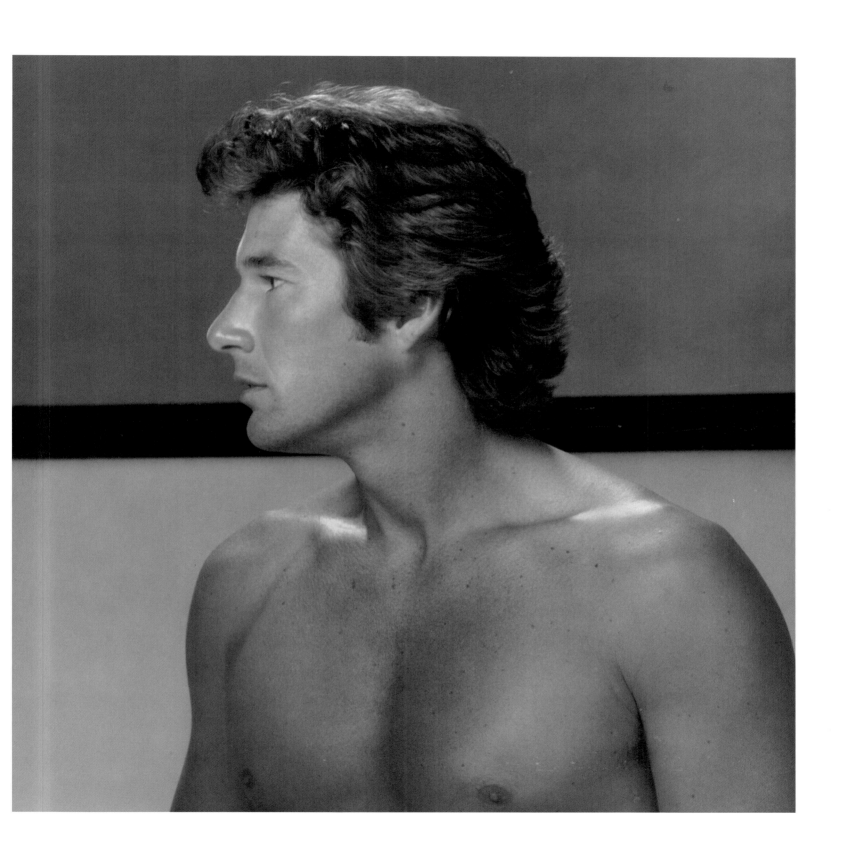

RICHARD GERE 1982

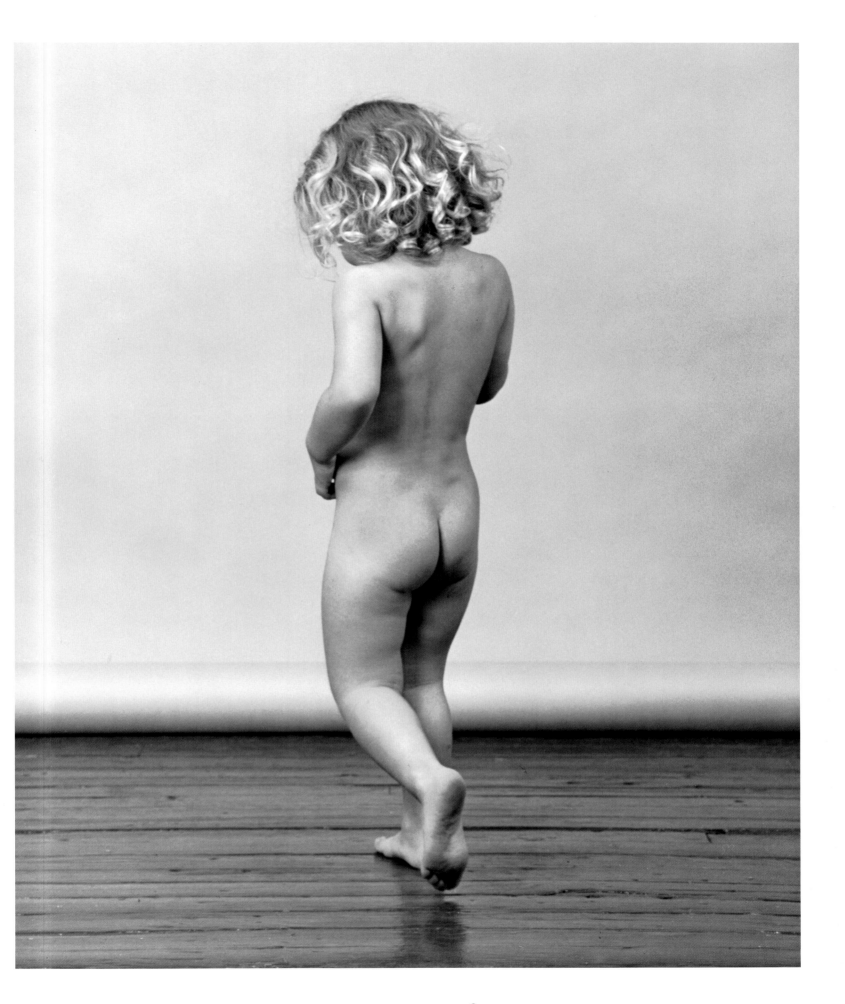

MELIA MARDEN 1983

119

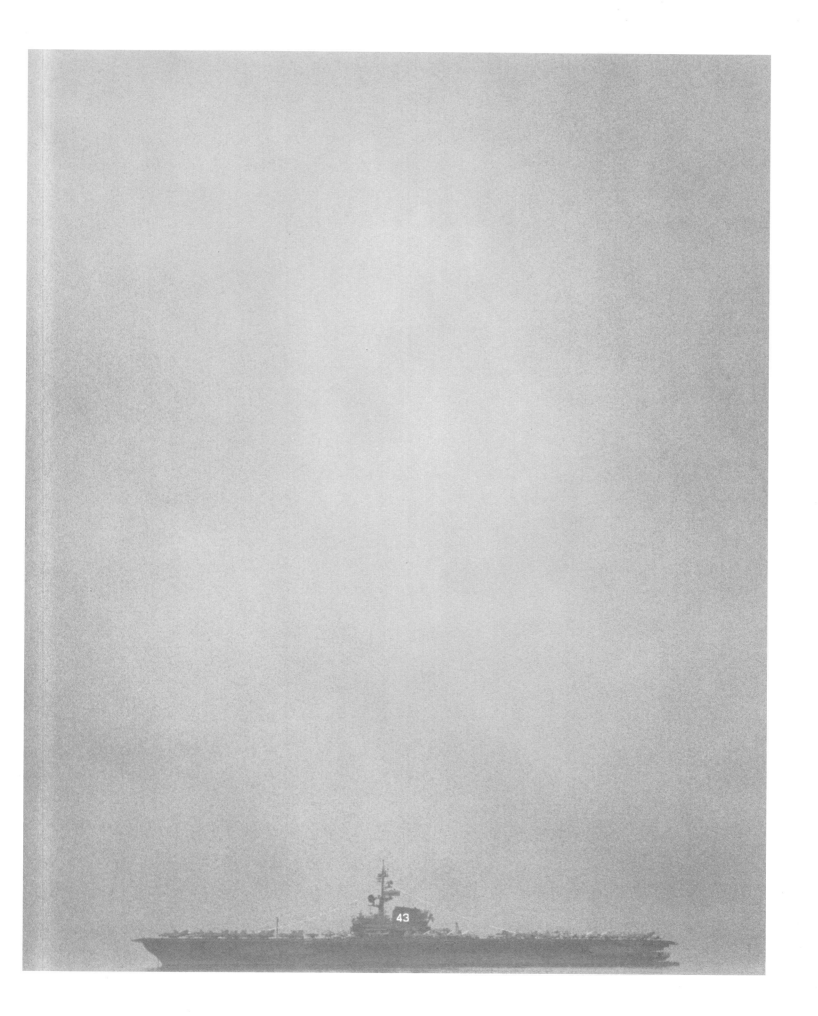

THE CORAL SEA 1983

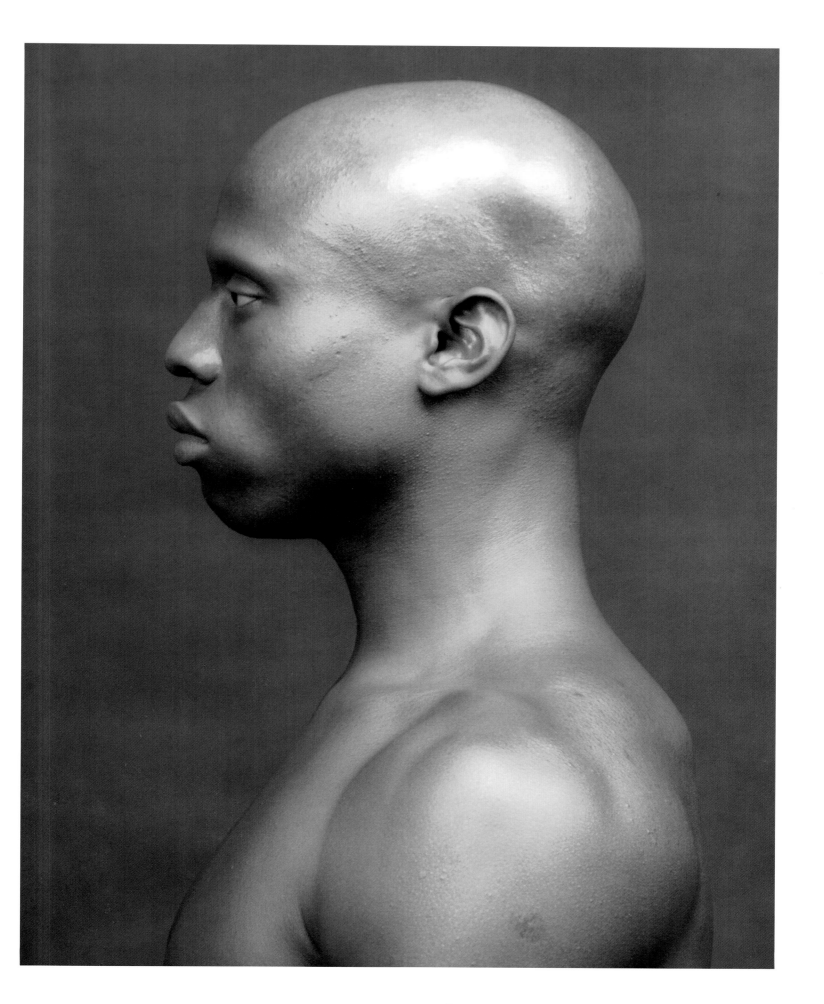

KEN MOODY 1983

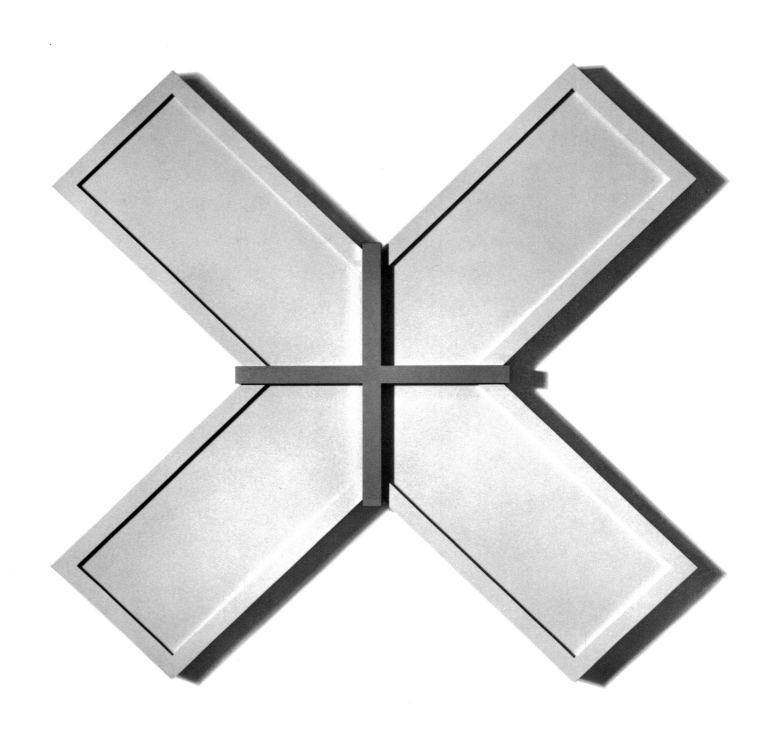

WHITE X WITH SILVER CROSS 1983

124

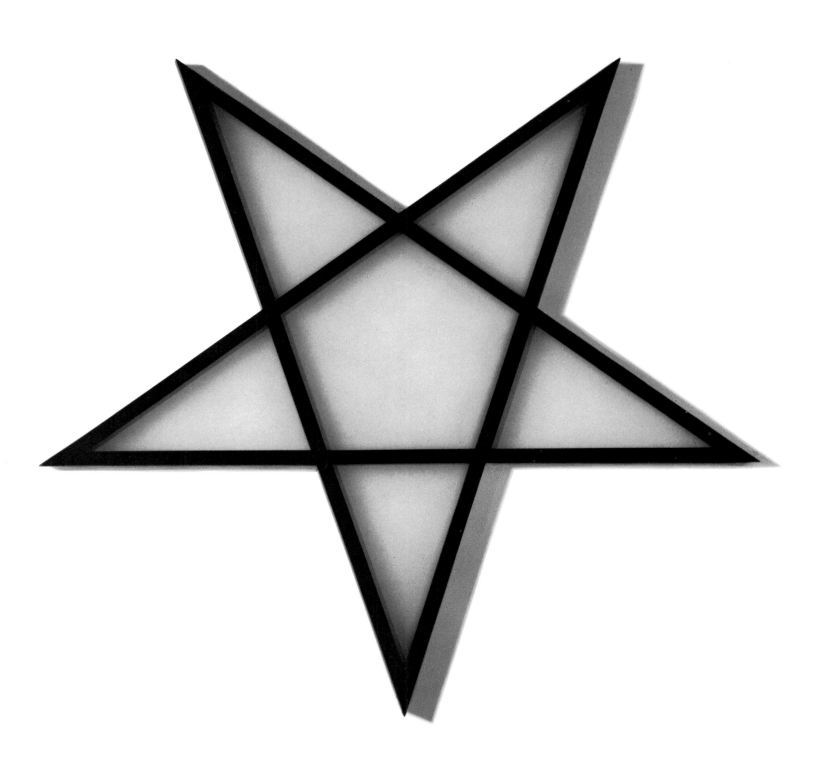

STAR WITH FROSTED GLASS 1983

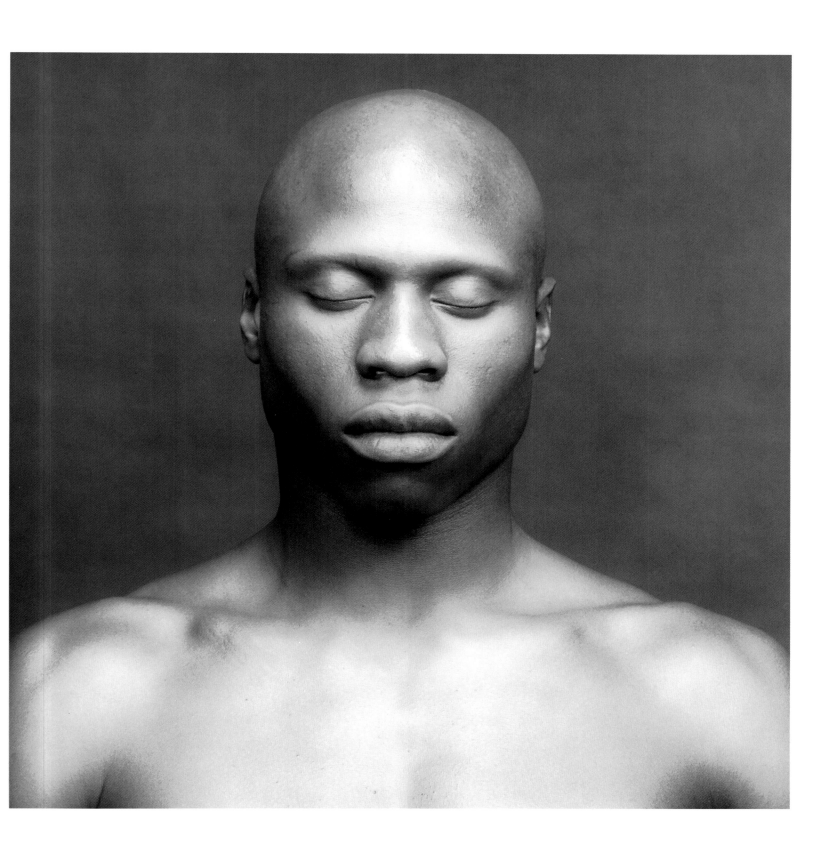

KEN MOODY 1983

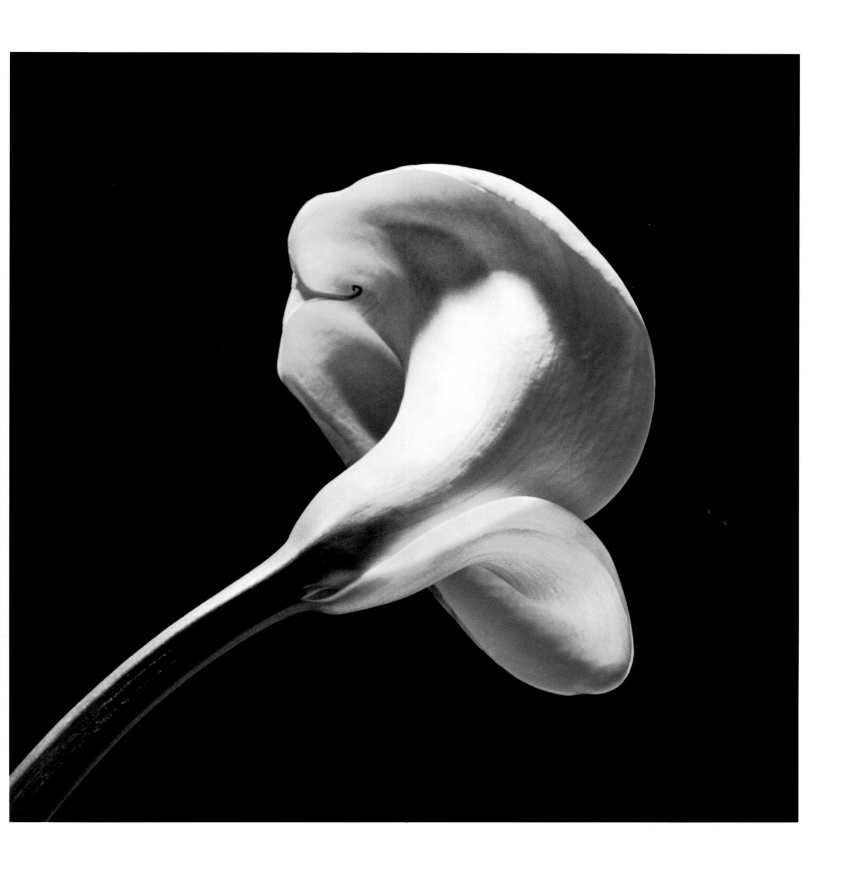

CALLA LILY 1984

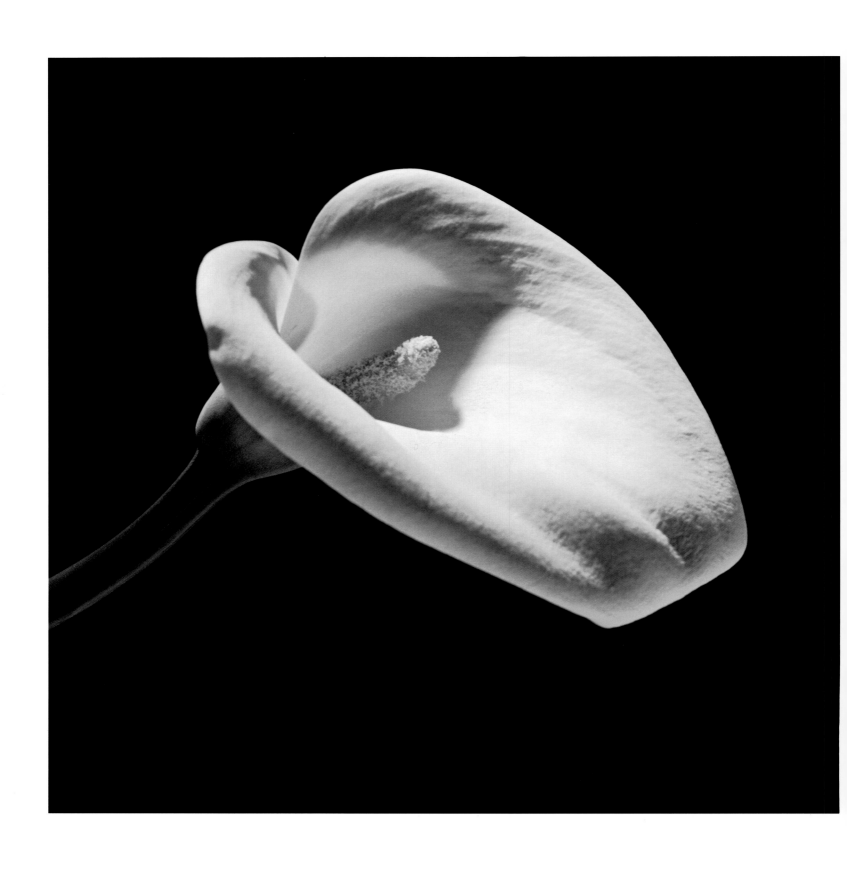

CALLA LILY 1984

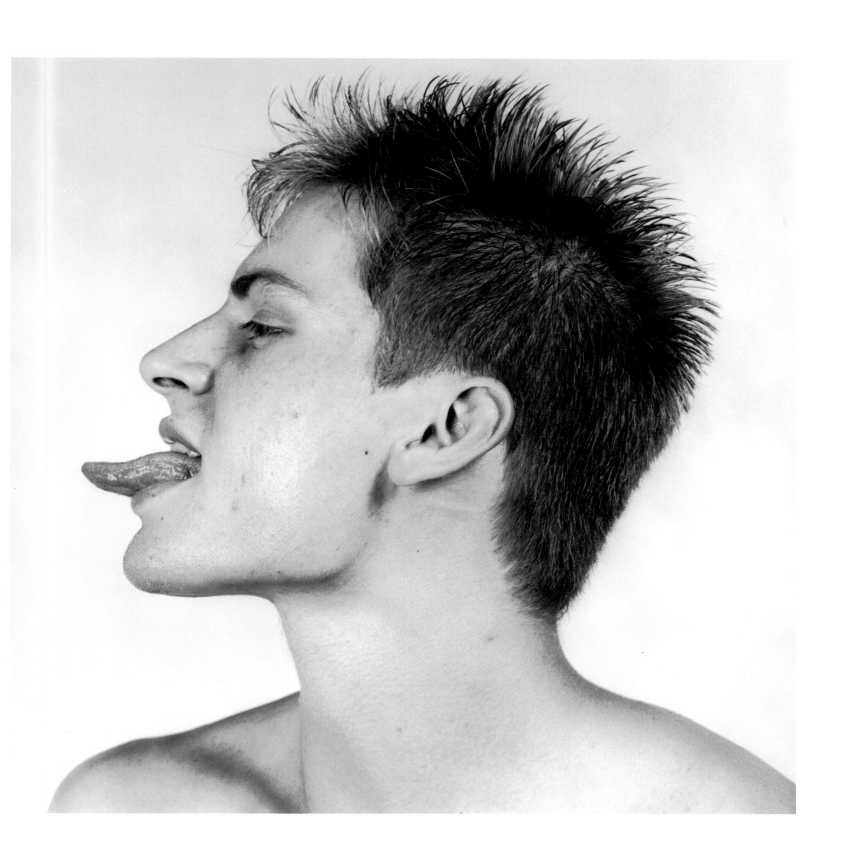

CHRIS HOFFMAN 1984

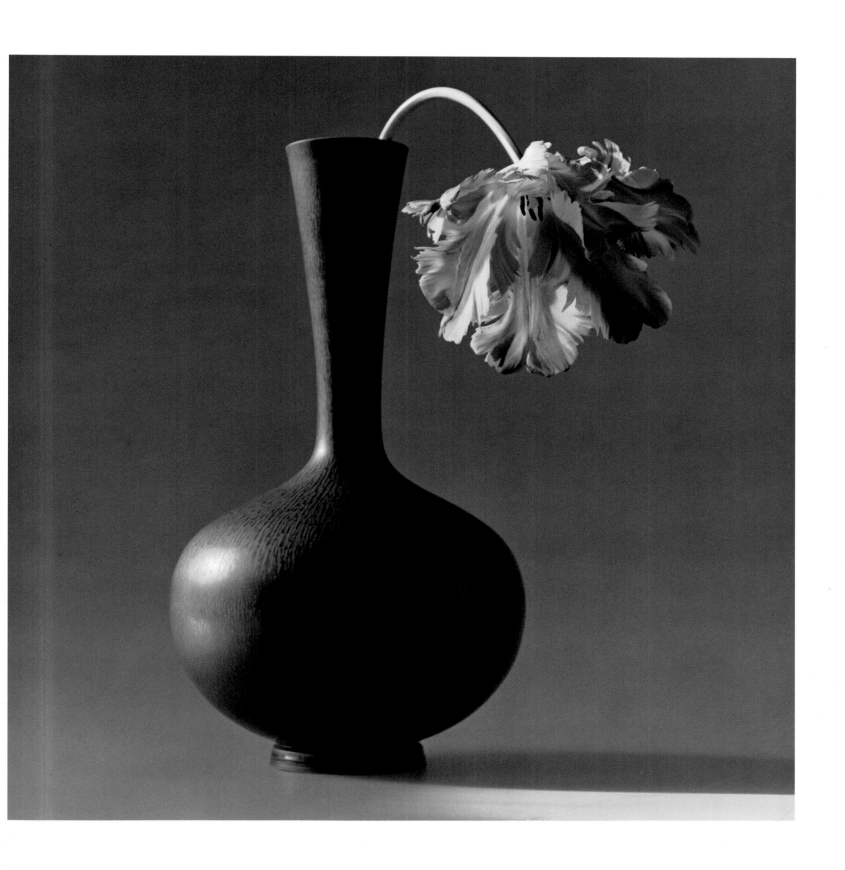

PARROT TULIP IN A BLACK VASE 1985

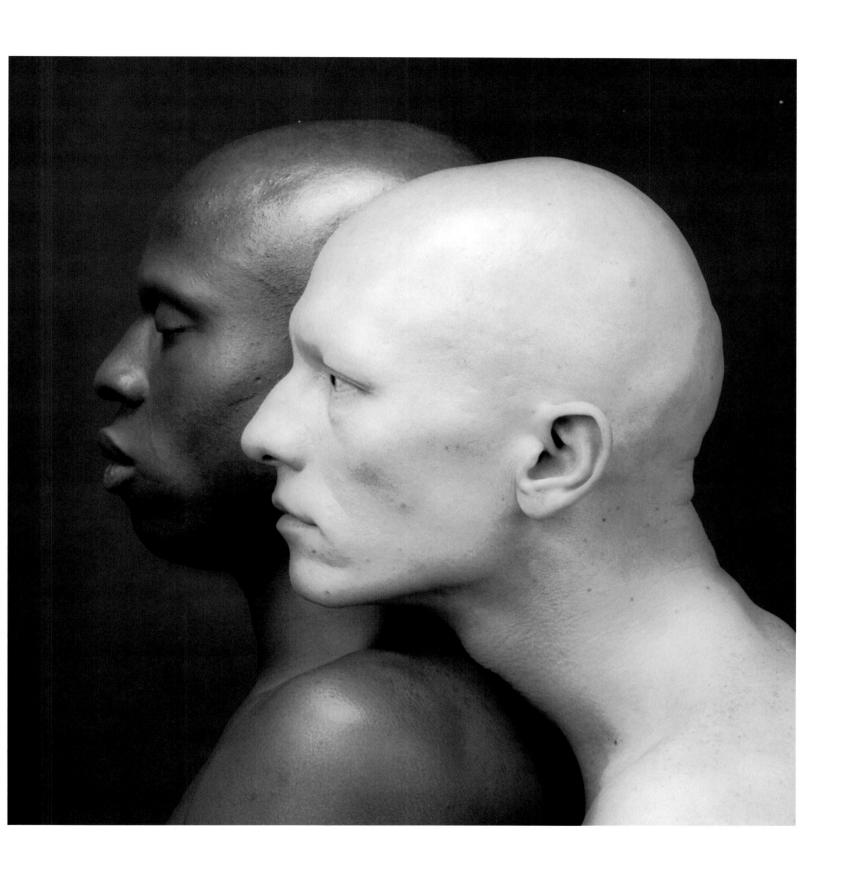

KEN MOODY AND ROBERT SHERMAN 1984

135

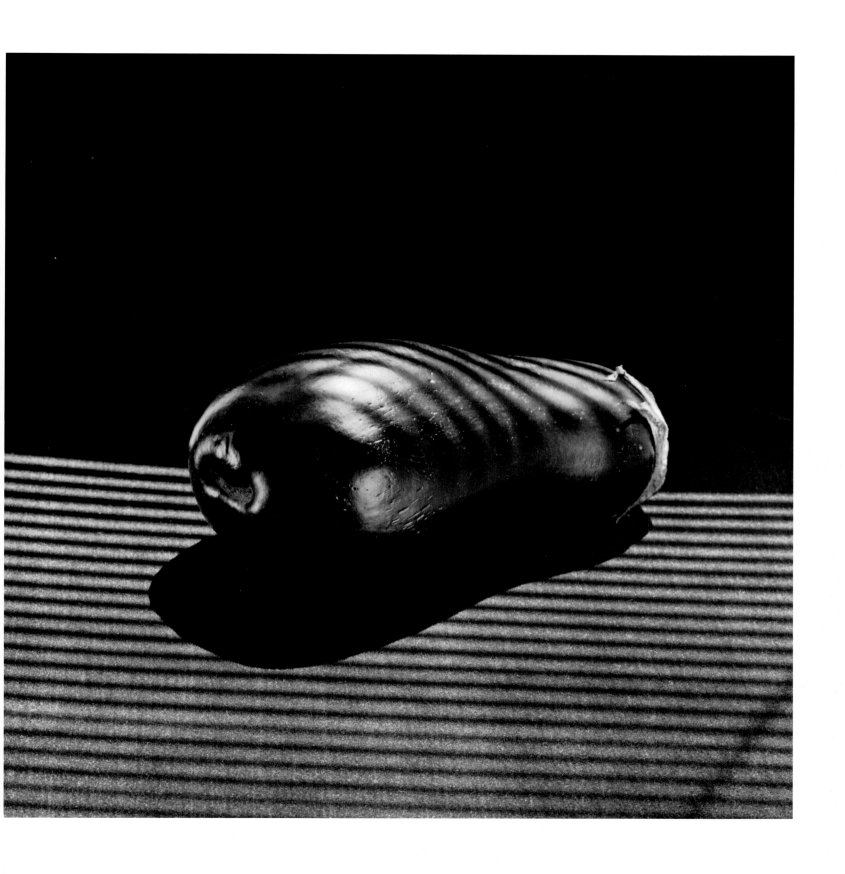

EGGPLANT 1985

137

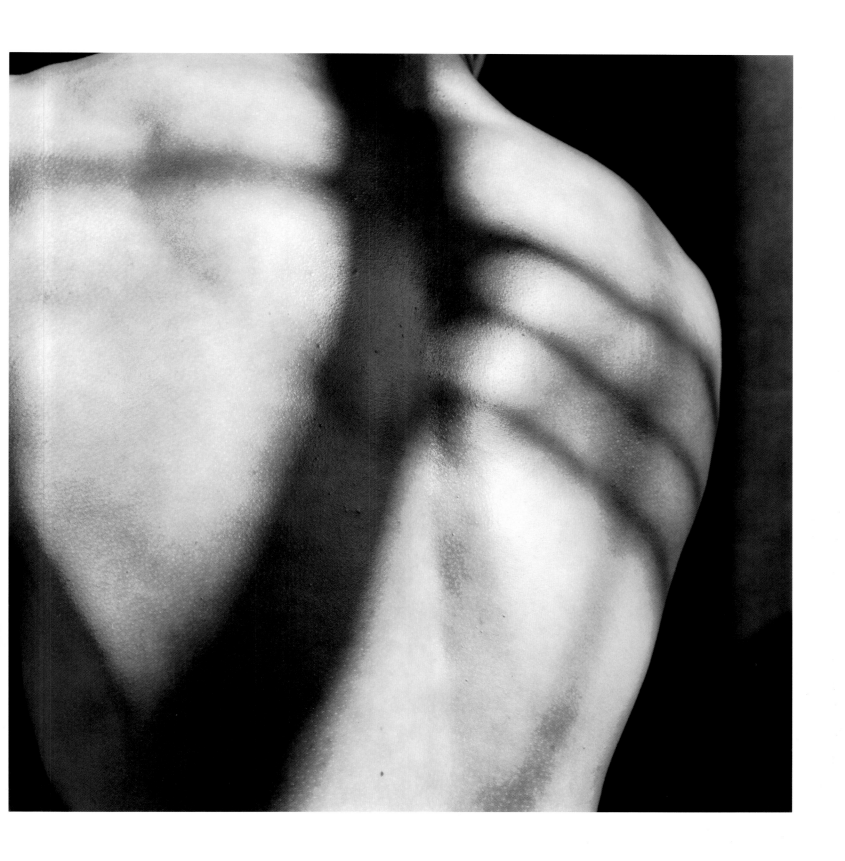

VIBERT 1984

139

FISH 1985

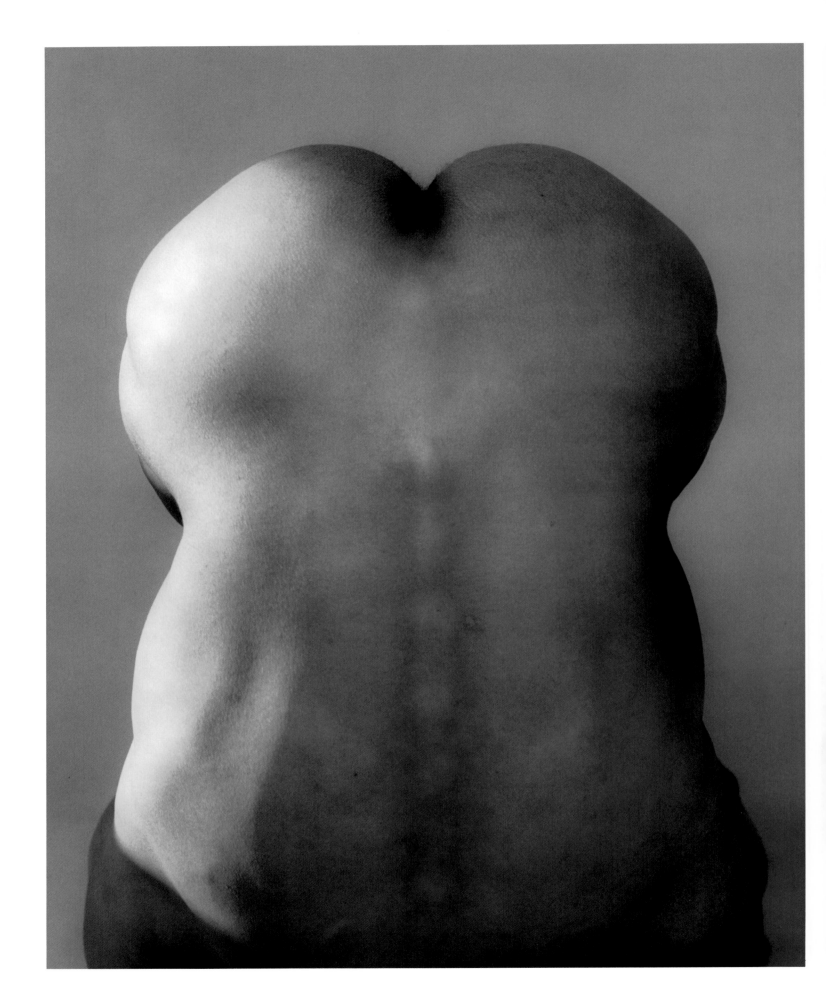

RAYMOND 1985

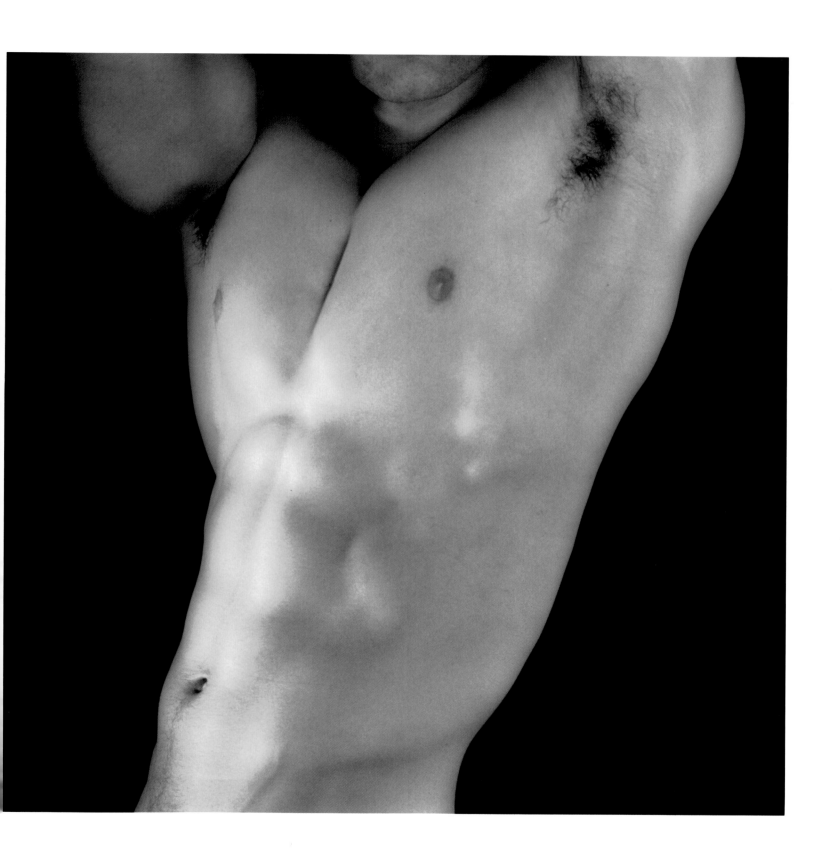

CHARLES 1985

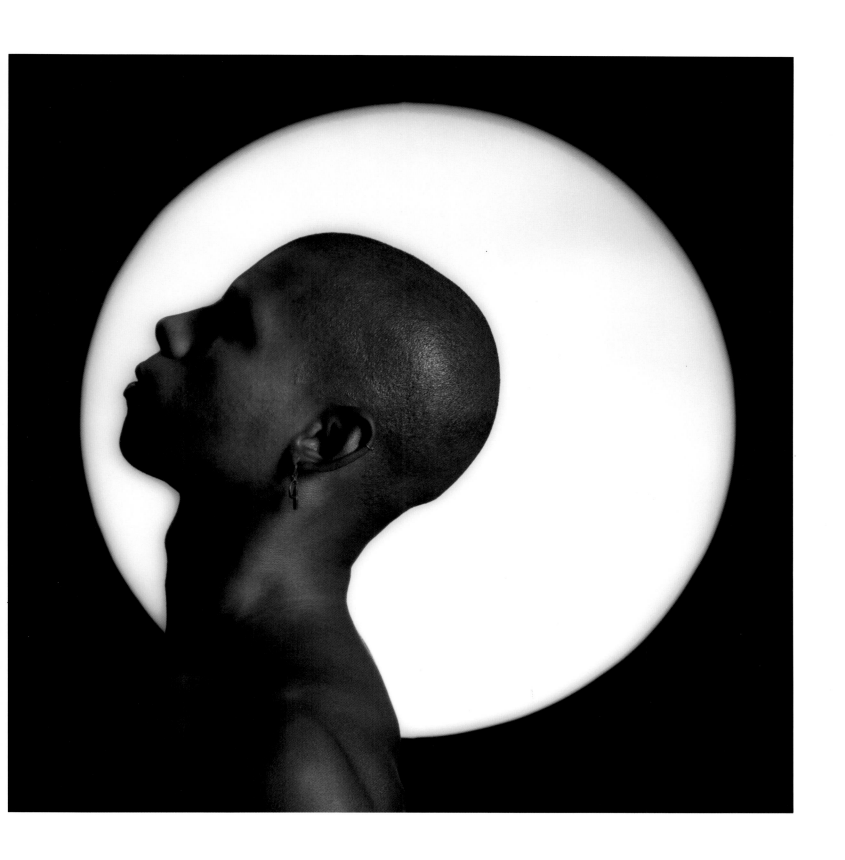

ANDRE 1984

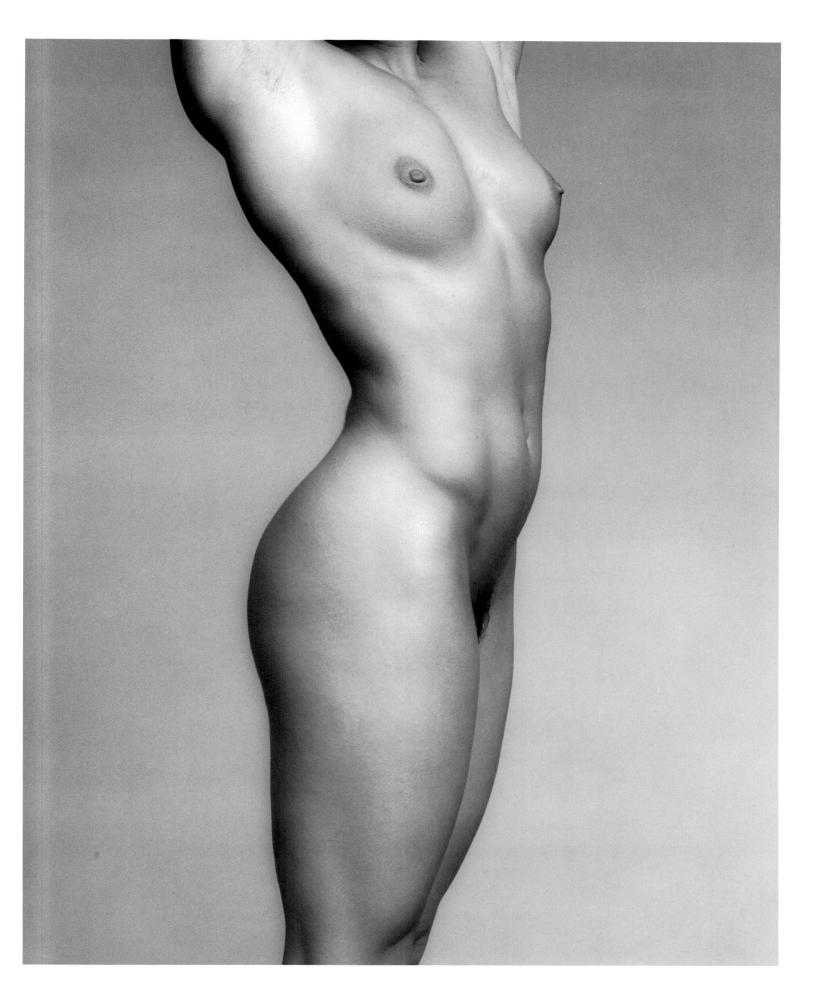

LYDIA 1985

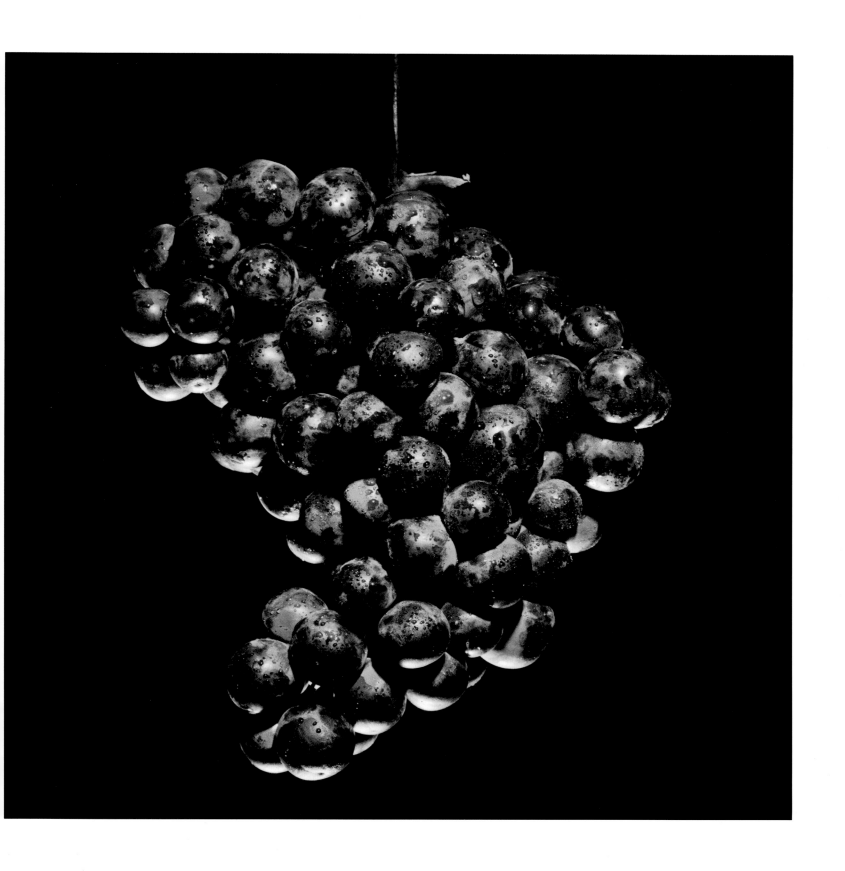

GRAPES 1985

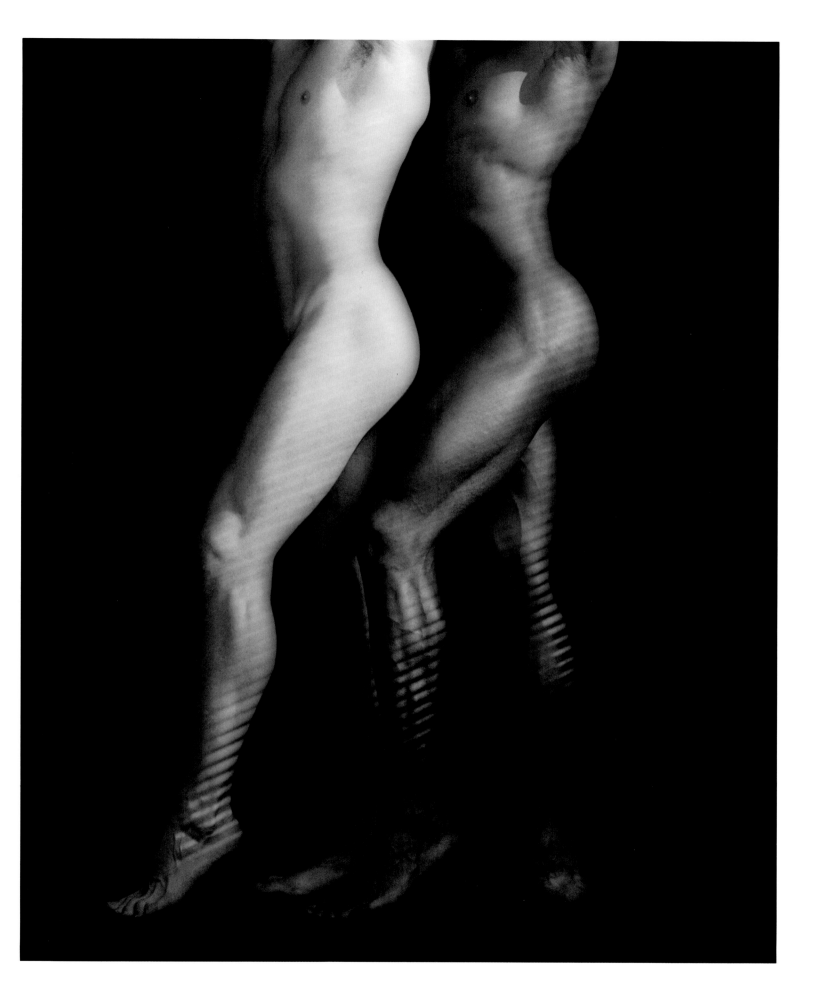

KEN AND TYLER 1985

THE
MAPPLETHORPE
EFFECT

Richard Howard

IN A LATE POEM, Jorge Luis Borges thanks the gathering darkness of amaurosis for rescuing him from the *prolixity of the real*: what is poetically singular is to be discerned by its disengagement from the world's plurals, necessarily prosaic. In any consideration of an artist's work, something of these constraints, these sunderings, must be invoked, even when it is the *prolixity of the unreal* which throngs the photographer's images, a congestion of fantasy and obsession. For in even the most schematic and fixated achievement, more meets the eye and the lens than the mind can discriminate. In Robert Mapplethorpe's work—granted, in his early work—there are a number of unexpected images, for example, of the sea, the one subject which cannot be made to pose; and in some of his latest work, anomalously in color, there are images of growing plants and of animals in the wild—granted, only an alligator's snout, but could even Mapplethorpe pose an alligator? As in the work of any venturesome artist, there are examples here which would appear to betray the strictness which the thematizing (and sense-making) onlooker must approve. It makes any effort of appreciation more arduous, having to register exceptions to what we were convinced—and happy with the conviction—was a kind of monomania. That Mapplethorpe is a gifted photographer of children, for example, or that he can allow the merest *furniture* to clog the attention so overwhelmingly bestowed upon *Brian Ridley and Lyle Heeter*, 1979 (p. 55), is an obstacle to our perception of him as a specific kind of artist—narrow, ensorcelled, not to be distracted.

No feature of a body of work, then, can be so important as it seems in our discussion of it—there will be, in Mapplethorpe's copious oeuvre, almost invariably a contradiction to the perceived drift, or even to the tyrannous current; he is venturesome enough, as I say, to inspect the nostalgias of the life we all live, of the sights we all see, as well as his own visions and vilifications. Yet for the rapt artist, the life we all live is not enough of a subject—and for the photographer, not enough of an object. It must be life with an inclination, a leaning, *a certain slant of light*, a tendency to shape itself only in certain forms, to afford its most valued and valuable revelations only in certain . . . darknesses.

And so it is with a crowding awareness of other pictures, a consciousness of their extension beyond my focus, that I shall discuss only some works, by no means a majority of the images Mapplethorpe has made, though I think they will be the ones he has made his own. I think, too, that in the general discussion of photography, the camera's powers are too generally received to permit their being looked at, effectively looked into and accounted for, unless they be isolated, epitomized—like something in an anthology of provisional faiths. Of

course there are, in Mapplethorpe as in other photographers we call fetishistic or fanatical, experiences beyond such sudden identification; indeed the camera by the nature of its processes invites a diversity of experiences—for like every art, photography has its "interferences," its obstacles to singular realization, and an artist is never more than partly himself—"a Mapplethorpe," say, or "a Borges," at any one time. There is besides a kind of outward impulse which keeps our recognition of his specialty muffled quite as much as there is an inward motive which keeps his specialty going in the first (and last) place. My desire to constitute or at least to estimate an imaginative unity in Mapplethorpe's photographs will violate their loyal dispersion in experience. His is an extreme case, perhaps, but is it not always worth making the case, whenever we claim to identify what an artist is doing? Further constructions can be put upon these things, other things can be seen in them beyond or within what has been seen. Here, then, an essay in emphasis, for as Borges himself would surely have acknowledged, even the poems of darkness must be read in the light.

Mapplethorpe differs perhaps from other artists in photography by this insistence upon the darkness: if other photographers are artists precisely insofar as they *see the light* and register its capacity to seize and transform our response to the world, Mapplethorpe would be the photographer who sees the darkness. As he said in 1986, with suggestive grammatical disregard: "my work is about seeing—seeing things like they haven't been seen before."

I have presumed to say that he sees a particular darkness through three subjects: through flowers, through faces, through figures, discarding the prolixity, then, of the real and discarding the prolixity of the unreal. When we are not prolix (which means when we are not liquid), then we are concise (which means we are crystalline), and this indeed is Mapplethorpe's quality and his goal: to restore potency to flowers, to restore aesthetic dignity to the genitals, and to restore form to identity—and in so doing to set his images before us in such a way that we realize that what might never have been seen at all can never be seen as anything but what it appears. Which is, as Paul Valéry used to say, the realization of the beautiful.

Flowers

Flowers are the sexual organs of plants. In all Mapplethorpe's photographs of flowers I have seen, they are no longer a growing member of plants, but dissevered from them, their provisional status emphasized, their duration *on sufferance*, in bowls, vases—one exception: *Tulips*, 1983 (p. 154), still growing from bulbs but not in earth, not destined for any completion of their cycle, but clumped together in a wooden flat, a suffocating contiguity of bloom, as *contra naturam* as any of the arresting orchids and lilies thrust into a thimbleful of water or simply cropped, like *Easter Lilies*, 1979 (p. 67), which admit of no attachment to anything beneath a stem. Yet if Mapplethorpe's flowers are never shown in any kind of fertile continuity, neither are they seen to have any traffic with mortality—no fallen petals, no withered or faded parts. Whatever their complexity of structure and fragility of substance, the flowers are shown—sometimes leaning into the shot from the side, with no basis in fact—*to perfection*, in their heightened, erectile state, engorged with the liquids which make them such solids, driven through the green fuse by that force which, Dylan Thomas wrote, drives our human age as well. In these images, which are never afforded a landscape or even a setting where the condition of

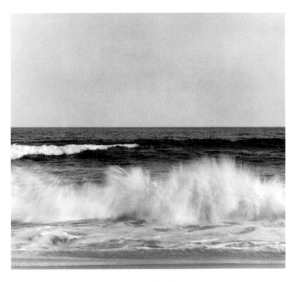

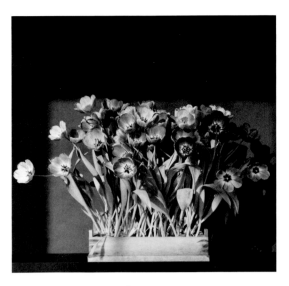

Wave (Fire Island), 1980

Tulips, 1983

being indoors might be implied by the absence of weather or world, withholding any object that might serve as a reference of scale, the flowers are indeed fetishized so that we must perceive them not only as the sexual organs they are, but as analogies to our own. In his 1985 collection *Black Flowers,* Mapplethorpe plays this game of equivalents in quite explicit terms, setting the flower studies opposite his highly genitalized male nudes which counter a millennial convention of pelvic disregard or concealment—he insists that we confront what Yeats once called "the mystery which touches the genitals, a blurred touch through a curtain." But Mapplethorpe would focus that blurred touch, would compel us to see with the same focusing wonder the "expression" of the uncircumcised glans and the "assertion" of the cut flower. The penis, in all the images by Mapplethorpe I have seen, is never shown erect, the flower always so, its erethism undeterred "by any natural thing" (Yeats again: Mapplethorpe has certainly sailed to Byzantium, no country for old men indeed; unlike Rodin, his greatest rival in the adoration of "bodily shape," Mapplethorpe "sees" only the fulfilled, perfected physique as his subject, his satisfaction). And even when the images of flowers and of the male genitals are not conflated, there are still extraordinary coherences: the photograph of *Michael,* 1983 (p. 155), in white tights which against a black wall make the genital contour more than explicit—which make it a decorative arabesque his stare defies us to disregard—leads us to the 1982 orchid (p. 103) in its prim white vase against a gaining outer darkness, with but the one iris leaf-spear to hold its analogously genital outline against our mind (even the verbal pun is presented: orchis-testicle). More surprisingly still, the 1976 photograph of *Mark Stevens* (p. 49), in which the nude model arches over a stone altar so that his genitals are laid on the surface like some sacrificial first-fruits, annexes the 1985 *Eggplant* (p. 137), in which the arcuate vegetable precisely echoes, in its identically shadowed realm, the phallic oblation. In all of Mapplethorpe's flower pictures, with their specific equivalents in his images of human sexual organs, we are granted what one of his Italian critics has called, after Nietzsche, the retroaction of form upon force. In these genital studies, human and botanical, something very intricate, very particular, and yet very generic is—I believe for the first time as a deliberate artistic manifestation—articulated, studied, with curious consequences for our conventions and decorums with regard to gender. Flowers—just think of Emily Dickinson, of Georgia O'Keeffe, with their patient explorations of bloom!—which have so traditionally been associated with female art and female organs, are here, in their engorged, erectile, anti-chthonic forms, identified with that "male" principle we so clumsily (and often so reductively) decry as "phallic"—in the brutal sense that the word is made to share with our related English word "bull." Indeed, much of Mapplethorpe's enterprise, in the flower photo-

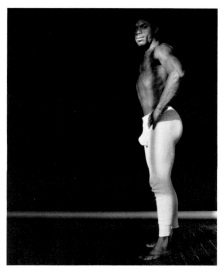

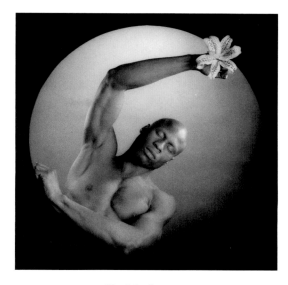

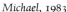
Michael, 1983 *Ken Moody*, 1984

graphs made to "match" photographs of male genitals, as well as in such images as the one of *Ken Moody*, 1984 (p. 155), where the oneiric figure (eyes closed) holds, on the rim of a bright circle, a fully open tiger lily: evident analogy of the sexual organs here not revealed—much of Mapplethorpe's enterprise urges us to see the male genitals as *potential forms* of great delicacy and poise, paired with the thrusting, assertive, conventionally female figurations of flowers. What is spoken, Heidegger says, is never—and in no language—what is said. I might add: not even in the language of flowers.

There is a further point to be made, or a perception (the word is a translation of "aesthetics") to be reached with regard to these fiercely present flowers—one that is suggested by Susan Sontag in her 1985 essay on the photographer: Mapplethorpe, she observes, could never become a photographer of accidents. He wants to photograph whatever can be made to pose. "What he looks for, which could be called Form, is the quiddity . . . of something. Not the truth about something, but the strongest version of it." An extremity of strength: that is why these flowers are always, for all their artifice and their assertion, perfect specimens, luminously disposed—as in *Orchid with Palmetto Leaf*, 1982 (p. 156)—to reveal the pinnacle, the crisis of *la condition botanique*, of that kingdom where only a master of shadows can reveal to us, without color, without odor, that all is yet Erotic Form.

And that is why the male genitals are often presented—as in the two notorious images of 1982, the *Untitled* naked man with the Klan-like pillowcase over his head (p. 156) and *Man in Polyester Suit*, 1980 (p. 95)—as surrogates for the face, forming with the carefully included hands a new and quite recognizable expressive entity, though one for which our culture has no accommodation. It is without incident or anecdote that these flowers, like these unaroused genitals, are presented: not as dramatic power but as lyric potentiality—as what Valéry, speaking of the effect of light upon the sea, calls "a mass of calm and visible reserve."

Our received sense of "flower" as "epitome" is invoked by these images: to flower is to come to a point of physical perfection which has something of the *sacred* about it—the fine flower of manhood, not a frivolous word in the context, though by Mapplethorpe's evident parodies of Muscleman poses and *House Beautiful* arrangements, it is a word manqué even more than a word mocking; it is a sacred traduced by commonplace associations, and Mapplethorpe's task is to restore the gravity which has leaked out of what is unspeakable.

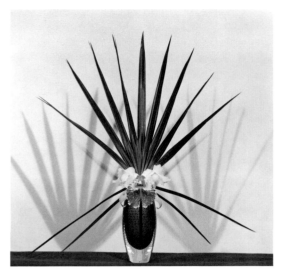

Orchid with Palmetto Leaf, 1982

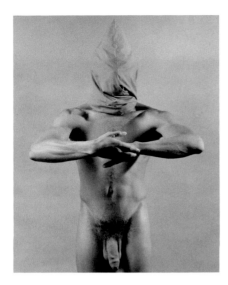

Untitled, 1982

Faces

Mapplethorpe has made a great many portraits—recently even a commercial book of *50 New York Artists* (1986), with very little variation in the images, either head-on or profile shots, all but ten against a blank ground; and all his exhibitions and other publications have contained many portraits. Inveterately, he supplies the names of his nude models as if these works too were portraits, and of course he has made a number of self-portraits, including the sensational pair on the front and back cover of *Certain People* (1985), presenting himself as parodically male and as appealingly androgynous. (The appeal, of course, is to our sense of participation: nothing of Diane Arbus' fascinated repulsion in Mapplethorpe's exploration of drastic erotic identities; unlike most photographers, he is willing, even eager, to expose his own narcissistic fantasies, nor is there that sense of "dressing up"—or down—which makes Leonor Fini's self-portraits as the heroine of *Histoire d'O* so trivial a masquerade.) Mapplethorpe's portraits, as he said when Sontag asked what he does with himself when he poses, try to find that part of the subject which is self-confident. This is by no means a part of which the subject is readily conscious. We may identify Mapplethorpe's people if we are cognizant of certain social and artistic circles, otherwise we merely learn to know them as they appear. As early as 1971, he made the astonishing confession—or was it a challenge, even a defiance?—about his work as a portrait-maker: "I often don't know who these people are. It's not that important to me. I never had heroes."

If he never had them, he makes heroes now: the carefully arranged, cropped, lighted, or rather shadowed countenances assert just that degree of victoriously fulfilled flesh which—without envy or *schadenfreude*—exemplifies a heroic mode of being there. The great majority of these faces are of beautiful people, particularly of black men perceived as physiognomies so symmetrical as not to admit those "accidentals" which for most of us constitute the recognizable self (*Ken Moody*, 1983, p. 123); and almost no one smiling. A remarkable exception to this general solemnity of regard is the portrait of Louise Bourgeois (one of three superb effigies of old-women artists in *Certain People*, the others, Alice Neel and Lee Krasner, revealed as flaunting the damages of a lifetime like a shield before them, stoically endured). Sometimes exhibited or reproduced in a cropped version, the Louise Bourgeois portrait (p. 115) then seems no more than a rictus of mysterious complicity. Seen in the version Mapplethorpe prints in the book, the complicity is

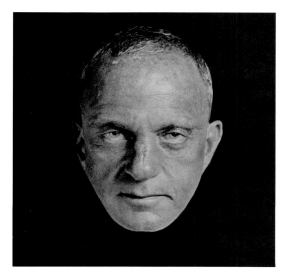

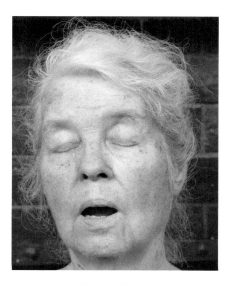

Roy Cohn, 1981 *Alice Neel, 1985*

accounted for: under her arm (and she is wearing a shaggy—monkey-fur?—jacket which accentuates the spooky side of things), she carries like a sidearm her own sculpture of a two-foot phallus-and-testicles, lighted and held in such a way as to form the base of a sinister—castrational?—pyramid. The livid light on Louise Bourgeois' face, explicitly tracing the seamed and wrinkled flesh, pronounces sentence on the entire composition: like some sibyl out of Petronius, the sculptor is on her way to a ceremony of puzzling erotic nature; she knows what she is about to do, as the shocking hand makes explicit: fingers can be taught, but that thumb was born knowing.

Within these faces, then, is a potential identity, not of necessity the celebrated or notorious ones associated with the name attached to the face (an exception: the portrait of the late Roy Cohn [p. 157], made in 1981, is precisely the portrait of everything that name has come to signify, and the portrait is not so much a proleptic death mask as a Veronica's Veil of ill-omen, floating in a black void, bodiless and therefore soulless). A Mapplethorpe portrait *represents* a power of the flesh as a Mapplethorpe flower constitutes an effigy of sacred assertion: it figures Being taken—posed, beguiled, inveigled by all the sortileges of darkness—to the very limits of itself, all that flesh is heir to without the connivance of circumstance. I approach this instance of the sacred gingerly, as does Mapplethorpe himself: implicit in each of these faces, famous or obscure, desirable or desolate, is that pulsion of energy, a velleity within the flesh, *against* the flesh often enough, which seeks to transcend the given, which counters the pervasively downward pull, the gravity of substance. Sometimes this power, or this potentiality, flickers very near the point of extinction, as in the portrait of *Alice Neel*, 1985 (p. 157), where only the open mouth—open on the same blackness as that which surrounds the disarranged hair—signifies an effort to resist subsidence. But often the symmetrical delight of certain faces is so instinct with just the counterpoise of potency, as in the portrait of *Ken Moody*, 1983 (p. 127), that there is no need for the eyes to be open, no need for the features to *register*. What we call the *facial mask* has momentarily triumphed over individuality, over the personal, the human, and all that the merely human hides. Indeed, in the face of such an image I no longer know why we must praise an artist, a photographer, for being "human," when as Mapplethorpe shows us, all that fulfills and completes humanity is inhuman, is superhuman . . . is divine?

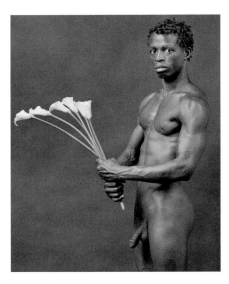

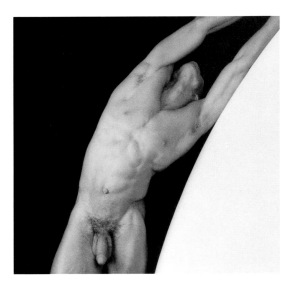

Dennis Speight, 1983

Thomas, 1986

Figures

In Mapplethorpe's photographs, the world of inorganic form is absent save as it is defined by the organic. What we think of as Leonardo's circle, and Leonardo's square inscribed within it, are evoked by many of the astonishing bodies, astonishingly posed in *Black Book* (1986), and indeed the geometry of these cherished figures is insistently caressed by deliberate and theatrical lighting, by occasional props of flowers—the sheaf of six calla lilies held by *Dennis Speight*, 1983 (p. 158), alludes to a potential orgasmic flowering, a sort of seminal bouquet—and by the photographer's repeated assertion that it is the bodies of black men which will take the light, and the darkness, with the most resolute formal determination. In most instances, Mapplethorpe's images of the nude male are isolated, solitary. Exceptionally the drama is offered as dialogue (an embrace, an agon between parallel black and white forms); characteristically, the "subject" is a lyric efflorescence within the intervals and analogies of a single body. Moreover this single body itself will not be taken whole but cropped (literally, anatomized) so as to declare its symmetrical relations intramurally, as it were, without reference to classical canons of wholeness, of completed form—rather, with regard to new proportions, new affinities, among them figures which include the genitals in unabashed exploration of what has always been treated as the body's disgraced member.

In his studies of the bodybuilder Lisa Lyon (pp. 110, 113, 114), it is of course a reversal of stereotypes which Mapplethorpe effects. Precisely the kind of lyric stasis so lovingly studied in male bodies traditionally granted movement and power (in other words, a paradoxical anti-phallicism, if we take our lead from the culture's interpretation of the phallic as dominance, as inflexibility, as denial of the other's response) is withheld in the *Lisa Lyon* series: Lyon repeatedly subverts, in images of sleek force and definition, the conventions of female iconography she is made to criticize, to parody, to transform. "Seeing things like they haven't been seen before"—Mapplethorpe's words hover over all his nude figures, though I am convinced that the major revelation of these studies, the burden of their enormous effort—in which the camera is compelled to acknowledge desire with an avidity not just optic but haptic—is that of the body's implicit *energeia* to rise, to mount, to erect itself into an insurgent principle.

Against what? What is the antagonist of these forms so suavely figured, so cunningly sectioned to reveal new anatomies, inadmissible analogies, what Macbeth calls *understood relations* which bring forth the secret'st man of blood? Perhaps the answer is given most diagrammatically in the photograph *Thomas*, 1986 (p. 158); in darkness, tangent to a great white arc on the right, the frontal nude—garishly lighted so that it has lost its bronze patina so prized by Mapplethorpe—yearns upward, strives, grasps (though the hands are cropped) for ascension while the body *depends*, the very organ of erection limp, the double socle of the thighs ponderous in their (also cropped) downward thrust. In all Mapplethorpe's figures, though, each separate body is its own repertoire of ascensional pulsions, reservoirs of potential elevation against the gravity of its own structure, a headlong architecture of antitheticals.

The unified if never uniform impulse I would discern in Mapplethorpe's flowers, Mapplethorpe's faces, Mapplethorpe's figures is a continuous struggle, the contestation of heft. Solemnity of effigy is the consequence, I suppose, of a certain undecided outcome: flowers spring up against their own weight; engorged with juice, they are never shown attached to the cycle which would make their momentary victory more than just that. Faces are transpicuous with energy, with appetite, yet there is always the gravity of the features, of the flesh which pulls, which *ponderates*, in the sense of bearing down what aspires to rise, to mount to expression, to identity. And figures glow with the potency of their rhythms, their newly revealed analogies of form—yet even as these arresting pelvic landscapes can rise and indeed reach beyond themselves, they are shown always in their dense and onerous potentiality only, the long muscles and the delicate veins finally burdensome, unredeemed—impugning all we used to mean by "phallic." If I reach for such terms as transcendence, redemption, the apparatus of the sacred, it is because I used to think Mapplethorpe's photography was grim with the restrictive occasions of obsession and fetishism; but after a certain meditation, pondering their reasons and their realizations, I discern these pictures—a good share of them—to be emblems of contested mortality, grave with the contradictions of organic life in their aspiration to ecstasy, as crystalline in terms of their own art as the sonatas of Scarlatti or the last paintings of Mondrian, but as problematic, as imprecatory as any representation of the body I know, fond enemy and ally.

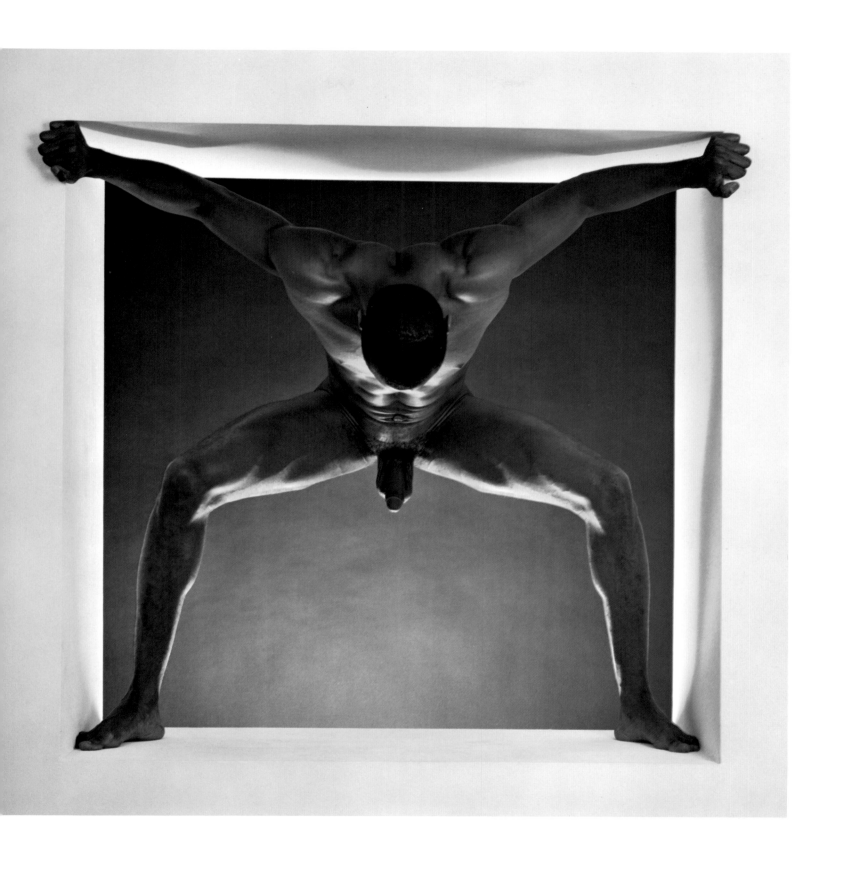

THOMAS 1986

161

163

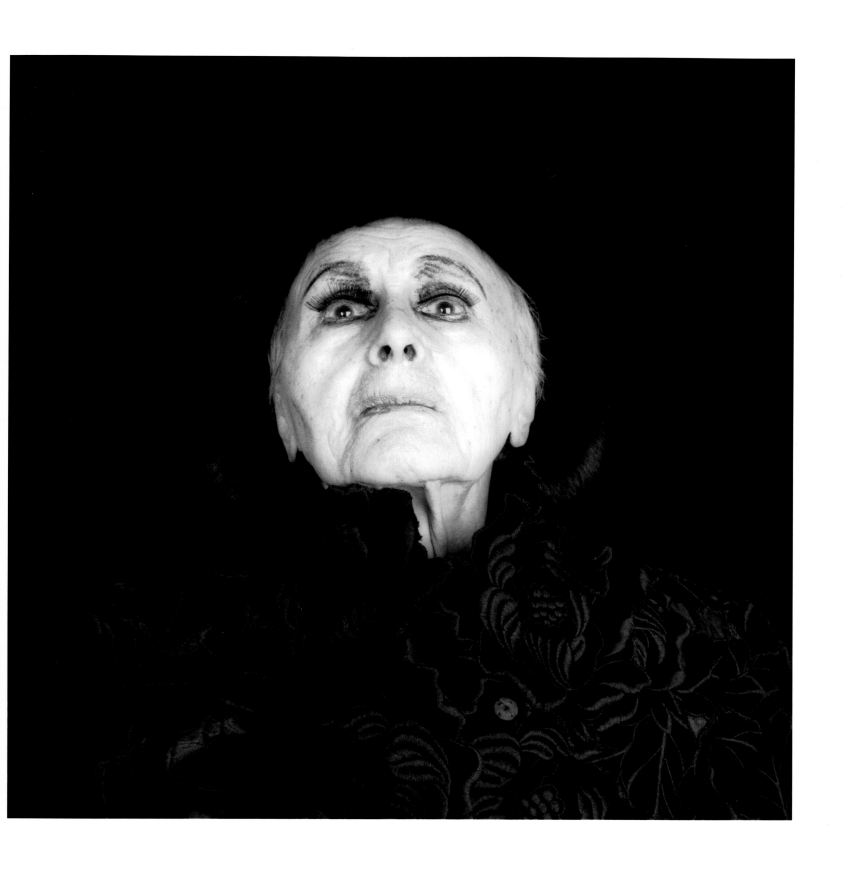

LOUISE NEVELSON 1986

161

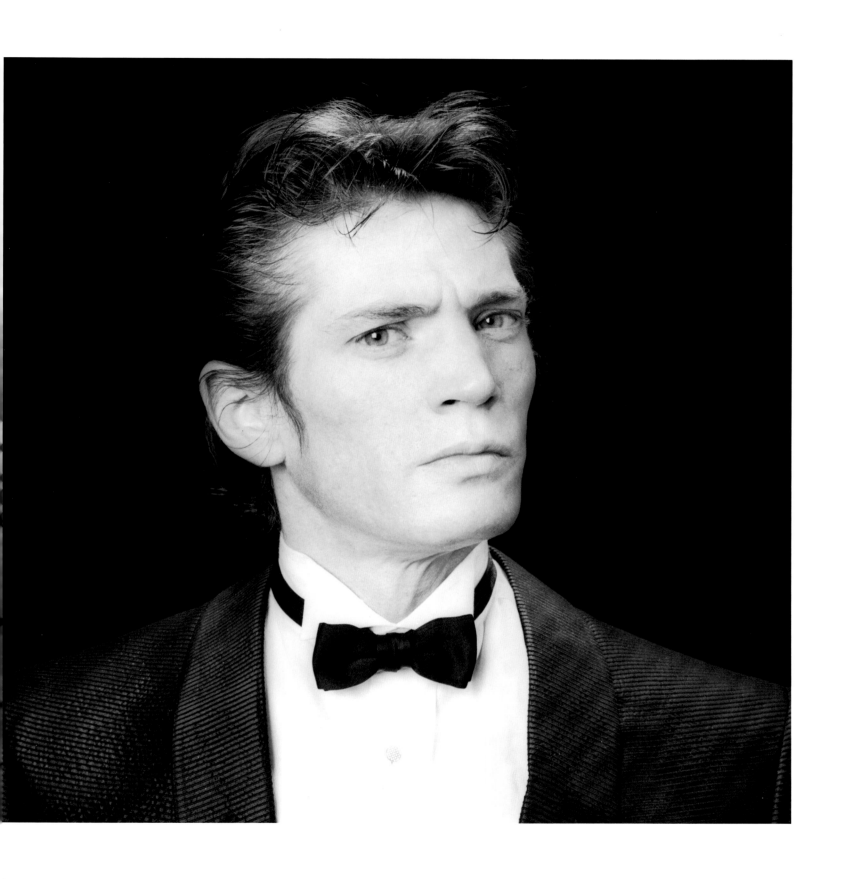

SELF PORTRAIT 1986

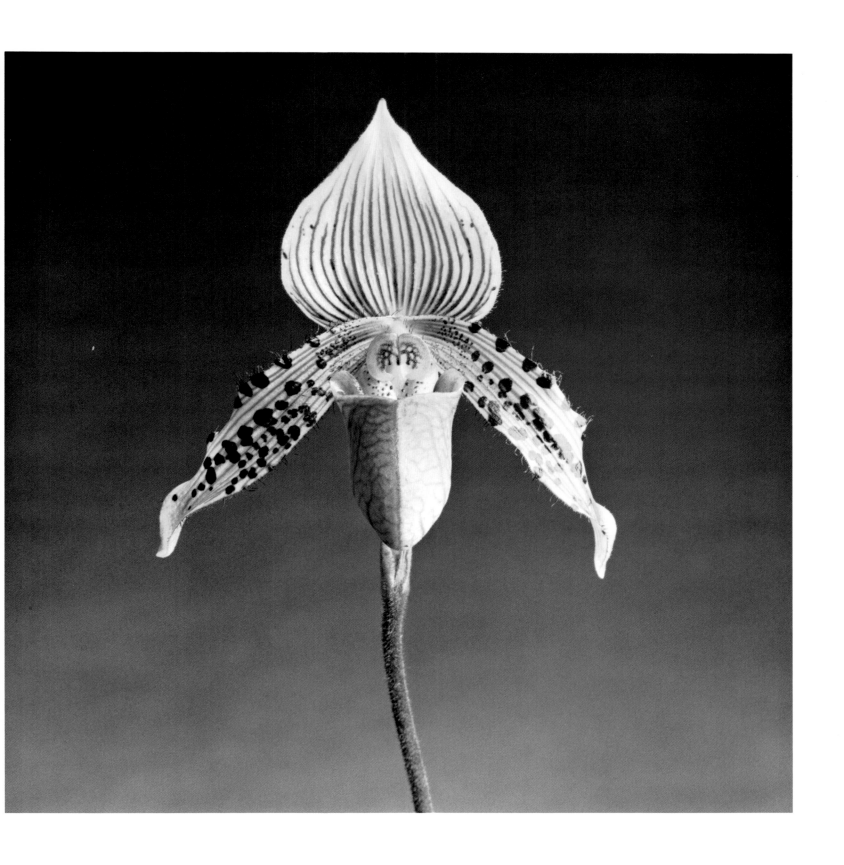

ORCHID 1987

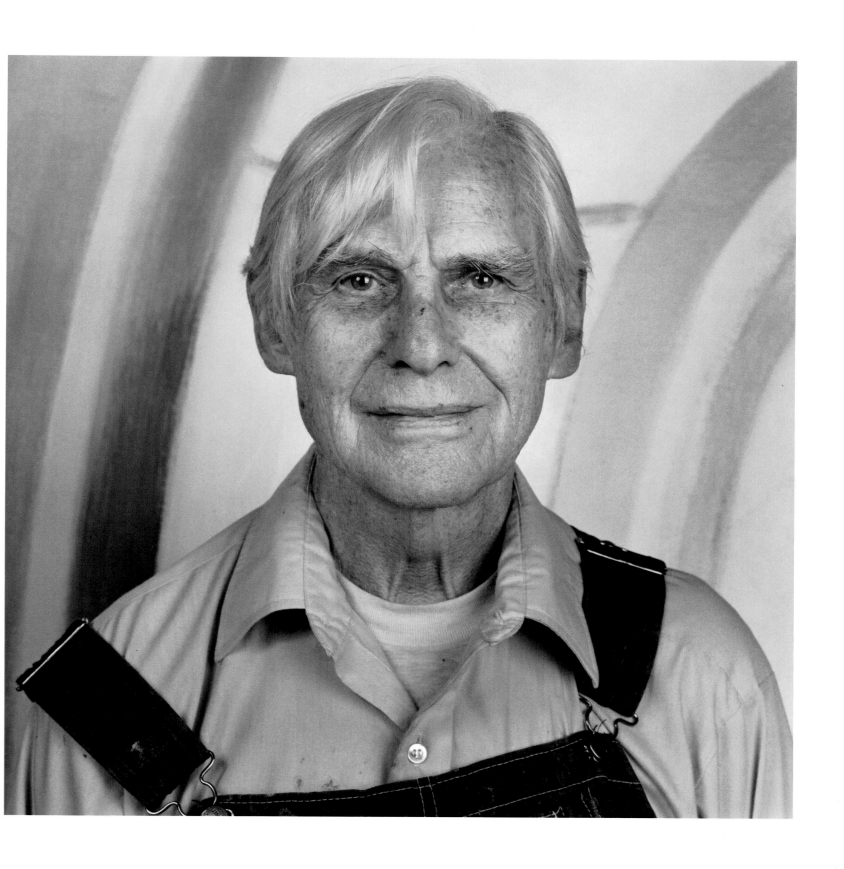

WILLEM DE KOONING 1986

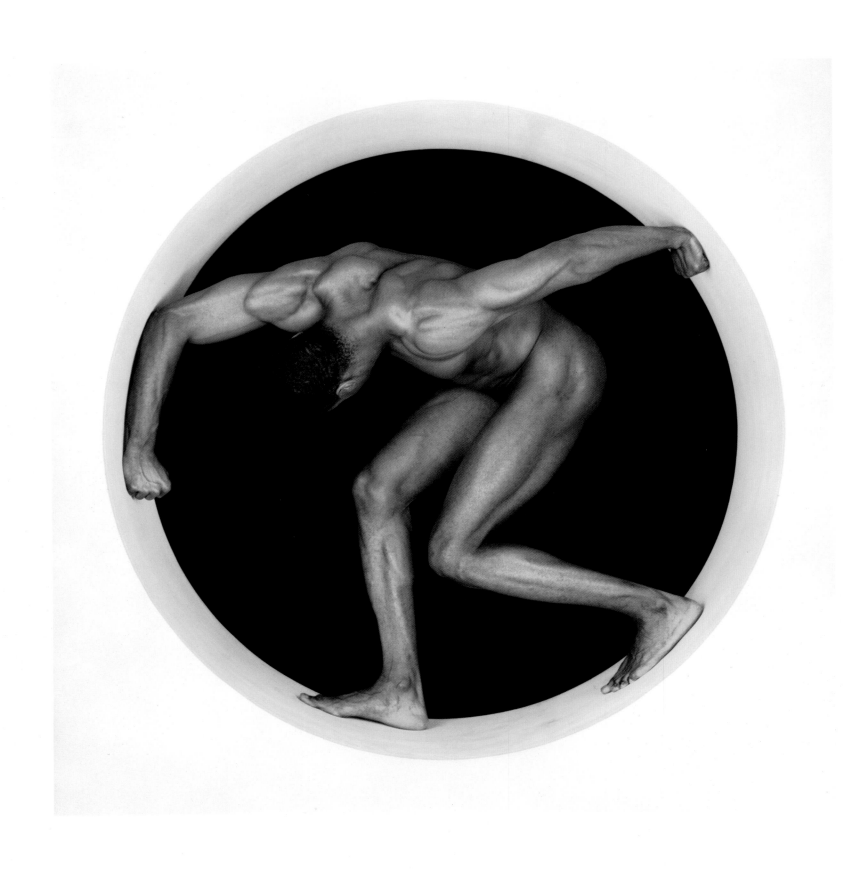

THOMAS 1986

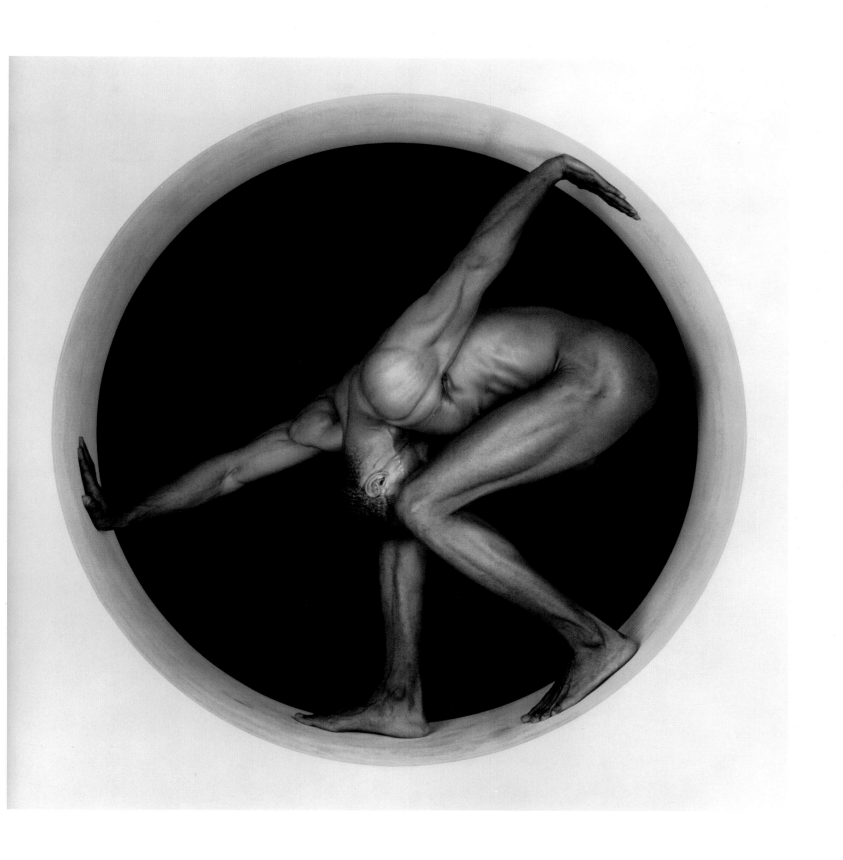

THOMAS 1986

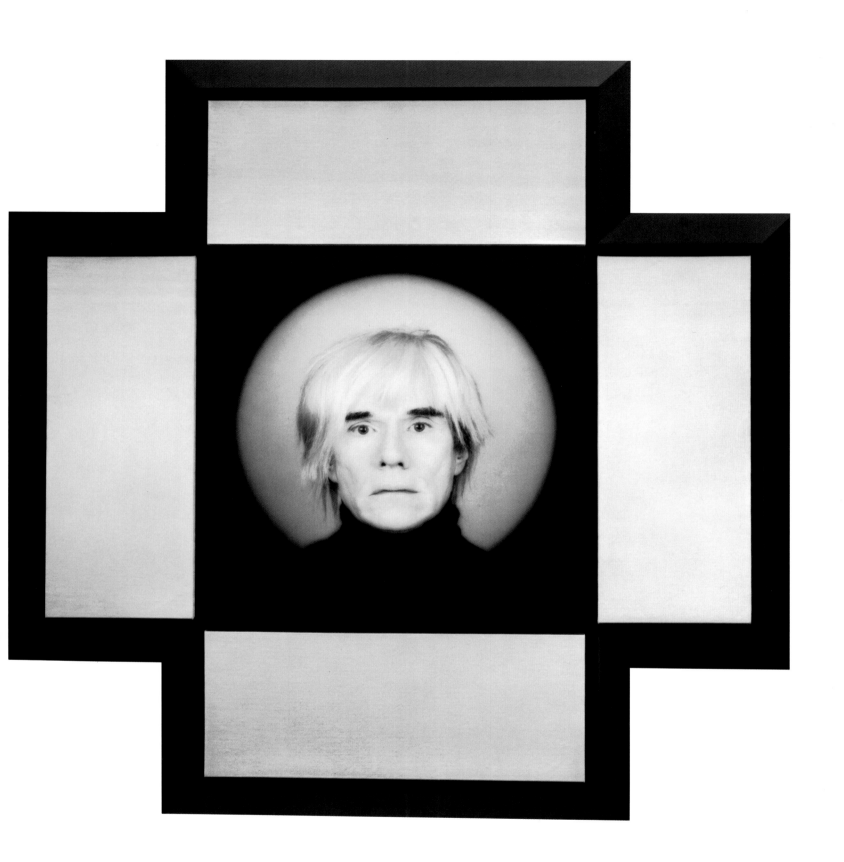

ANDY WARHOL 1987

173

CHEST 1987

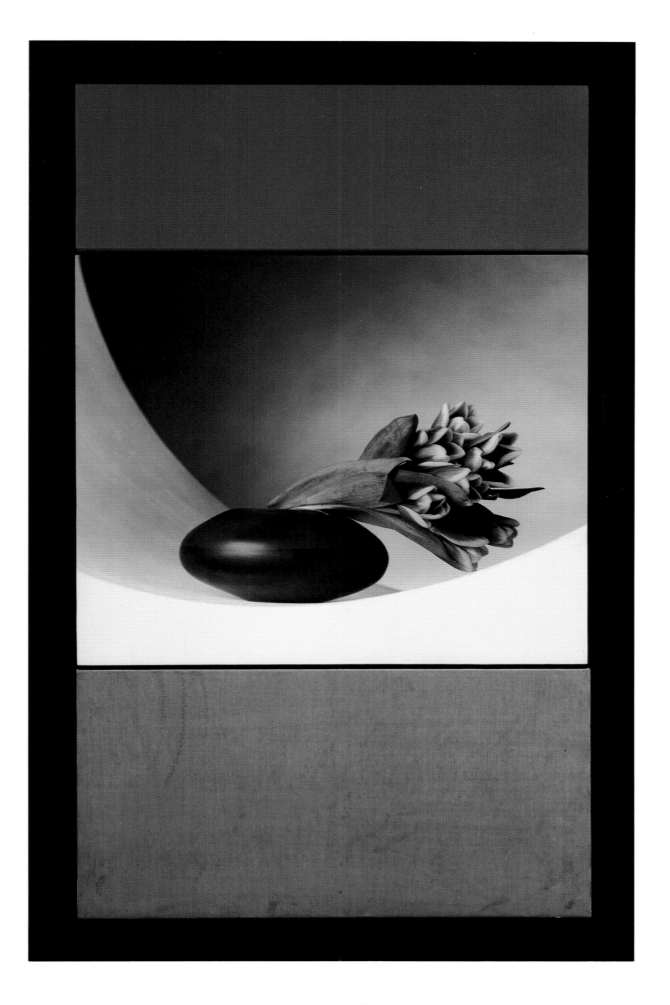

TULIPS 1987

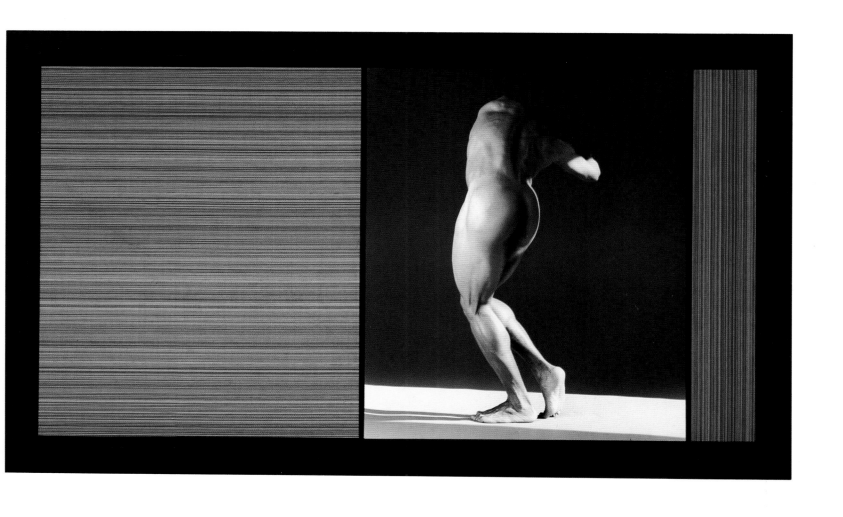

MICHAEL 1987

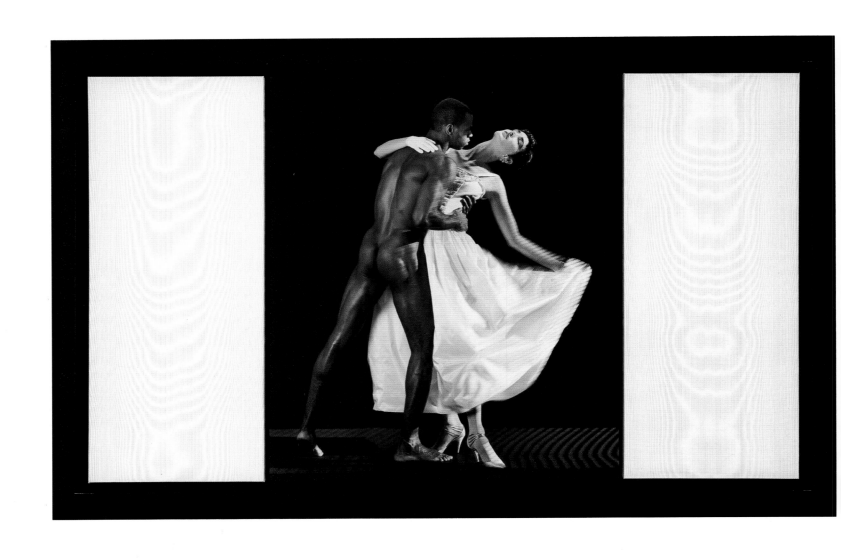

THOMAS AND DOVANA 1987

180

CALLA LILY 1987

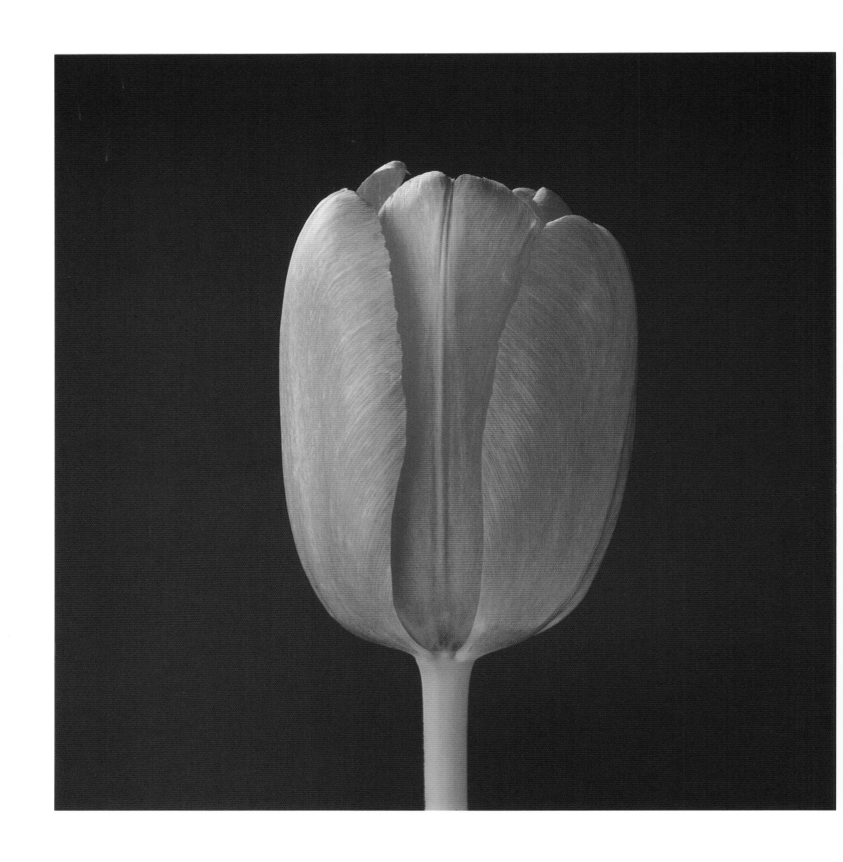

TULIP 1988

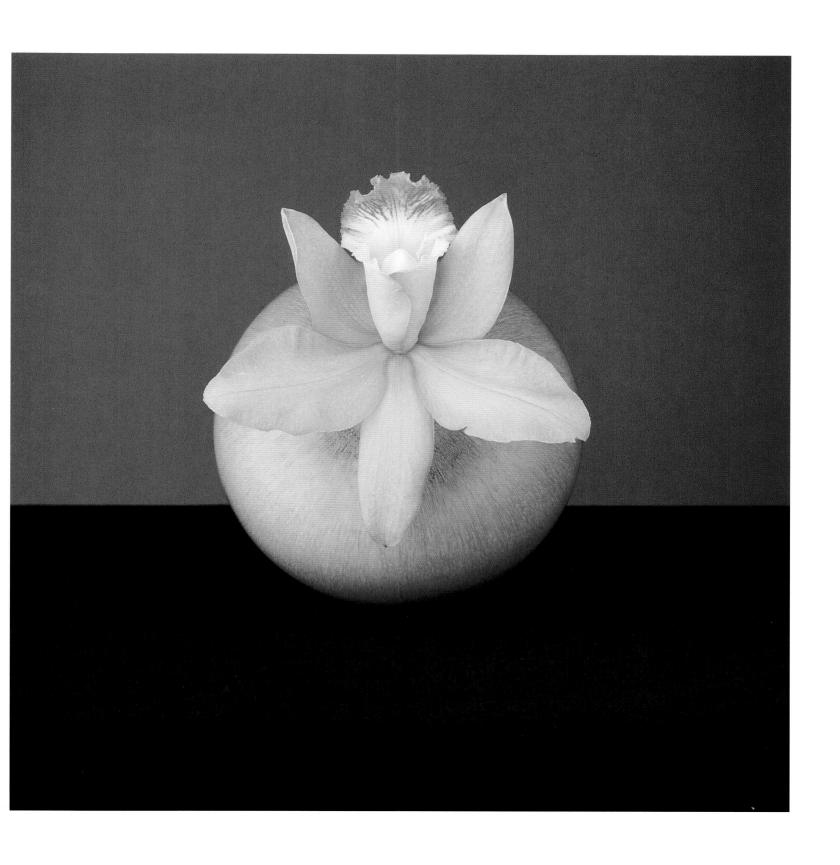

ORCHID 1988

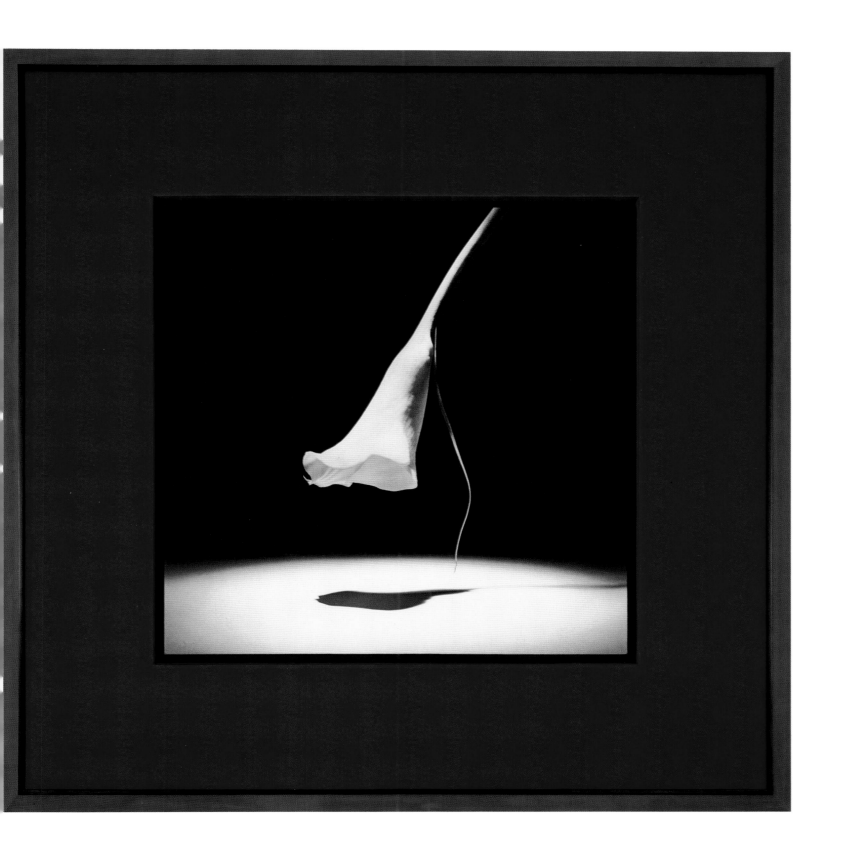

CALLA LILY 1987

185

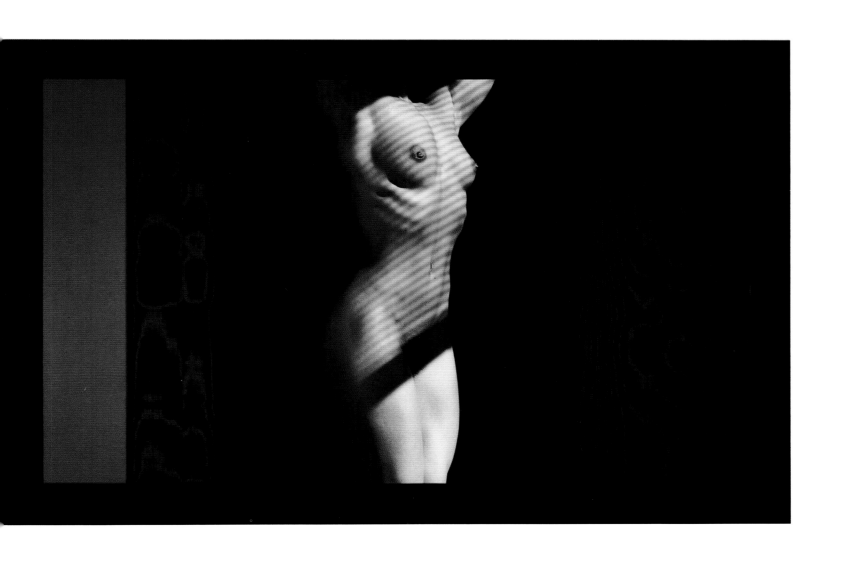

LYDIA 1987

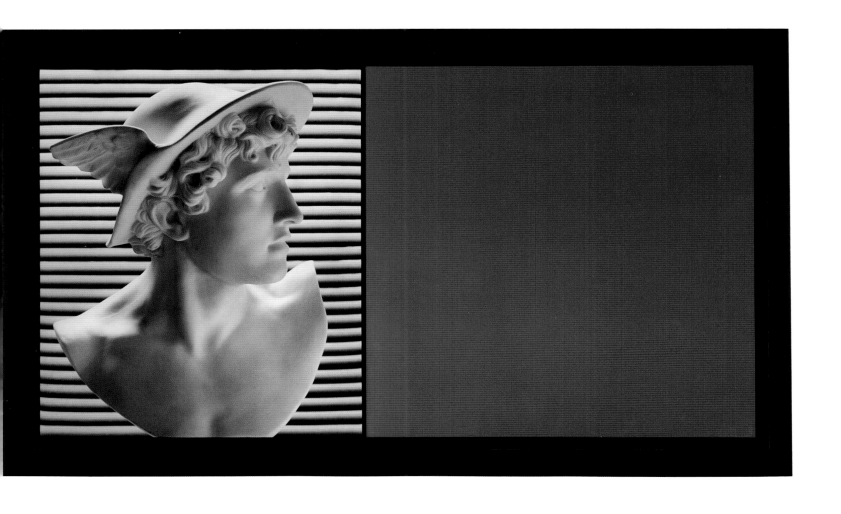

MERCURY 1987

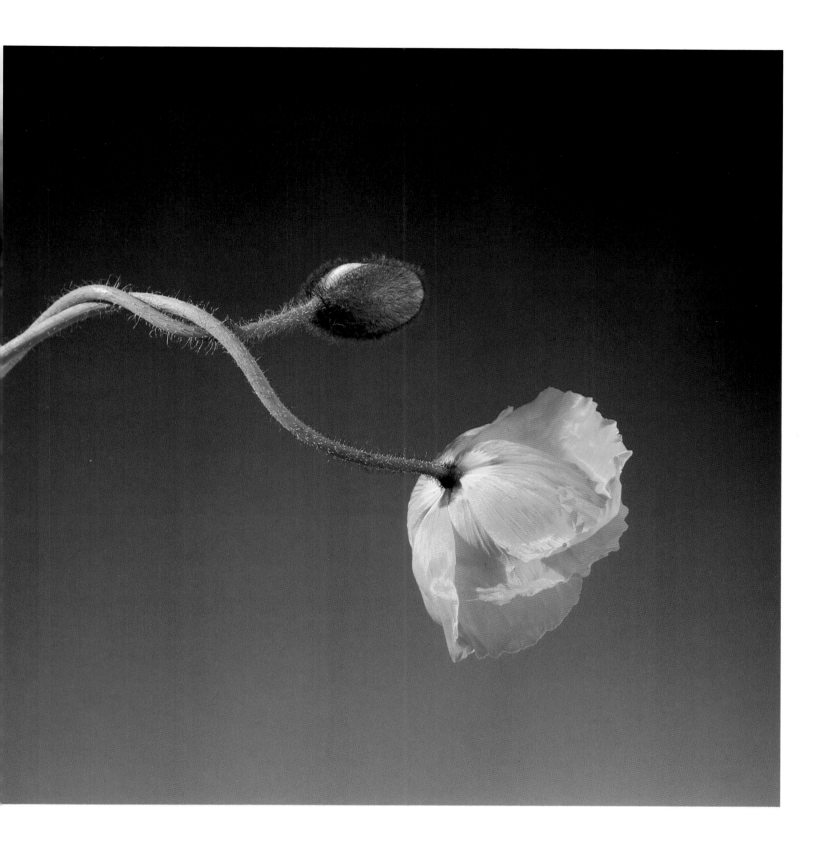

POPPY 1988

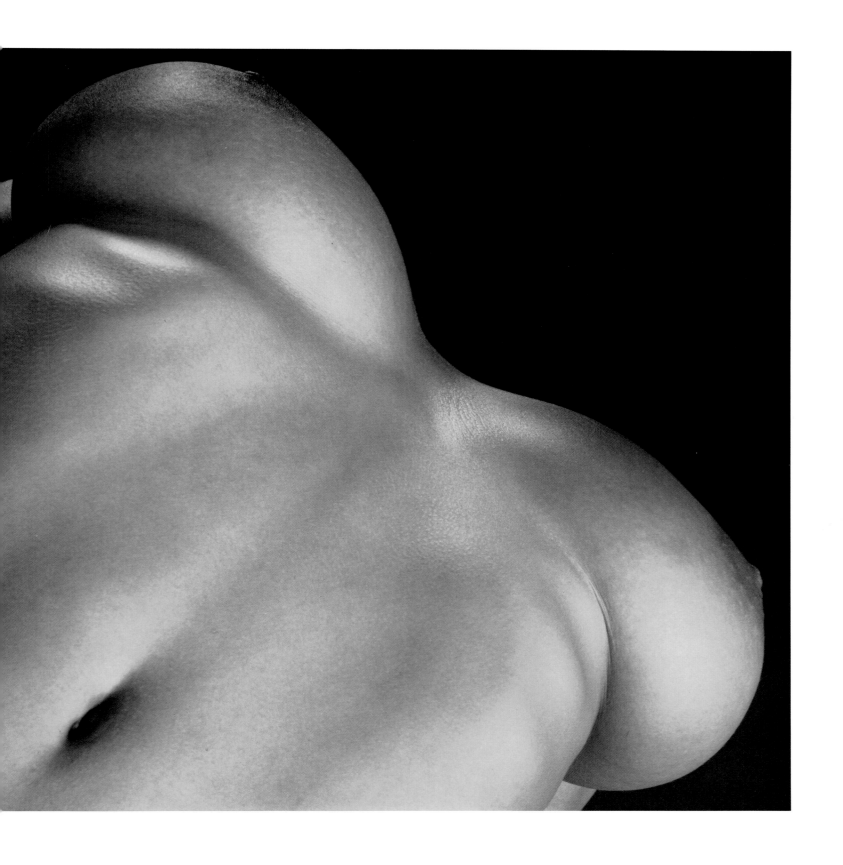

BREASTS 1988

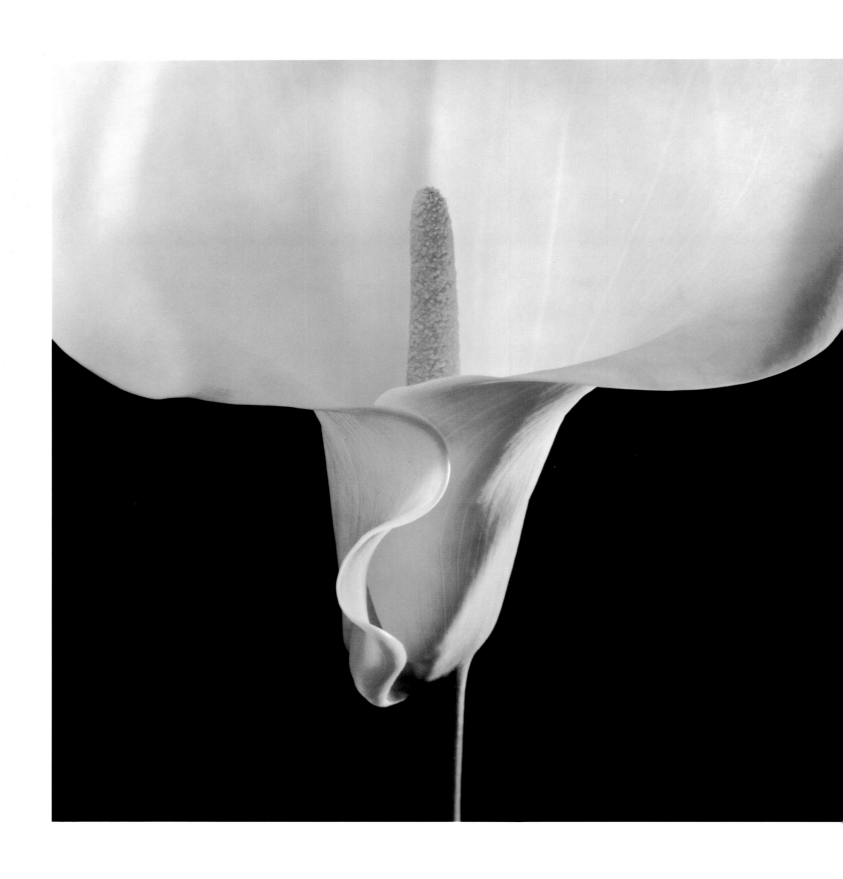

CALLA LILY 1988

194

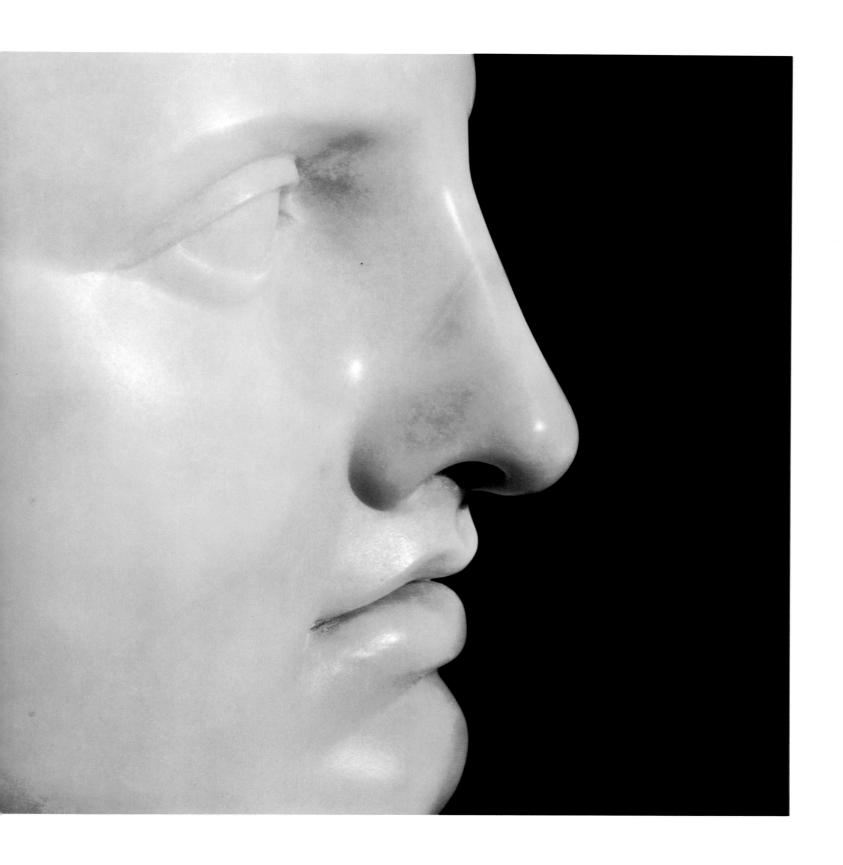

APOLLO 1988

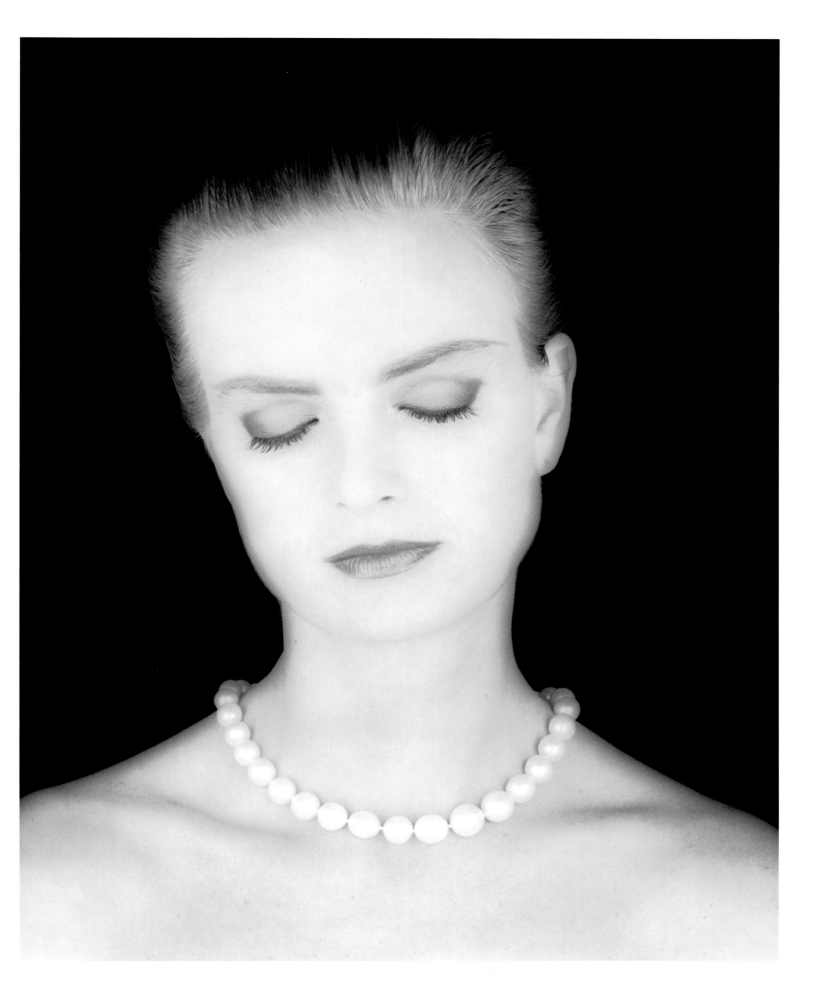

PRINCESS GLORIA VON THURN UND TAXIS 1987

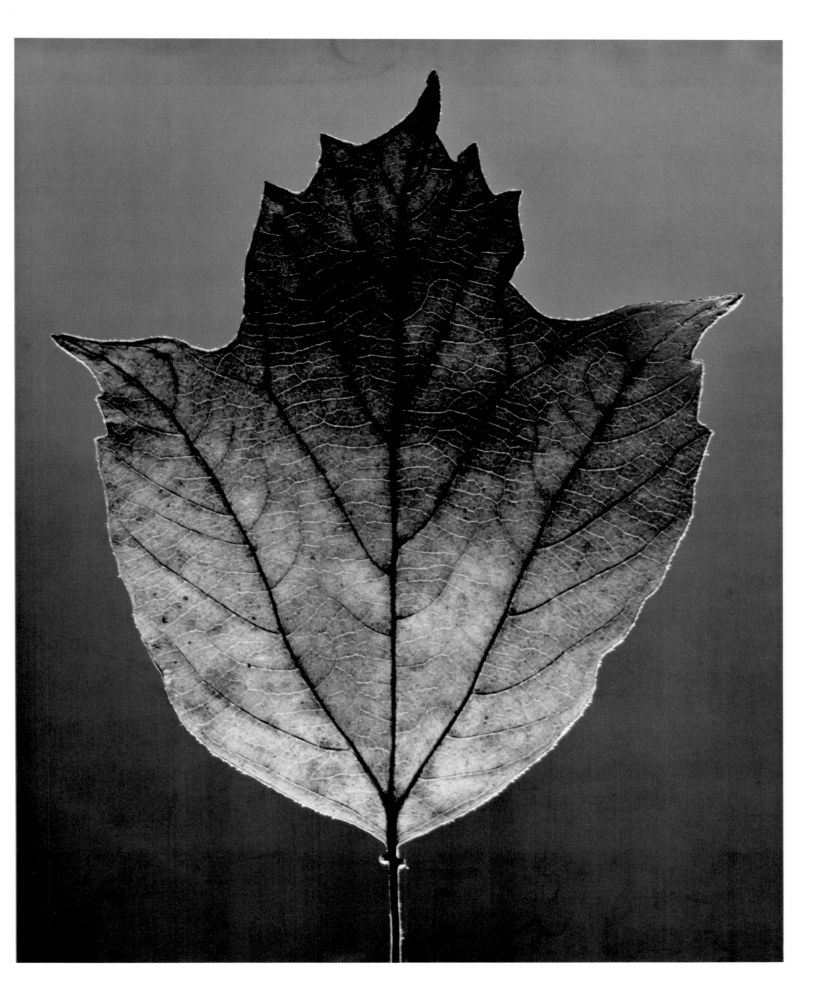

LEAF 1988

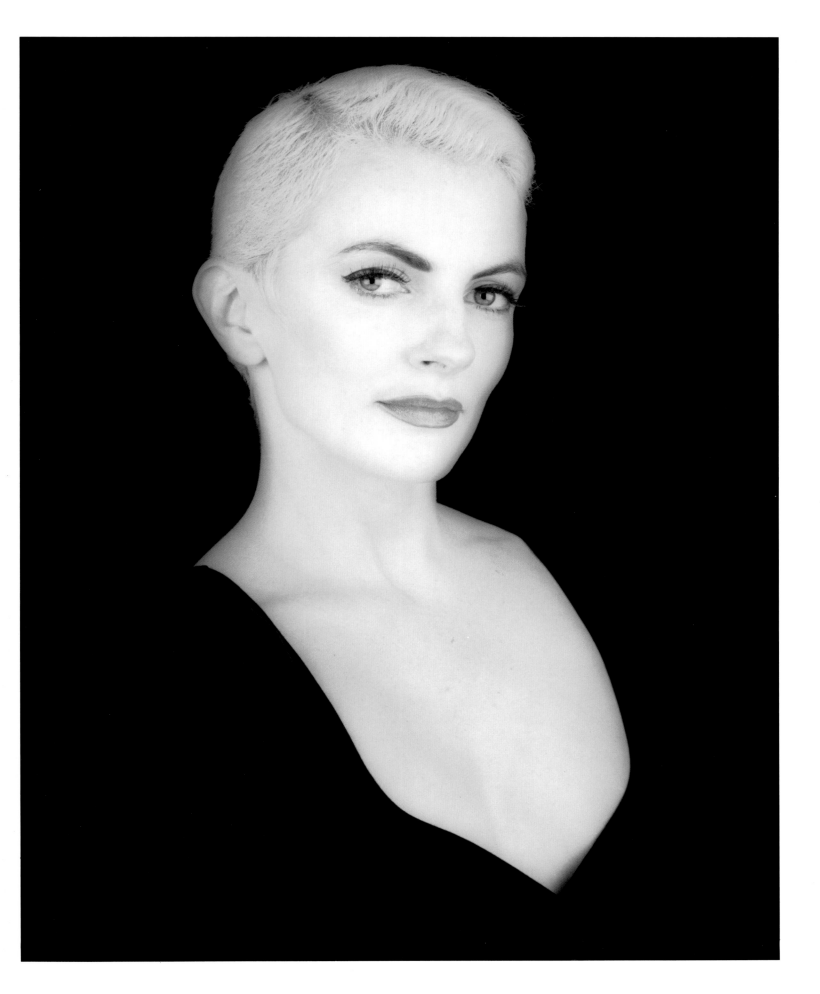

MELODY 1988

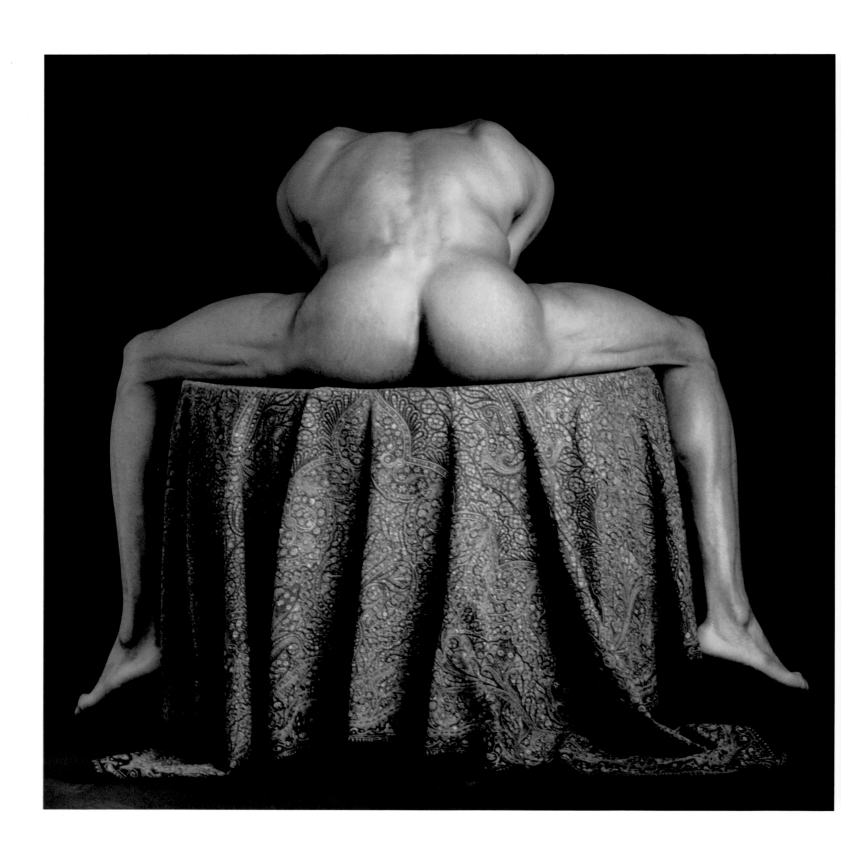

CARLTON 1988

NIPPLE 1988

LIST OF ILLUSTRATIONS

Numbers in bold refer to pages. Dimensions are in inches; height precedes width. Unless otherwise noted, editioned prints are courtesy of the artist.

Self Portrait, 1971 **17**
Three Polaroids with spray paint on paper bag, 17 x 7¾
Collection of Charles Cowles

Leatherman II, 1970 **18**
Collage, 13½ x 10½
Collection of the artist

Untitled, 1971 **19**
Collage, 10 x 8
Collection of the artist

Jesus, 1971 **20**
Spray paint on magazine page, 15⅞ x 11¾
Collection of the artist

Julius of California, 1971 **21**
Spray paint on magazine page, 10⅞ x 8⅜
Collection of Charles Cowles

Untitled, 1972 **22**
Spray paint on magazine page, 10 x 7½
Collection of the artist

Andy Warhol, 1971 **23**
Spray paint on magazine page, 11 x 8½
Collection of the artist

Model Parade, 1972 **25**
Photo-transfer and acrylic on canvas with frame, 21½ x 25½
Collection of the artist

Patti Smith (Don't Touch Here), 1973 **27**
Four Polaroids with plastic mounts, 5½ x 18¾
Collection of the artist

Candy Darling, 1973 **28**
Four Polaroids with plastic mounts, 5½ x 15
Collection of the artist

Untitled, 1973 **29**
Six Polaroids with plastic mounts, 10¾ x 11¼
Collection of the artist

Self Portrait, 1973 **30**
Unique gelatin silver print with frame, 14 x 16
Collection of the artist

The Slave, 1974 **31**
Unique gelatin silver print with frame, 20 x 16
Collection of the artist

Wood on Wood, 1974 **32**
Two unique gelatin silver prints with frame, 37 x 44¾
Collection of the artist

Black Shoes, 1974 **33**
Two unique gelatin silver prints with frame, 37 x 44½
Collection of Fredericka Hunter and Ian Glennie

Self Portrait, 1974 **35**
Unique gelatin silver print with frame, 14½ x 23¼
Collection of the artist

François, 1974–75 **36**
Four unique gelatin silver prints with frames, 28¼ x 29 each
Robert Miller Gallery, New York

Patti Smith (Horses), 1975 **39**
Two unique gelatin silver prints with mat and frame,
25 x 39½
Collection of the artist

David Hockney and Henry Geldzahler, 1976 **40**
Three unique gelatin silver prints with mat and frame,
47¾ x 23
Collection of Holly Solomon

Dennis, 1976 **41**
Three unique gelatin silver prints with mat and frame,
45 x 23½
Collection of the artist

Brice Marden, New York, 1976 **43**
Two unique gelatin silver prints with mat and frame,
22¼ x 57¼
Private collection

Holly Solomon, 1976 **45**
Three unique gelatin silver prints with mat and frame,
22¾ x 50¾
Collection of Holly Solomon

Pan Head and Flower, 1976 **46**
Unique gelatin silver print with mat and frame, 25¼ x 25
Collection of Holly Solomon

Arnold Schwarzenegger, 1976 **47**
Unique gelatin silver print with mat and frame, 36¾ x 36¾
Collection of Barbara and Eugene Schwartz

Mark Stevens (Mr. 10½), 1976 **49**
Gelatin silver print, edition 5; 20 x 16

Joe, 1978 **51**
Gelatin silver print, edition 5; 20 x 16

Philip Glass and Robert Wilson, 1976 **53**
Gelatin silver print, edition 5; 20 x 16

Brian Ridley and Lyle Heeter, 1979 **55**
Gelatin silver print, edition 10; 20 x 16

Tulips, 1977 **57**
Two unique gelatin silver prints with mat and frame,
25⅝ x 33¾
Collection of Paul F. Walter

Tiger Lily, 1977 **58**
Two unique gelatin silver prints with mat and frame,
23 x 42¼
Collection of the artist

Patti Smith (Still Moving), 1978 **59**
Three unique gelatin silver prints with frame, 22 x 51
Collection of the artist

Philip Johnson, 1978 **61**
Two unique gelatin silver prints with tinted plexiglass and
frame, 21¼ x 33¾
Collection of the artist

Jim and Tom, Sausalito, 1977–78 **63**
Three unique gelatin silver prints with mat and frame,
21½ x 50
Collection of Fredericka Hunter and Ian Glennie

Bob Love, 1979 **65**
Three unique gelatin silver prints with mat and frame,
26 x 61½
Collection of the artist

Bill, New York, 1976–77 **66**
Two unique gelatin silver prints with mirror and frame,
20¾ x 42¼
Collection of the artist

Easter Lilies with Mirror, 1979 **67**
Four unique gelatin silver prints with mirror and frame,
49 x 49
Collection of the artist

Richard, 1978 **69**
Two unique gelatin silver prints with mat and frame,
21½ x 33¾
Collection of Baldwin Fong

Helmut, 1978–79 **70**
Unique gelatin silver print with mirrors and frame,
40½ x 40½
Collection of the artist

Patti Smith (with Neck Brace), 1977 **71**
Unique gelatin silver print with mat and frame, 24½ x 24
Collection of the artist

Patti Smith, 1976 **72**
Gelatin silver print, edition 5; 20 x 16

Self Portrait, 1975 **73**
Gelatin silver print, edition 5; 20 x 16

Self Portrait, 1978 **75**
Gelatin silver print, edition 5; 20 x 16

Self Portrait, 1980 **89**
Unique gelatin silver print, 30 x 30
Collection of Howard and Suzanne Feldman

Carolina Herrera, 1979 **90**
Gelatin silver print, edition 5; 20 x 16

Paloma Picasso, 1980 **91**
Gelatin silver print, edition 10; 20 x 16

Dan, 1980 **93**
Unique gelatin silver print, 40 x 30
Collection of Lynn Hurst and John Van Alstine

Man in Polyester Suit, 1980 **95**
Unique gelatin silver print, 40 x 30
Collection of Baldwin Fong

Ajitto, 1981 **96**
Unique gelatin silver print, 40 x 30
Collection of Lois and Bruce Berry

Ajitto, 1981 **97**
Unique gelatin silver print, 40 x 30
The Israel Museum, Jerusalem

Ajitto, 1981 **98**
Unique gelatin silver print, 40 x 30
Collection of Harry H. Lunn, Jr.

Ajitto, 1981 **99**
Unique gelatin silver print, 40 x 30
Collection of the artist

Francesca Thyssen, 1981 **101**
Unique gelatin silver print, 30 x 30
Collection of the artist

Baby's Breath, 1982 **102**
Unique gelatin silver print, 30 x 30
Collection of the artist

Orchid and Leaf in White Vase, 1982 **103**
Unique gelatin silver print, 38 x 32
Collection of Anne and Joel Ehrenkranz

Untitled, 1981 **105**
Unique gelatin silver print, 30 x 30
Collection of the artist

Marty and Veronica, 1982 **107**
Unique gelatin silver print, 30 x 30
Collection of Baldwin Fong

Self Portrait (with Gun and Star), 1982 **109**
Unique gelatin silver print, 30 x 30
Collection of the artist

Lisa Lyon, 1982 **110**
Unique gelatin silver print, 30 x 30
Collection of Laura L. Carpenter

Derrick Cross, 1982 **111**
Unique gelatin silver print, 30 x 30
Robert Miller Gallery, New York

Lisa Lyon, 1981 **113**
Gelatin silver print, edition 10; 20 x 16

Lisa Lyon, 1982 **114**
Gelatin silver print, edition 10; 20 x 16

Louise Bourgeois, 1982 **115**
Gelatin silver print, edition 10; 20 x 16

Richard Gere, 1982 **117**
Gelatin silver print, edition 10; 20 x 16

Melia Marden, 1983 **119**
Gelatin silver print, edition 10; 20 x 16

The Coral Sea, 1983 **121**
Platinum print, edition 3; 25½ x 22
Collection of Barbara Gladstone

Ken Moody, 1983 **123**
Gelatin silver print, edition 10; 20 x 16

White X with Silver Cross, 1983 **124**
Painted wood and glass, 45¼ x 45¼
Collection of the artist

Star with Frosted Glass, 1983 **125**
Painted wood and glass, 47 x 49
Collection of the artist

Ken Moody, 1983 **127**
Unique gelatin silver print, 40 x 40
The Rivendell Collection

Calla Lily, 1984 **129**
Platinum print, edition 3; 25½ x 22
Collection of Barbara and Bruce Berger

Calla Lily, 1984 **130**
Platinum print, edition 3; 25½ x 22
Collection of Mr. and Mrs. Laurence Kleinman

Chris Hoffman, 1984 **131**
Gelatin silver print, edition 10; 20 x 16

Parrot Tulip in a Black Vase, 1985 **133**
Platinum print, edition 3; 25½ x 22
Hoyle, Morris & Kerr, Philadelphia

Ken Moody and Robert Sherman, 1984 **135**
Platinum print, edition 3; 25½ x 22
Collection of Aaron and Barbara Levine

Eggplant, 1985 **137**
Platinum print, edition 3; 25½ x 22
Collection of Andrew and Betsy Rosenfield

Vibert, 1984 **139**
Platinum print, edition 3; 25½ x 22
San Francisco Museum of Modern Art; Gift of
Anne MacDonald Walker

Fish, 1985 **141**
Platinum print, edition 3; 22 x 25½
Collection of Sondra Gilman and Celso Gonzalez-Falla

Raymond, 1985 **142**
Platinum print, edition 3; 25½ x 22
Robert Miller Gallery, New York

Charles, 1985 **143**
Platinum print, edition 3; 25½ x 22
Collection of Edward Fisher and Dennis Peak

Andre, 1984 **145**
Platinum print, edition 3; 25½ x 22
National Museum of American Art, Smithsonian Institution,
Washington, D.C.

Lydia, 1985 **147**
Platinum print, edition 3; 25½ x 22
Collection of Dr. M. Anwar Kamal

Grapes, 1985 **149**
Platinum print, edition 3; 25½ x 22
Collection of Harry H. Lunn, Jr.

Ken and Tyler, 1985 **151**
Platinum print, edition 3; 25½ x 22
G.H. Dalsheimer Gallery, Baltimore

Thomas, 1986 **161**
Gelatin silver print, edition 10; 24 x 20

Louise Nevelson, 1986 **163**
Gelatin silver print, edition 10; 24 x 20

Self Portrait, 1986 **165**
Gelatin silver print, edition 10; 24 x 20

Orchid, 1987 **167**
Photogravure on silk mounted on paper, edition 27; 50 x 44

Willem de Kooning, 1986 **169**
Gelatin silver print, edition 10; 24 x 20

Thomas, 1986 **170**
Gelatin silver print, edition 10; 24 x 20

Thomas, 1986 **171**
Gelatin silver print, edition 10; 24 x 20

Andy Warhol, 1987 **173**
Unique platinum print on linen with silk and frame, 43 x 42
Collection of George and Betsy Frampton

Chest, 1987 **175**
Three unique gelatin silver prints with frame, 40 x 40
Collection of Emily Fisher Landau

Tulips, 1987 **177**
Unique platinum print on linen with silk and frame, 46 x 29½
The Rivendell Collection

Michael, 1987 **179**
Unique platinum print on linen with silk and frame, 29½ x 50
Collection of Emily Fisher Landau

Thomas and Dovana, 1987 **180**
Unique platinum print on linen with silk and frame, 29½ x 48
Collection of the artist

Calla Lily, 1987 **181**
Unique platinum print on linen with frame, 25½ x 25½
Collection of Faith Golding

Tulip, 1988 **182**
Dye transfer print, edition 7; 24 x 20

Orchid, 1988 **183**
Dye transfer print, edition 7; 24 x 20

Calla Lily, 1987 **185**
Unique platinum print on linen with velvet and frame,
35 x 35
Collection of Laura Donnelley

Lydia, 1987 **187**
Unique platinum print on linen with silk and frame,
29½ x 45½
Collection of Mr. and Mrs. James Johnson

Mercury, 1987 **189**
Unique platinum print on linen with cotton fabric and frame,
29½ x 50
Collection of Harry H. Lunn, Jr.

Poppy, 1988 **191**
Dye transfer print, edition 7; 24 x 20

Breasts, 1988 **193**
Gelatin silver print, edition 10; 24 x 20

Calla Lily, 1988 **194**
Gelatin silver print, edition 10; 24 x 20

Apollo, 1988 **195**
Gelatin silver print, edition 10; 24 x 20

Princess Gloria von Thurn und Taxis, 1987 **197**
Gelatin silver print, edition 10; 24 x 20

Leaf, 1988 **199**
Unique gelatin silver print, 39 x 30
Collection of the artist

Melody, 1988 **201**
Gelatin silver print, edition 10; 24 x 20

Carlton, 1988 **202**
Gelatin silver print, edition 10; 24 x 20

Nipple, 1988 **203**
Gelatin silver print, edition 10; 24 x 20

SELECTED EXHIBITIONS

One-Artist Exhibitions

1973
Light Gallery, New York, "Polaroids"

1977
The Kitchen, New York, "Erotic Pictures"
Holly Solomon Gallery, New York, "Flowers"
Holly Solomon Gallery, New York, "Portraits"

1978
The Chrysler Museum, Norfolk, Virginia
The Corcoran Gallery of Art, Washington, D.C.
Galerie Remise du Parc, Paris
Langdon Street Gallery, San Francisco, "Censored"
Simon Lowinsky Gallery, San Francisco
Robert Miller Gallery, New York, "Film and Stills"

1979
International Center of Photography, New York, "Trade Off"
 (with Lynn Davis)
Robert Miller Gallery, New York, "Contact"
Robert Samuel Gallery, New York, "Robert Mapplethorpe
 1970–1975"
Texas Gallery, Houston

1980
Galerie Jurka, Amsterdam, "Robert Mapplethorpe:
 Black Males"
In a Plain Brown Wrapper Gallery, Chicago
Lawson/De Celle Gallery, San Francisco, "Robert Mapple-
 thorpe: Blacks and Whites"
Vision Gallery, Boston

1981
Fraenkel Gallery, San Francisco
Frankfurter Kunstverein, Frankfurt
Galerie Contretype, Brussels
Galerie Nagel, West Berlin
Galerie Texbraun, Paris

Lunn Gallery, Washington, D.C.
Robert Miller Gallery, New York, "Black Males"

1982
Contemporary Arts Center, New Orleans
Gagosian Gallery, Los Angeles
Galerie Jurka, Amsterdam
Galerie Ton Peek, Utrecht, The Netherlands
Galerie Watari, Tokyo
Galleria il Ponte, Rome, "Black Males"
Fay Gold Gallery, Atlanta
Shore Gallery, The Pines, Long Island, New York
Young Hoffman Gallery, Chicago

1983
Leo Castelli Gallery, New York, "Robert Mapplethorpe:
 Lady, Lisa Lyon"
Jane Corkin Gallery, Toronto
Galerie Rüdiger Schöttle, Munich, "Lady, Lisa Lyon"
Galerie Watari, Tokyo, "Flowers"
Barbara Gladstone Gallery, New York, "Photogravures"
Hardison Fine Arts Gallery, New York, "Robert Mapple-
 thorpe: Fashion and Head Shots"
Hardison Fine Arts Gallery, New York
Institute of Contemporary Arts, London, "Robert Mapple-
 thorpe 1970–1983"
Robert Miller Gallery, New York
Musée National d'Art Moderne, Centre Georges Pompidou,
 Paris
Olympus Centre, London, "Lady, Lisa Lyon"
Photographie Galerie, Düsseldorf, "Lady, Lisa Lyon"
The Saint Louis Art Museum, "Flowers"

1984
Centro di Documentazione, Palazzo Fortuny, Venice
Fondazione Lucio Amelio, Naples
Galeria Fernando Vijande, Madrid, "Fotografías 1970–1983"
Barbara Gladstone Gallery, New York, "Robert Mapple-
 thorpe: Process"
Palazzo delle Cento Finestre, Florence

1985
Fraenkel Gallery, San Francisco, "Robert Mapplethorpe:
 Recent Work in Platinum"
Galerie Daniel Templon, Paris
Robert Miller Gallery, New York, "Robert Mapplethorpe:
 New Works in Platinum"

1986
Australian Centre for Contemporary Art, South Yarra,
 "Robert Mapplethorpe: Photographs 1976–1985"
Palladium, New York
Betsy Rosenfield Gallery, Chicago
Texas Gallery, Houston

1987
Fraenkel Gallery, San Francisco
Galerie Pierre Huber, Geneva

Galerie Kicken-Pauseback, Cologne
Galerie Françoise Lambert, Milan
Galerie Raab, West Berlin
Julia Gallery, New Orleans
Obalne Galerije, Ljubljana, Yugoslavia
Robert Miller Gallery, New York

1988
Galerie Jurka, Amsterdam
Hamiltons Gallery, London
Institute of Contemporary Art, University of Pennsylvania,
 Philadelphia
Middendorf Gallery, Washington, D.C.
Robert Miller Gallery, New York
National Portrait Gallery, London
Betsy Rosenfield Gallery, Chicago
Stedelijk Museum, Amsterdam

Group Exhibitions

1973
Gotham Book Mart, New York, "Polaroids: Robert Mapple-
 thorpe, Brigid Polk, Andy Warhol"

1974
Bykert Gallery, New York, "Group Exhibition"

1976
Holly Solomon Gallery, New York, "Animals"

1977
Museum Fridericianum, Kassel, West Germany, "Documenta 6"
Holly Solomon Gallery, New York, "Surrogates/Self-Portraits"

1978
The Corcoran Gallery of Art, Washington, D.C., "The Col-
 lection of Sam Wagstaff"
The Museum of Modern Art, New York, "Mirrors and Win-
 dows: Photography 1960 to the Present"
Marge Neikrug Gallery, New York, "Rated X"
Holly Solomon Gallery, New York, "The New York Boat
 Show"

1979
The Aspen Center for the Visual Arts, Colorado, "American
 Portraits of the Sixties and Seventies"

The Santa Barbara Museum of Art, "Attitudes: Photography
 in the 1970's"
Whitney Museum of American Art, Downtown Branch,
 New York, "Artists by Artists"

1980
Carson-Sapiro Gallery, Denver, "New Visions"
Freedman Gallery, Albright College, Reading, Pennsylvania,
 "Presences: The Figure and Manmade Environments"
Jacksonville Art Museum, Florida, "The Norman Fisher
 Collection"
Jehu Gallery, San Francisco, "Erotic Paintings and Photo-
 graphs"
Padiglione d'Arte Contemporanea, Milan, "Quattro fotografi
 differenti"
School of Visual Arts Museum, New York, "In Photography:
 Color as Subject"

1981
Albright-Knox Art Gallery, Buffalo, New York, "Figures:
 Forms and Expressions"
Marlborough Gallery, New York, "Surrealist Photographic
 Portraits, 1920–1980"
Musée National d'Art Moderne, Centre Georges Pompidou,
 Paris, "Autoportraits photographiques"
Newport Harbor Art Museum, Newport Beach, California,
 "Inside Out: Self Beyond Likeness"

Nordiska Kompaniet, Stockholm, "US Art Now"

P.S. 1, Institute for Art and Urban Resources, Long Island City, New York, "New York/New Wave"

Rheinisches Landesmuseum Bonn, "Lichtbildnisse: Das Porträt in der Fotografie"

Robert Samuel Gallery, New York, "Marked Photographs"

Stedelijk Museum, Amsterdam, "Instant Fotografie"

Whitney Museum of American Art, New York, "1981 Biennial Exhibition"

1982

Concord Gallery, New York, "Portraits"

Galerie Texbraun, Paris, "La photographie en Amérique"

The Grey Art Gallery and Study Center, New York University, "Faces Photographed"

Harlem Exhibition Space, New York, "The Black Male Image"

Roger List Gallery, New York, "The Erotic Impulse"

The Metropolitan Museum of Art, New York, "Counterparts: Form and Emotion in Photographs"

Museum of Art, University of Oklahoma, Norman, "Points of View: 1982"

Museum Fridericianum, Kassel, West Germany, "Documenta 7"

1983

Leo Castelli Gallery, New York, "Drawings and Photographs"

Castelli Graphics, New York, "Three-Dimensional Photographs"

Whitney Museum of American Art, Downtown Branch, New York, "Phototypes: The Development of Photography in New York City"

Linda Farris Gallery, Seattle, "Self-Portraits"

The Taft Museum, Cincinnati, "Presentation: Recent Portrait Photography"

The Tampa Museum, Florida, "Photography in America: 1910–1983"

The Tate Gallery, London, "New Art"

1984

Cable Gallery, New York, "Sex"

Contemporary Arts Museum, Houston, "The Heroic Figure"

Delahunty Gallery, Dallas, "Portrait Photography"

Fondazione Lucio Amelio, Naples, "Terrae Motus"

Institute of Contemporary Art, University of Pennsylvania, Philadelphia, "Face to Face: Recent Portrait Photography"

Jason McCoy, Inc., New York, "Still-Life Photographs"

Nexus Contemporary Art Center, Atlanta, "Radical Photography: The Bizarre Image"

School of the Museum of Fine Arts, Boston, "Twelve on 20 x 24"

Superior Street Gallery, The School of the Art Institute of Chicago, "Sex-Specific: Photographic Investigations of Contemporary Sexuality"

Wave Hill, Bronx, New York, "Flower as Image in 20th-Century Photography"

1985

Josh Baer Gallery, New York, "Entertainment"

Mary and Leigh Block Gallery, Northwestern University, Evanston, Illinois, "Picture Taking"

Hayden Gallery, Massachusetts Institute of Technology, Cambridge, "Nude, Naked, Stripped"

Jeffrey Hoffeld and Company, New York, "Big Portraits"

Palladium, New York, "Beauty"

Photographer's Gallery, London, "Five Years with 'The Face'"

1986

Artspace, San Francisco, "Paravent"

Mead Art Museum, Amherst College, Amherst, Massachusetts, "Rules of the Game: Culture Defining Gender"

Mint Museum, Charlotte, North Carolina, "The Fashionable Image: Unconventional Fashion Photography"

Musée National d'Art Moderne, Centre Georges Pompidou, Paris, "Invitation: la revue Parkett"

Photography Resource Center, Boston University, "The Sacred and the Sacriligious: Iconographic Images in Photography"

San Francisco Museum of Modern Art, "The Nude in Modern Photography"

Turman Gallery, Indiana State University, Terre Haute, "Intimate/Intimate"

Whitney Museum of American Art, New York, "Sacred Images in Secular Art"

1987

Comune di Ravenna, Italy, "Il nudo maschile nella fotographia"

International Center of Photography, New York, "Legacy of Light"

Milwaukee Art Museum, "Of People and Places: The Floyd and Josephine Segal Collection of Photography"

Virginia Museum of Fine Arts, Richmond, "Portrait: Faces of the '80s"

1988

Burden Gallery, Aperture Foundation, New York, "The Return of the Hero"

Grand Rapids Art Museum, Michigan, "Flowers"

The High Museum of Art, Atlanta, "First Person Singular: Self-Portrait Photography, 1840–1986"

SELECTED BIBLIOGRAPHY

Books and Catalogues

Amaya, Mario. *Robert Mapplethorpe Photographs*. Norfolk, Virginia: The Chrysler Museum, 1978.

Augur, Julie. *American Portraits of the Sixties and Seventies*. Aspen, Colorado: The Aspen Center for the Visual Arts, 1979.

Baker, Lauren, Jennifer Dowd, and Philip Hotchkiss Walsh. *Phototypes: The Development of Photography in New York City* (brochure). New York: Whitney Museum of American Art, Downtown Branch, 1983.

Barendse, Henry. *The Fashionable Image: Unconventional Fashion Photography*. Charlotte, North Carolina: Mint Museum, 1986.

Barents, Els. *Instant Fotografie*. Amsterdam: Stedelijk Museum, 1981.

——. *Robert Mapplethorpe*. Munich: Schirmer/Mosel in association with the Stedelijk Museum, Amsterdam, 1988.

Barns, Lawrence, ed. *The Male Nude in Photography*. Introduction by Marcuse Pfeifer. Waitsfield, Vermont: Vermont Crossroads Press, 1980.

Barter, Judith, and Anne Mochon. *Rules of the Game: Culture Defining Gender*. Amherst, Massachusetts: Mead Art Museum, Amherst College, 1986.

Bonuomo, Michele, and Diego Cortez. *Terrae Motus*. Naples: Electa Napoli, 1984.

Borden, Janet. *Presentation: Recent Portrait Photography*. Foreword by Ruth K. Meyer. Cincinnati: The Taft Museum, 1983.

Cathcart, Linda L., and Craig Owens. *The Heroic Figure*. Houston: Contemporary Arts Museum, 1984.

Celant, Germano. *Robert Mapplethorpe: Fotografie*. Milan: Idea Books, Publimedia Editrice, 1983.

——. *Robert Mapplethorpe: Photographien 1984–1986*. Munich: Schirmer/Mosel, 1986.

Clyde, Jim, ed. *Exquisite Creatures*. Introduction by Donald Barthelme. New York: William Morrow and Company, 1985.

Compton, Michael. *New Art*. London: The Tate Gallery, 1983.

Conrad, Peter. *Mapplethorpe Portraits*. Foreword by Robin Gibson and Terence Pepper. London: National Portrait Gallery, 1988.

Cruger, George. *Portrait: Faces of the '80s*. Richmond: Virginia Museum of Fine Arts, 1987.

Curtis, Verna Posever. *Of People and Places: The Floyd and Josephine Segal Collection of Photography*. Foreword by Russell Bowman, essay by Robert M. Tilendis. Milwaukee: Milwaukee Art Museum, 1987.

Ewing, William A. *The Fugitive Gesture: Masterpieces of Dance Photography*. London: Thames and Hudson, 1987.

Fabre, Jan, and Robert Mapplethorpe. *The Power of Theatrical Madness*. Introduction by Kathy Acker, essay by Germano Celant. London: Institute of Contemporary Arts, 1986.

Fernandes, Joyce. *Sex-Specific: Photographic Investigations of Contemporary Sexuality*. Chicago: Superior Street Gallery, The School of the Art Institute of Chicago, 1984.

Frank, Peter. *Self-Portraits*. Introduction by Linda Farris. Seattle: Linda Farris Gallery, 1983.

Friis-Hansen, Dana. *Nude, Naked, Stripped*. Cambridge: Hayden Gallery, Massachusetts Institute of Technology, 1985.

Gamwell, Lynn, and Victoria Kogan. *Inside Out: Self Beyond Likeness*. Newport Beach, California: Newport Harbor Art Museum, 1981.

Grynsztejn, Madeline, Junko Iwabuchi, Brooke Kamin, Lisa Suzuki, and Helen Woodall. *Sacred Images in Secular Art* (brochure). New York: Whitney Museum of American Art, 1986.

Hanhardt, John G., Barbara Haskell, Richard Marshall, and Patterson Sims. *1981 Biennial Exhibition*. New York: Whitney Museum of American Art, 1981.

Hedberg, Lars Peder. *US Art Now*. Foreword by Jan Eric Lowenadler. Stockholm: Nordiska Kompaniet, 1981.

Hollinghurst, Alan, and Stuart Morgan. *Robert Mapplethorpe 1970–1983*. Preface by Sandy Nairne. London: Institute of Contemporary Arts, 1983.

Holmes, John. *Twelve on 20 x 24*. Introduction by Jim Field. Cambridge, Massachusetts: The New England Foundation for the Arts, 1984.

Honnef, Klaus. *Lichtbildnisse: Das Porträt in der Fotografie*. Bonn, West Germany: Rheinisches Landesmuseum Bonn, 1982.

Horton, Anne. *Robert Mapplethorpe 1986*. West Berlin: Galerie Raab and Galerie Kicken-Pauseback, Cologne, 1987.

Kotik, Charlotta, Susan Krane, Robert Collingnon, Biff Henrich, William Currie, and G. Roger Denson. *Figures: Forms and Expressions*. Buffalo, New York: Albright-Knox Art Gallery, The Buffalo Fine Arts Academy, 1981.

Lifson, Ben. *Faces Photographed*. New York: The Grey Art Gallery and Study Center, New York University, 1982.

Longwell, Dennis. *Surrealist Photographic Portraits, 1920–1980*. New York: Marlborough Gallery, 1981.

Macklowe, Linda. *Flower as Image in 20th-Century Photography*. Foreword by Helen Gee. Bronx, New York: Wave Hill, 1984.

Mapplethorpe, Robert. *The Agency*. New York: Hardison Fine Arts Gallery, 1983.

——. *Black Book*. Foreword by Ntozake Shange. New York: St. Martin's Press, 1986.

——. *Black Flowers*. Madrid: Fernando Vijande Editor, 1985.

——. *Black Males*. Preface by Edmund White. Amsterdam: Galerie Jurka, 1980.

——. *Certain People: A Book of Portraits*. Preface by Susan Sontag. Los Angeles: Twelvetrees Press, 1985.

——. *Flowers*. Preface by Sam Wagstaff. Tokyo: Galerie Watari, 1983.

——. *Lady, Lisa Lyon*. Foreword by Sam Wagstaff, text by Bruce Chatwin. New York: The Viking Press, 1983.

——. *Robert Mapplethorpe*. Introduction by Ikuroh Takano, interview by David Hershkovits. Tokyo: Parco Co., 1987.

Marshall, Richard, and Robert Mapplethorpe. *50 New York Artists*. San Francisco: Chronicle Books, 1986.

Mayer, Charles S. *Intimate/Intimate*. Introduction by Bert Brouwer. Terre Haute, Indiana: Turman Gallery, Indiana State University, 1986.

Naef, Weston. *Counterparts: Form and Emotion in Photographs*. New York: The Metropolitan Museum of Art in association with E.P. Dutton, 1982.

Parker, Fred R. *Attitudes: Photography in the 1970's*. Santa Barbara: The Santa Barbara Museum of Art, 1979.

Rimbaud, Arthur. *A Season in Hell*. Translated by Paul Schmidt. Photographs by Robert Mapplethorpe. New York: The Limited Edition Book Club, 1984.

Roche, Denis. *Autoportraits photographiques*. Paris: Musée National d'Art Moderne, Centre Georges Pompidou, 1981.

Saul, Julie M. *Photography in America: 1910–1983*. Foreword by Genevieve A. Linnehan. Tampa, Florida: The Tampa Museum, 1983.

Sheftel, Bruce. *Presences: The Figure and Manmade Environments*. Reading, Pennsylvania: Freedman Gallery, Albright College, 1980.

Sidlauskas, Susan. *Intimate Architecture: Contemporary Clothing Design*. Cambridge, Massachusetts: Hayden Gallery, Massachusetts Institute of Technology, 1982.

Silverman, Ruth. *Athletes: Photographs, 1860–1986.* New York: Alfred A. Knopf, 1987.

———. *The Dog Observed: Photographs, 1844–1983.* New York: Alfred A. Knopf, 1984.

Smith, Patti. *Robert Mapplethorpe.* New York: Bellport Press, 1987.

Squiers, Carol. *Quattro fotografi differenti.* Milan: Padiglione d'Arte Contemporanea, 1980.

Sullivan, Constance, ed. *Legacy of Light.* Introduction by Peter Schjeldahl, essays by Gretel Ehrlich, Robert Stone, Richard Howard, and Diane Johnson. New York: Alfred A. Knopf, 1987.

———. *Nude: Photographs, 1850–1980.* Essays by Robert Sobieszek and Ben Maddow. New York: Harper and Row, 1980.

von der Fuhr, Rein. *Robert Mapplethorpe: Photographs.* Amsterdam: Galerie Jurka, 1979.

Wagstaff, Sam, ed. *A Book of Photographs.* New York: Gray Press in association with The Corcoran Gallery of Art, Washington, D.C., 1978.

Weiermair, Peter. *Männer sehen Männer.* Schaffhausen, Switzerland: Verlag Photographie, 1986.

Weiermair, Peter, ed. *Robert Mapplethorpe.* Introduction by Sam Wagstaff. Frankfurt: Frankfurter Kunstverein, 1981.

Wise, Kelly, ed. *Portrait: Theory.* New York: Lustrum Press, 1981.

Articles and Reviews

Anderson, Alexandra. "The Collectors." *Vogue,* March 1985, pp. 304–06.

Bourdon, David. "Robert Mapplethorpe." *Arts Magazine,* 51 (April 1977), p. 7.

Champeau, Albert. "Robert Mapplethorpe." *Créatis: La photographie au présent,* 7 (1978).

Chatwin, Bruce, and Donald Richards. "Strong Stuff: Lisa Lyon's Body Beautiful." *Tattler,* June 1983.

Davis, Douglas. "The Return of the Nude." *Newsweek,* September 1, 1986, pp. 78–79.

Ellenzweig, Allen. "Robert Mapplethorpe at Robert Miller." *Art in America,* 69 (November 1981), pp. 171–72.

Everly, Bart. "Robert Mapplethorpe." *Splash,* April 1988.

Filler, Martin. "Robert Mapplethorpe." *House & Garden,* 160 (June 1988), pp. 158–63.

Fischer, Hal. "Calculated Opulence." *Artweek,* 12 (November 21, 1981), pp. 11–12.

Foster, Hal. "Robert Mapplethorpe." *Artforum,* 16 (February 1978), pp. 68–69.

Friedman, Jan R. "Robert Mapplethorpe." *Arts Magazine,* 53 (June 1979), p. 32.

Grundberg, Andy. "Is Mapplethorpe Only Out to Shock?" *The New York Times,* March 13, 1983, pp. 32, 35.

———. "Prints That Go Beyond the Border of the Medium." *The New York Times,* May 3, 1987, p. 29.

Handy, Ellen. "Robert Mapplethorpe/Hollis Sigler." *Arts Magazine,* 58 (December 1983), pp. 38–39.

Henry, Gerrit. "Robert Mapplethorpe—Collecting Quality: An Interview." *The Print Collector's Newsletter,* 13 (September/October 1982), pp. 128–30.

Hershkovits, David. "Shock of the Black and the Blue." *The Soho News*, May 20, 1981, pp. 9–11.

Himmel, Eric. "Cut Flowers." *Camera Arts*, 3 (April 1983), pp. 56–61.

Indiana, Gary. "Mapplethorpe." *The Village Voice*, May 14, 1985, p. 97.

———. "Robert Mapplethorpe." *Bomb*, no. 12 (Winter 1988), pp. 19–23.

Jordan, Jim. "End of the Individual." *Artweek*, 16 (June 1, 1985), p. 13.

Kissel, Howard. "Robert Mapplethorpe: Unsettling Images." *W*, July 14–21, 1986, p. 22.

Koch, Stephen. "Guilt, Grace and Robert Mapplethorpe." *Art in America*, 74 (November 1986), pp. 144–51.

Kohn, Michael. "Robert Mapplethorpe." *Arts Magazine*, 57 (September 1982), p. 43.

Kolbowski, Silvia. "Covering Mapplethorpe's 'Lady.'" *Art in America*, 71 (Summer 1983), pp. 10–11.

Larson, Kay. "Between a Rock and a Soft Place." *New York*, June 1, 1981, pp. 56–58.

Manegold, C.S. "Robert Mapplethorpe, 1970–1983." *Arts Magazine*, 58 (February 1984), pp. 96–99.

Marshall, Richard, ed. "Robert Mapplethorpe: Heads and Flowers." *The Paris Review*, 95 (Spring 1985), pp. 27–35.

Mittlemark, Howard. "Letter from Japan." *Art & Auction*, 7 (November 1984), pp. 32, 36.

Morgan, Stuart. "Mapplethorpe: Le jeu kaleidoscopique." *Clichés*, 40 (October 1987), pp. 16–23.

———. "Something Magic." *Artforum*, 25 (May 1987), pp. 118–23.

Panicelli, Ida. "Robert Mapplethorpe, Palazzo delle Cento Finestre, Galleria Lucio Amelio." *Artforum*, 23 (October 1984), pp. 98–99.

Perrone, Jeff. "Robert Mapplethorpe." *Artforum*, 17 (Summer 1979), pp. 70–71.

Ripp, Allan, Carol Squiers, and Steven Koch. "Mapplethorpe." *American Photographer*, 20 (January 1988), pp. 44–55.

Simson, Emily. "Portraits of a Lady." *Art News*, 82 (November 1983), pp. 53–54.

Sontag, Susan. "Sontag on Mapplethorpe." *Vanity Fair*, 48 (July 1985), pp. 68–72.

Squiers, Carol. "The Visible Face." *The Village Voice*, November 30, 1982, p. 134.

———. "Mapplethorpe Off the Wall." *Vanity Fair*, 48 (January 1985), pp. 88–89.

———. "Undressing the Issues." *The Village Voice*, April 5, 1983.

Stretch, Bonnie Barrett. "Contemporary Photography." *Art & Auction*, 9 (May 1987), pp. 140–47.

Tamblyn, Christine. "Poses and Positions." *Artweek*, 18 (June 27, 1987), p. 11.

Tatransky, Valentin. "Robert Mapplethorpe." *Arts Magazine*, 57 (May 1977), p. 29.

Trucco, Terry. "State of the Art." *American Photographer*, 12 (January 1984), p. 18.

Walker, Anne. "Holly Solomon/Robert Mapplethorpe." *Shift*, 1 (1987), pp. 18–19, 24.

Weaver, Mike. "Mapplethorpe's Human Geometry: A Whole Other Realm." *Aperture*, no. 101 (Winter 1985), pp. 43–51.

ACKNOWLEDGMENTS

SINCERE APPRECIATION is extended to the following people for their valuable assistance and consideration in the realization of this book and exhibition: Tom Armstrong, Susan Arthur, Tom Baril, John Cheim, Suzanne Donaldson, Laura Donnelley, Brian English, Celso Gonzalez-Falla, Sondra Gilman Gonzalez-Falla, Frederick Henry, Richard Howard, James Kraft, Carol Judy Leslie, Dimitri Levas, Anne Long, Edward Maxey, Robert Miller, Barbara Mortimer, Howard Read, Jennifer Russell, Ingrid Sischy, Holly Solomon, Michael Stout, Tina Summerlin. In addition, the generosity of the owners of works in the exhibition is gratefully acknowledged. Most important was the time, thoughtfulness, and consideration of the artist throughout the planning and preparation of this project.

THIS PUBLICATION was organized at the Whitney Museum by Doris Palca, Head, Publications and Sales; Sheila Schwartz, Editor; Deborah Lyons, Associate Editor; and Vicki Drake, Supervisor, Printing Services.

Designed by Richard Marshall with La Riviere · Hanson Design; typeset in Monotype Dante by Michael and Winifred Bixler; four-color printing by Eastern Press, Inc; duotone printing by Rembrandt Press Inc.; binding by Acme Bookbinding Company, Inc.

For quotations from or about Robert Mapplethorpe in "A Society Artist" the writer has benefited from conversations with the artist and from *Robert Mapplethorpe*, a videotape produced by the BBC in 1988.

Illustrations for "Mapplethorpe's Vision": p. 9, F. Holland Day, *The Seven Words*, 1898, seven platinum prints with frame, Private collection; p. 10, Man Ray, *Rrose Sélavy alias Marcel Duchamp*, 1920–21, gelatin silver print, Philadelphia Museum of Art; Samuel S. White, III and Vera White Collection; *Solarization (Calla Lilies)*, 1931, solarized silver print, Private collection; p. 11, Edward Weston, *Pepper No. 30*, 1930, gelatin silver print, The Metropolitan Museum of Art, New York; David Hunter McAlpin Fund; George Platt Lynes, *John Leaphart*, 1952, gelatin silver print, Private collection; p. 12, Donald Judd, *To Susan Buckwalter*, 1964, lacquer on aluminum and galvanized iron, Private collection; p. 13, Andy Warhol, *Self Portrait*, 1964, acrylic and silkscreen ink on canvas, Private collection; p. 14, Brice Marden, *Summer Table*, 1972–73, oil and wax on canvas, Whitney Museum of American Art, New York; Purchase, with funds from the National Endowment for the Arts 73.30; p. 15, Edward Ruscha, *Pure Ecstacy*, 1974, tea on moiré, Stedelijk van Abbemuseum, Eindhoven, The Netherlands.

Black-and-white photographs courtesy of Robert Mapplethorpe studio, except p. 14 (Geoffrey Clements); p. 15 (Eric Pollitzer); pp. 9, 10 right (Sotheby's, Inc.); p. 11 right (Adam Reich). Color photographs by Adam Reich, except pp. 17, 21 (eeva-inkeri); pp. 33, 63 (Rick Gardner); pp. 57, 69 (Bill Jacobson Studio); pp. 182, 183, 191 (Robert Mapplethorpe studio); pp. 175, 177, 179, 180, 181, 185, 187, 189 (Zindman/Fremont).